HISTORIC PHOTOS OF
COLORADO SPRINGS

TEXT AND CAPTIONS BY SHARON SWINT

TURNER
PUBLISHING COMPANY

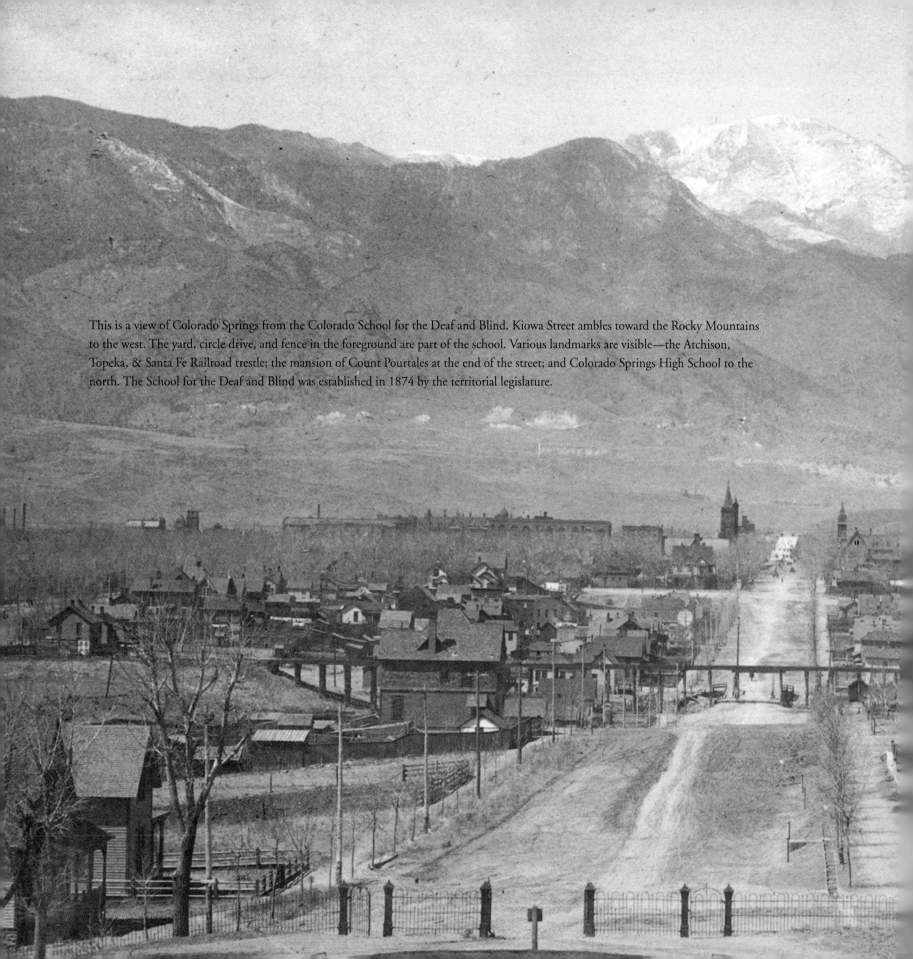

This is a view of Colorado Springs from the Colorado School for the Deaf and Blind. Kiowa Street ambles toward the Rocky Mountains to the west. The yard, circle drive, and fence in the foreground are part of the school. Various landmarks are visible—the Atchison, Topeka, & Santa Fe Railroad trestle; the mansion of Count Pourtales at the end of the street; and Colorado Springs High School to the north. The School for the Deaf and Blind was established in 1874 by the territorial legislature.

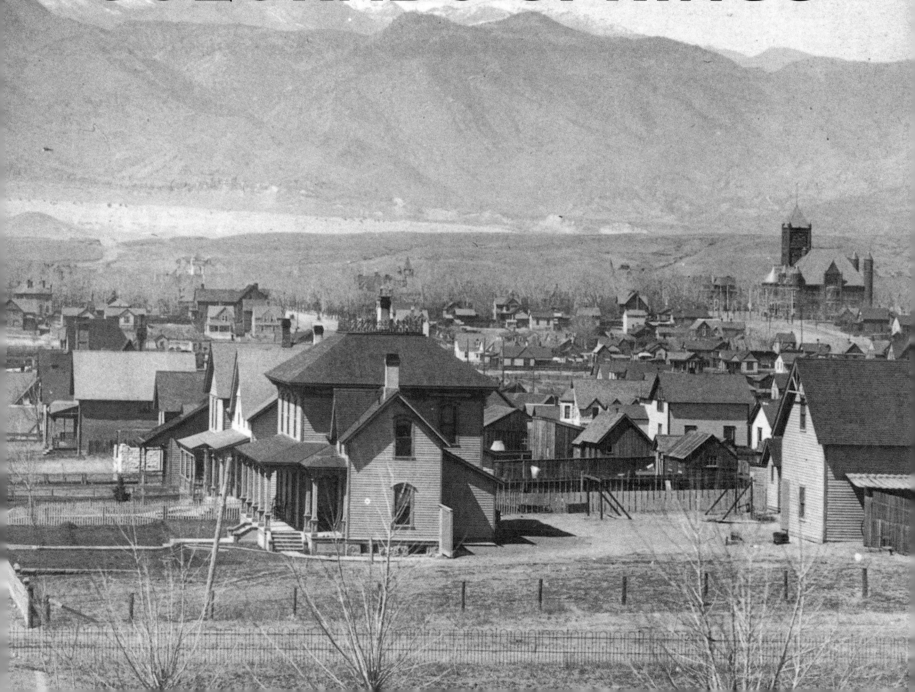

HISTORIC PHOTOS OF
COLORADO SPRINGS

Turner Publishing Company
200 4th Avenue North • Suite 950
Nashville, Tennessee 37219
(615) 255-2665

www.turnerpublishing.com

Historic Photos of Colorado Springs

Copyright © 2009 Turner Publishing Company

Library of Congress Control Number: 2007942097

ISBN-13: 978-1-59652-437-8

Printed in China

09 10 11 12 13 14 15 16—0 9 8 7 6 5 4 3 2 1

Contents

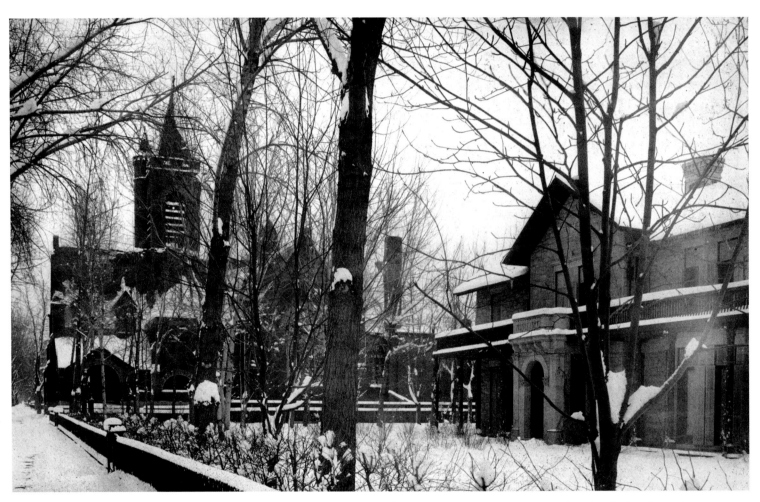

The stone residence of pioneer Irving Howbert is shown on the right on South Weber Street. The First Baptist Church is farther down the block at Kiowa and Weber. Howbert arrived in the Pikes Peak region in 1860 with his Methodist minister father. He was the El Paso County Clerk in 1869 when General Palmer began to acquire land for the town, later becoming president of the First National Bank.

ACKNOWLEDGMENTS

This volume, *Historic Photos of Colorado Springs,* is the result of the cooperation and efforts of many individuals and organizations. It is with great thanks that we acknowledge the valuable contribution of the following for their generous support:

Denver Public Library

Library of Congress

Old Colorado City Historical Society

Pikes Peak Library District

Tutt Library, Colorado College

———————

This book is dedicated to the many, many men, women, and children who came to the frontier for a variety of reasons and stayed on to build an amazing town, Colorado Springs. It is also dedicated to the many historians who continue to research and write, and educate others concerning our regional history. There is no substitute for the tenacity of either group.

PREFACE

Colorado Springs has thousands of historic photographs that reside in archives, both locally and nationally. This book began with the observation that, while those photographs are of great interest to many, they are not easily accessible. During a time when the city is looking ahead and evaluating its future course, many people are asking, How do we treat the past? These decisions affect every aspect of the city—architecture, public spaces, commerce, infrastructure—and these, in turn, affect the way that people live their lives. This book seeks to provide easy access to a valuable, objective look into the history of Colorado Springs.

The power of photographs is that they are less subjective than words in their treatment of history. Although the photographer can make subjective decisions regarding subject matter and how to capture and present it, photographs seldom interpret the past to the extent textual histories can. For this reason, photography is uniquely positioned to offer an original, untainted look at the past, allowing the viewer to learn for himself what the world was like a century or more ago.

This project represents countless hours of review and research. The researchers and writer have reviewed many hundreds of photographs in numerous archives. We greatly appreciate the generous assistance of the organizations listed in the acknowledgments of this work, without whom this project could not have been completed.

The goal in publishing this history is to provide broader access to this set of extraordinary photographs, as well as to inspire, provide perspective, and evoke insight that might assist citizens as they work to plan the city's future. In addition, the book seeks to preserve the past with adequate respect and reverence.

With the exception of touching up imperfections caused by the vicissitudes of time and cropping where necessary, no other changes have been made. The focus and clarity of many images is limited to the technology and the ability of the photographer at the time they were taken.

The work is divided into eras. Beginning with some of the earliest known photographs of Colorado Springs, the first section records photographs through the end of the nineteenth century. The second section spans the beginning of the twentieth century through the World War I era. Section Three moves from the 1920s to the eve of World War II. The last section covers the World War II era to recent times.

In each of these sections we have made an effort to capture various aspects of life through our selection of photographs. People, commerce, transportation, infrastructure, religious institutions, and educational institutions have been included to provide the most widely encompassing look at the subject feasible.

We encourage readers to reflect as they go walking in Colorado Springs, exploring the city, its parks, and its neighborhoods. It is the publisher's hope that in utilizing this work, longtime residents will learn something new and that new residents will gain a perspective on where Colorado Springs has been, so that each can contribute to its future.

—Todd Bottorff, Publisher

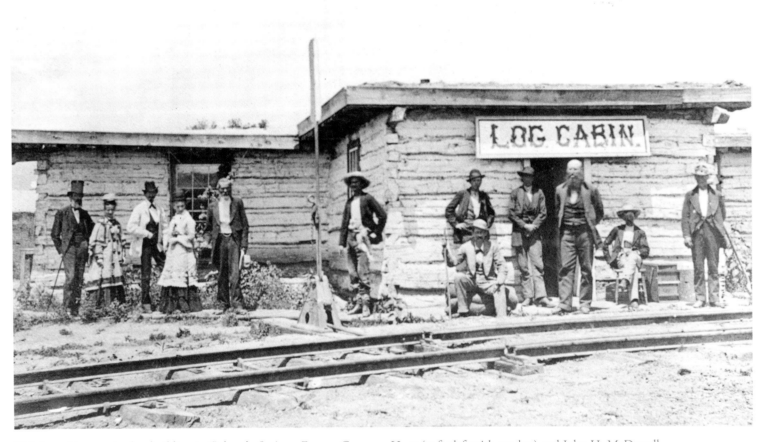

This log cabin was the first building in Colorado Springs. Former Governor Hunt (at far left with top hat) and John H. McDowell (fifth from left) built it as a headquarters while working with General Palmer on the town. The structure later became a rustic hotel for new arrivals, serving outstanding food. A December 1871 menu listed eleven categories of food, from soup and hot and cold meat to pastries and desserts. The Denver and Rio Grande Railroad tracks are visible in the foreground.

THE EARLY YEARS

(1859–1899)

Bring me men to match my mountains,
Bring me men to match my plains;
men with empires in their purpose
and new eras in their brains.

—*Samuel Walter Foss, "The Coming American," 1895*

The Pikes Peak region beckoned and men responded. The Cheyenne and Arapahoe came from the plains, and the Ute came from the mountains. Explorers like Ruxton, Fremont, Pike, and still more answered the summons. They all passed through but did not stay. Then in 1869, a man with a vision, a dream, and a hunger heard the call. General William Jackson Palmer felt that he had found "home." Not the Pennsylvania town he came from but a place he, a wife, a family, and a company of friends could develop into a community of like-minded people.

There was already a small community, Colorado City, which had begun to take shape a few years earlier at the bottom of the Ute Pass. This town hoped to grow as a supply area for miners seeking their fortunes. In 1871, Palmer was able to purchase government land a bit east of Colorado City and lay out his new town. He enlisted the aid of old friends and military cohorts like William Bell, William Sharpless Jackson, Henry McAllister, and bright settlers like Irving Howbert. The Denver and Rio Grande Railroad, also founded by Palmer, arrived. Now visitors and settlers could get to the Pikes Peak region more easily. The men, the women, the famous, and the not-so-famous all came, paying $50 for residential lots and $100 for business lots, and together they built "Little London"—Colorado Springs.

When gold was discovered to the west at Cripple Creek and Victor in the early 1890s, the wealth generated trickled over to the city. Winfield Scott Stratton's Independence Mine made him a fortune, some of which he used to make buildings and parks possible for the citizens of Colorado Springs. With the building of the cog railway to Pikes Peak from Manitou Springs in the early 1890s, Colorado Springs and its environs were placed solidly on the map.

This early photograph from around 1860 shows the beginnings of the town of Colorado City, established in 1859. Colorado City hoped to be the main supply point for miners on their way to the goldfields of South Park. Yucca punctuate the foreground of this spectacular mountain vista.

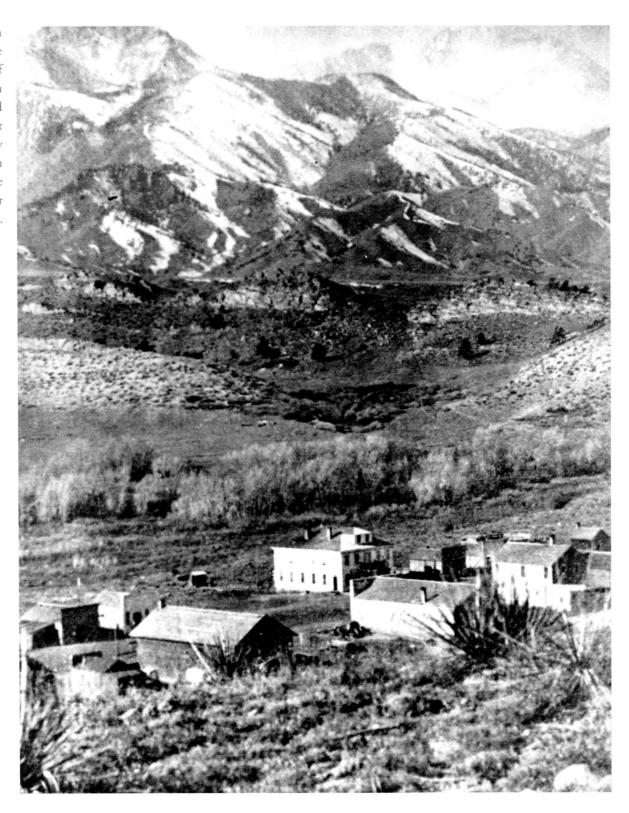

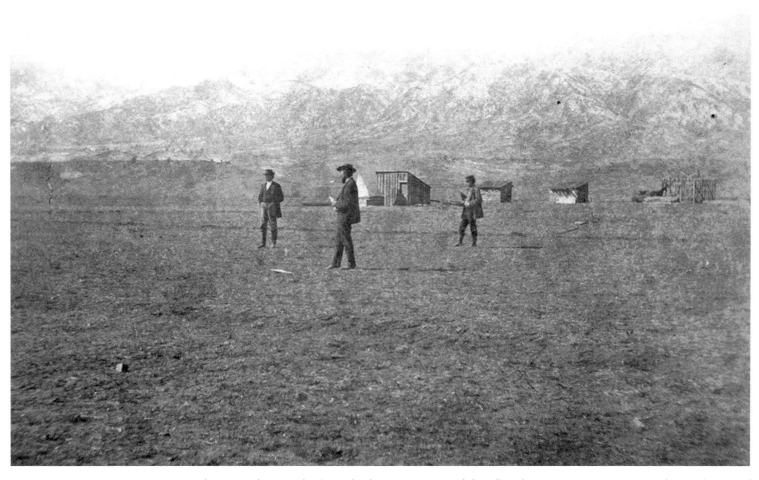

In this 1871 photograph, General Palmer (at center, with beard) and a two-man survey team work near the area of Pikes Peak Avenue and Tejon Street laying out the town of Colorado Springs. The first stake of the town was driven in this vicinity, noticeably surrounded by a vast open prairie. Plow rows were used to mark streets.

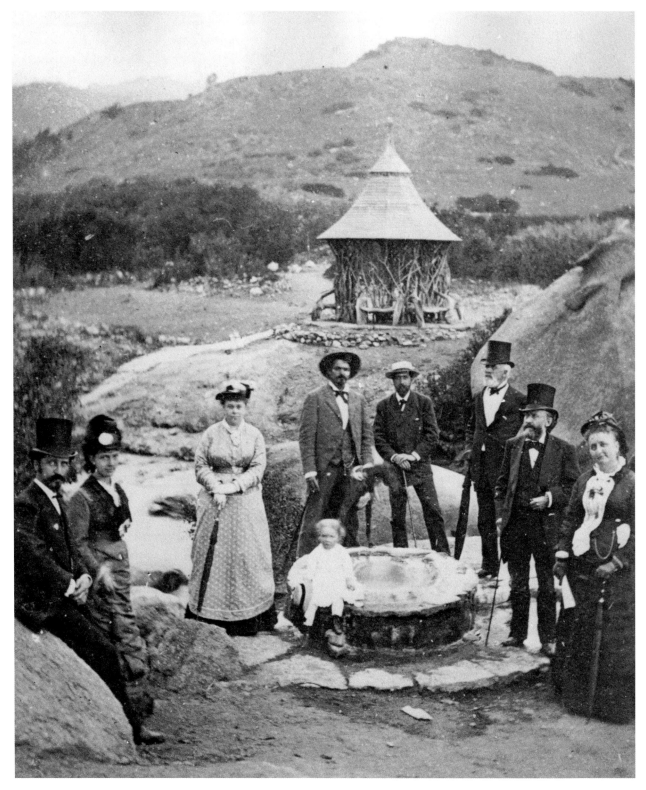

Eight well-dressed men and women and a child pose around the mineral-encrusted basin at Navajo Springs in Manitou. This early photograph from around 1872 shows Navajo Springs without a pavilion, which was added later.

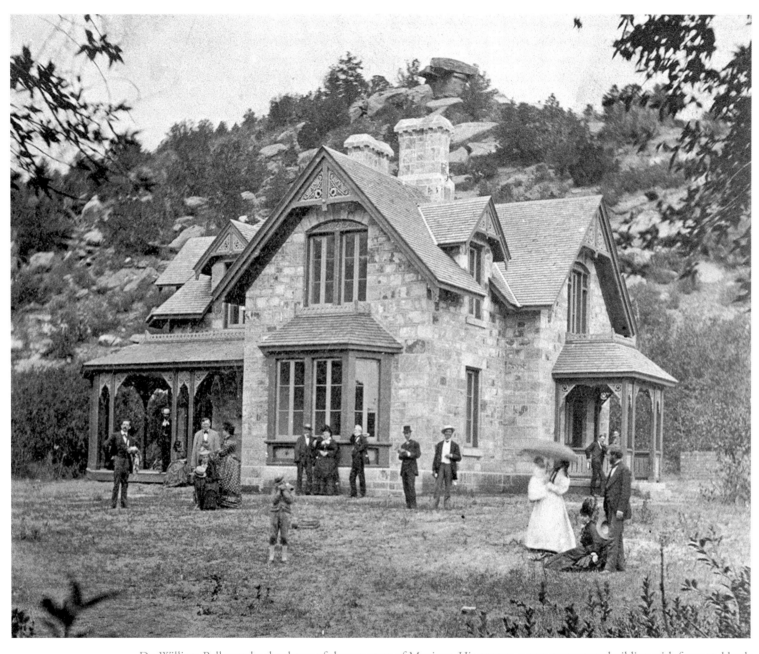

Dr. William Bell was the developer of the spa town of Manitou. His cottage, a two-story stone building with front and back porches and bay windows, is shown here with rocky cliffs behind. Well-dressed men, women, and children stand in front of the building sometime in the 1870s. Built in 1873, the cottage burned in 1886, but was rebuilt. Today the manor is the beautifully restored Briarhurst Restaurant.

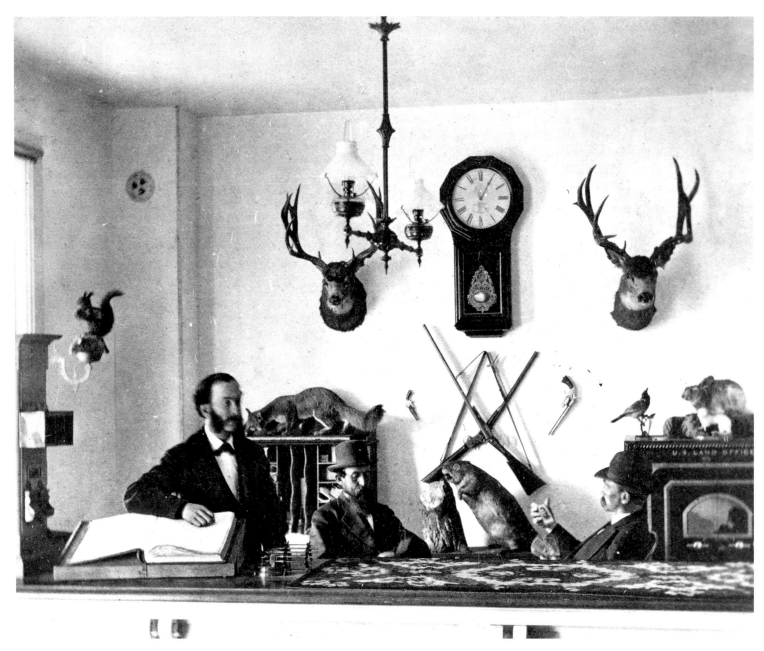

A clerk sits at the front desk of the Manitou House Hotel in Manitou in August 1874. His arm rests on the guestbook on the counter. Stuffed animals, armaments, and a clock combine to form unique interior decor. "Colliers Rocky Mountain Scenery" stated that the hotel was "pleasantly located near the springs and is a central point for tourist . . . appointments," with excellent accommodations and management.

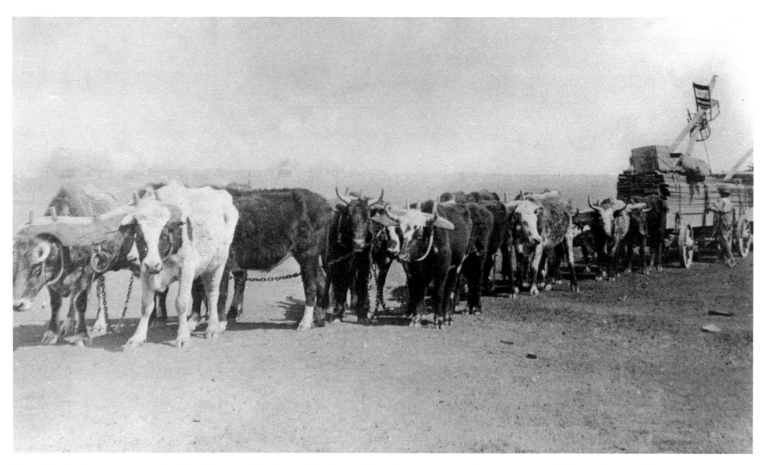

Sometime in the 1870s, several yoke of oxen pull a Crissey Fowler Lumber Company wagon from Weems Mill, located in the Black Forest east of Colorado Springs. The Black Forest provided many boardfeet of lumber for the building of the city. Crissey-Fowler continued in business until approximately 1999 in a downtown location near the Denver and Rio Grande railroad tracks.

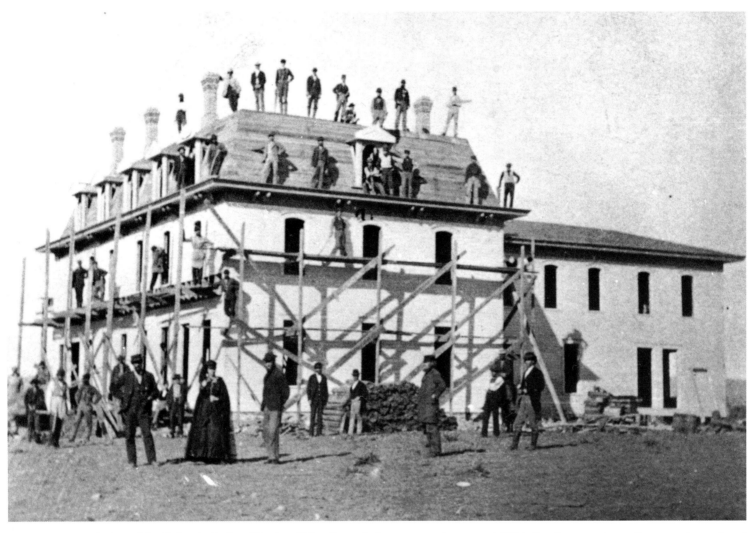

A view of the Colorado Springs Hotel on Tejon Street during construction around 1872. People are posing at front, on the roof, and along the scaffolding. Rose and Maurice Kingsley are standing at left-front. Their father was Charles Kingsley, writer and canon of Westminster Abbey. Maurice was the assistant treasurer of Palmer's Fountain Colony.

Widowed author Helen Hunt moved to Colorado Springs for her health in 1873. There she met and married William Sharpless Jackson, friend and business associate of General Palmer. She later championed the cause of displaced Indians and wrote the novels *Ramona* and *A Century of Dishonor.* Helen died of cancer in San Francisco and was buried on her beloved Cheyenne Mountain in Colorado Springs. The grave was eventually moved to Evergreen Cemetery.

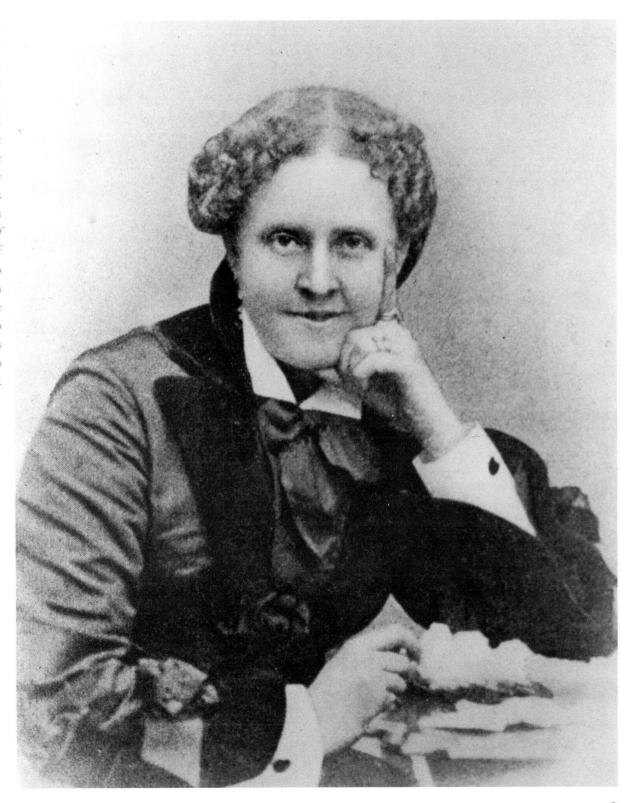

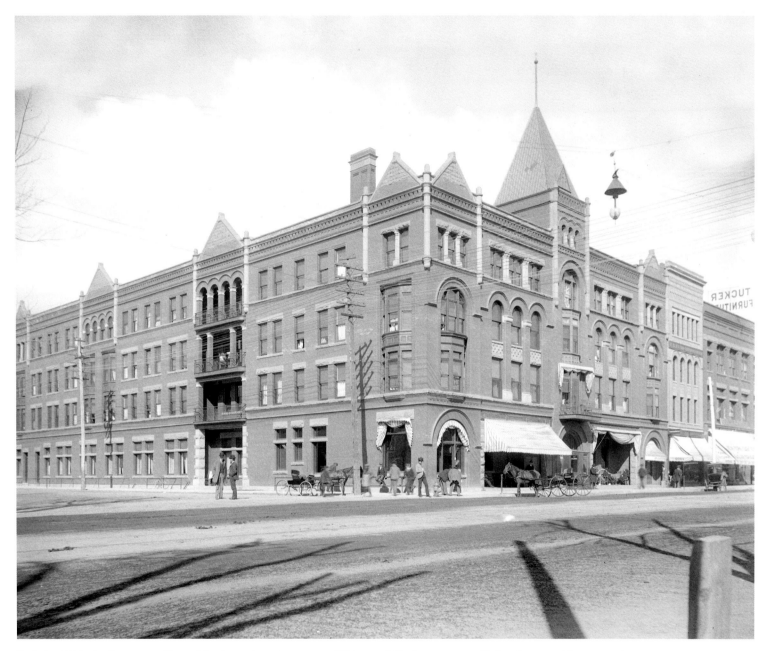

Built in 1889, the four-story Alamo Hotel stood on the corner of Tejon and Cucharras streets. Pedestrians outside seem to be enjoying a fine, wintry afternoon sometime late in the nineteenth century. The handsome brick and stone edifice was a luxury hotel with a spacious lobby, marble columns, and sweeping staircase. It stood the test of time, but did not withstand urban renewal in the 1970s, which destroyed many of the city's most beautiful and historic buildings.

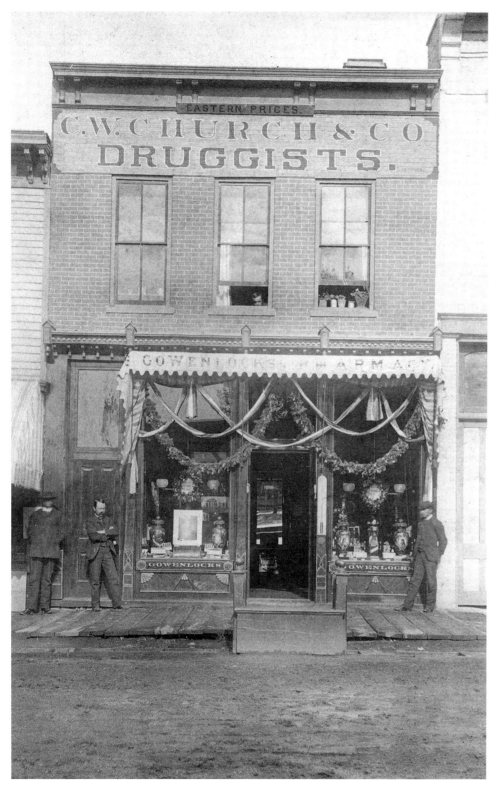

Gowenlock's grocery sent this Christmas and New Year's card to their customers in the holiday season of 1884-85, showing the store festooned with garland. The store was located at 26 South Tejon in the center of Colorado Springs. The second-story sign says, "C. W. Church & Co. Druggists" and "Eastern Prices." The reverse of the card thanked customers for their business.

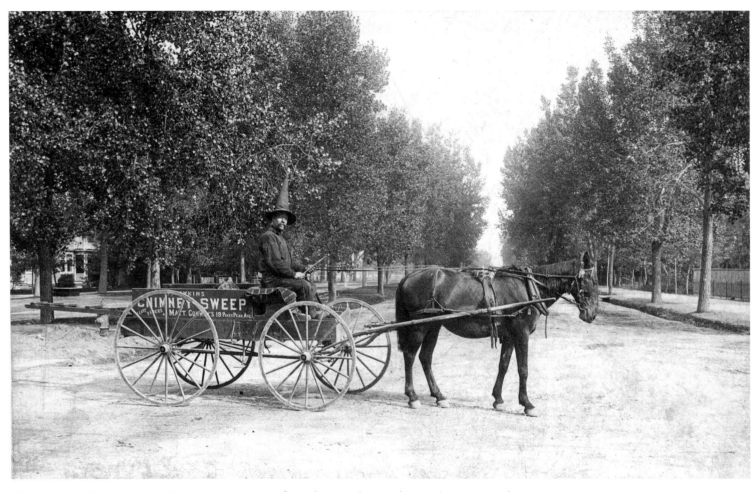

The Hawkins Chimney Sweep Company wagon stops for a photograph on wide Nevada Avenue in the 1890s. Isaac Hawkins, a well-known figure in the area for many years, sports an unusual pointed hat. Hand-lettered advertising on the wagon says, "Hawkins Chimney Sweep, Leave Orders at Matt Conway's 19 Pikes Peak Ave."

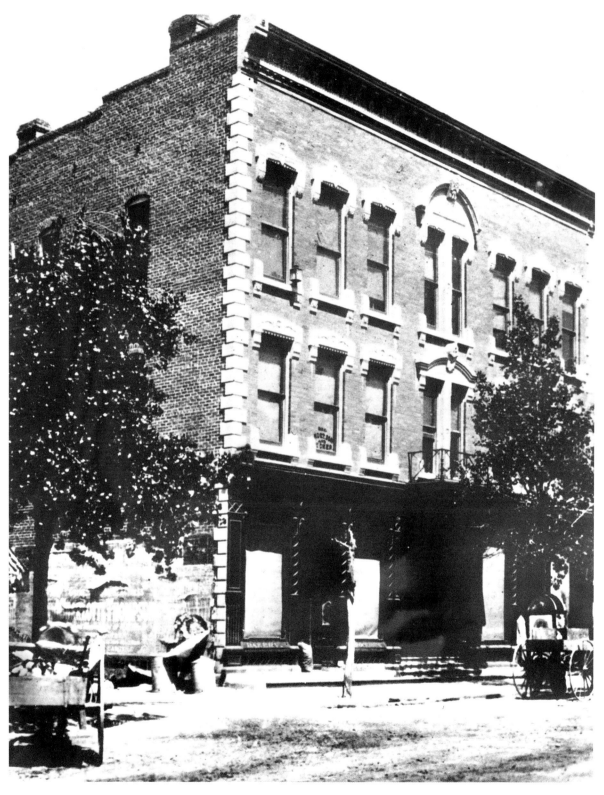

The Colorado Springs Opera House opened in 1881 as the first proper-sized facility for traveling performances in the Pikes Peak area. Irving Howbert and Ben Crowell built it on the west side of Tejon Street, north of the First National Bank building. Colorado Springs native Lon Chaney was one of the stagehands on opening night, as Maude Granger starred in *Camille*. The facility operated for 25 years until the Burns Opera House replaced it, whereupon it later became an office building.

The Columbian Club, a frame spindle-style Victorian building, was a girl's dormitory near the Colorado College campus on the northeast corner of North Cascade Avenue and Columbia Street. On January 1, 1884, it burned to the ground. Soon thereafter College Hose Company #4 formed to help protect the college campus and the north end of town. It was provided with a house for equipment and a hose cart.

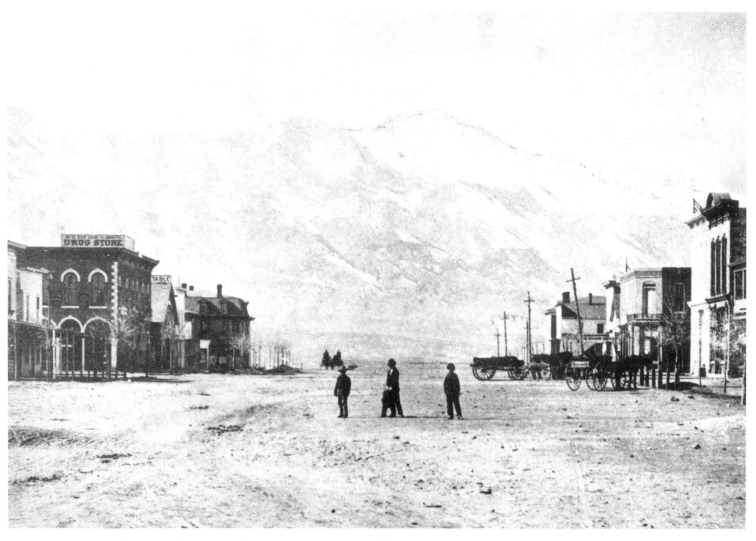

This early photograph, taken prior to construction of the first Antlers Hotel in 1883, shows Pikes Peak Avenue facing west with businesses along the Wanless Block, including First National Bank on the near right. A large, two-story drugstore is visible at far-left as the Rockies rise upward beyond the dirt avenue.

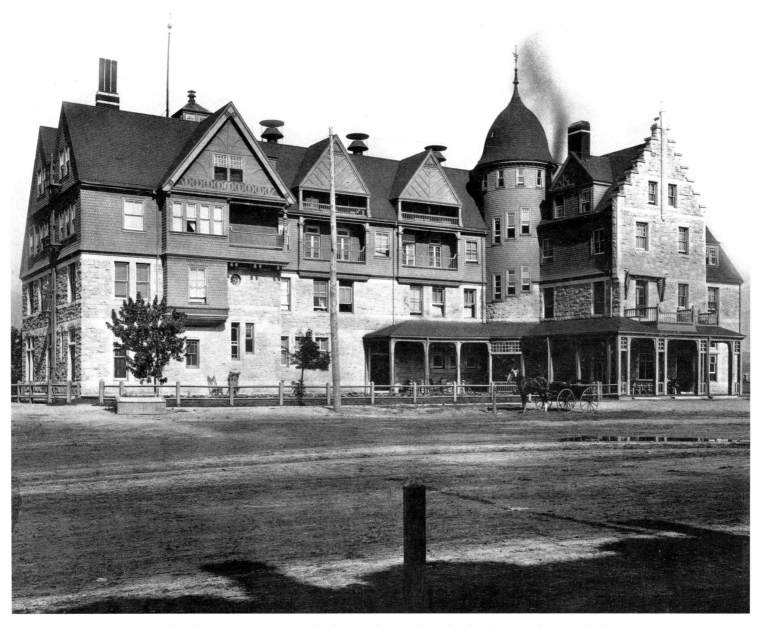

When the town outgrew the Colorado Springs Hotel, General Palmer built a grand new hotel right across the street for $125,000. Since the hotel housed Palmer's large stuffed-animal collection, it was named the Antlers Hotel. Amenities included an elevator, central heat, gaslights, bridal suite with private bath, barbershop, Turkish bath, and two bathrooms on each floor. This image shows the hotel as it appeared around 1883. The first Antlers burned in 1898.

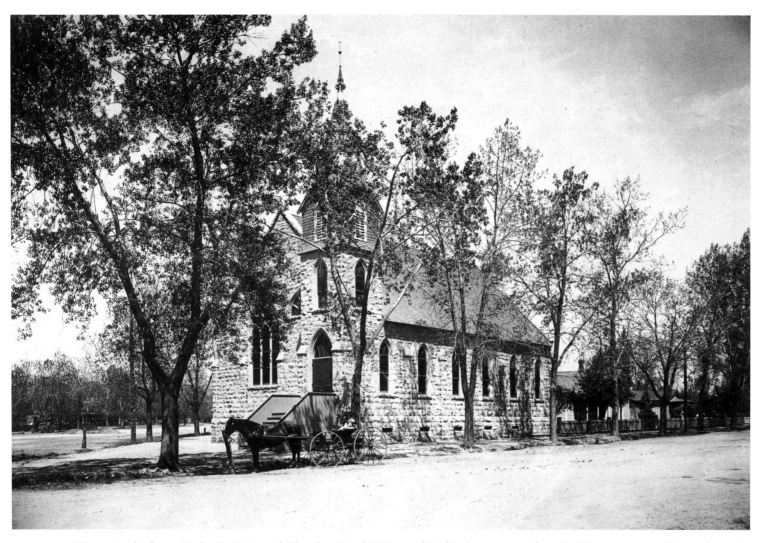

The original African Methodist Episcopal Church at South Weber and Pueblo Avenue was a frame building constructed in 1884 on a lot donated by the Colorado Springs Company (General Palmer's company). The congregation replaced the frame structure with this Gothic Revival stone chapel. Members used their own wagons and horses to bring sandstone from Bear Creek Canyon on the south side of town for construction. When completed, it was renamed Payne Chapel for Daniel Payne, an early bishop. Having outgrown the space, the congregation sold Payne in the 1980s. The A.M.E. Church was an offshoot of American Methodism formed to protest slavery.

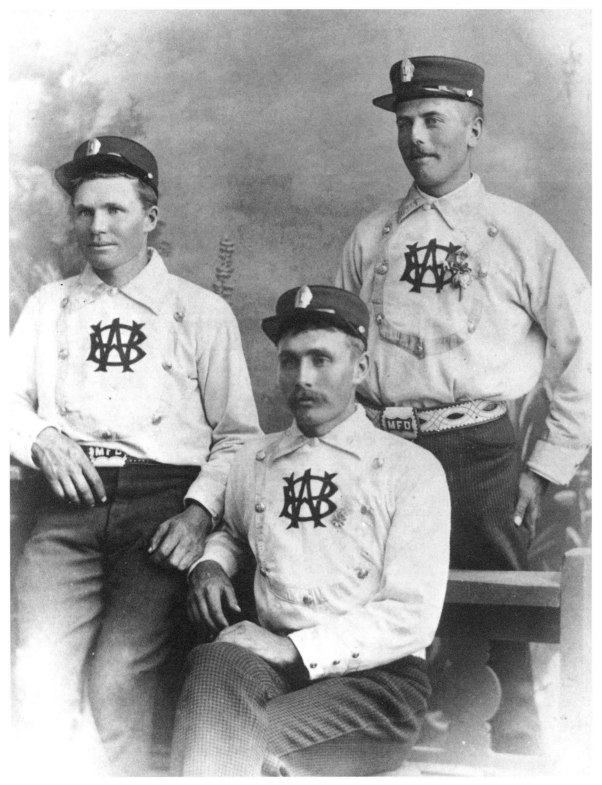

Members of the Manitou Springs Fire Department pose in their dress uniforms sometime in the 1880s. The hats and belt buckles are initialed MFD (for Manitou Fire Department). The shirts carry "WB," the initials of Dr. William Bell, founder of Manitou.

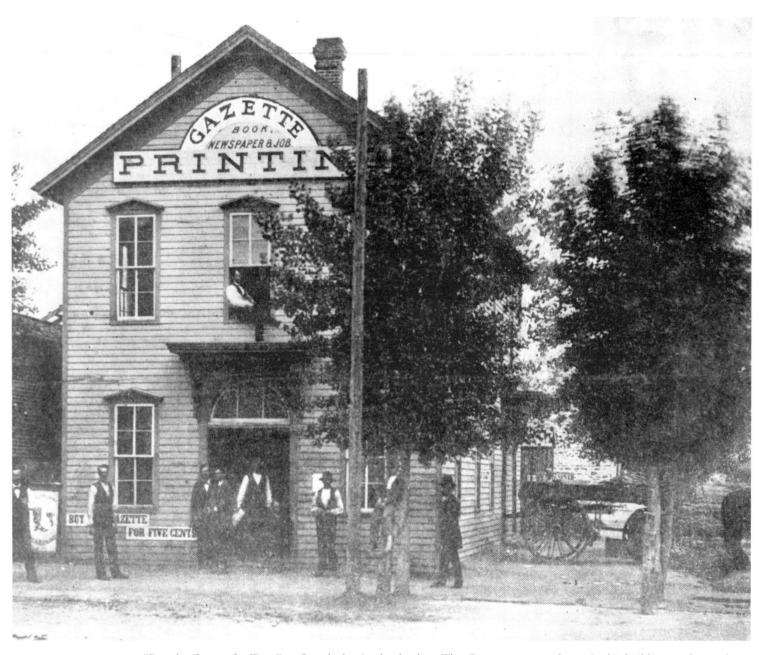

"Buy the Gazette for Five Cents" reads the sign by the door. The *Gazette* newspaper began in this building on the northeast corner of Huerfano (later Colorado Avenue) and Tejon in 1885. General Palmer put J. E. Liller, an Englishman, in charge of the business. At the time this photograph was made, a printing business was part of the Gazette organization. "Gazette Book Newspaper and Job Printing" is written above the window.

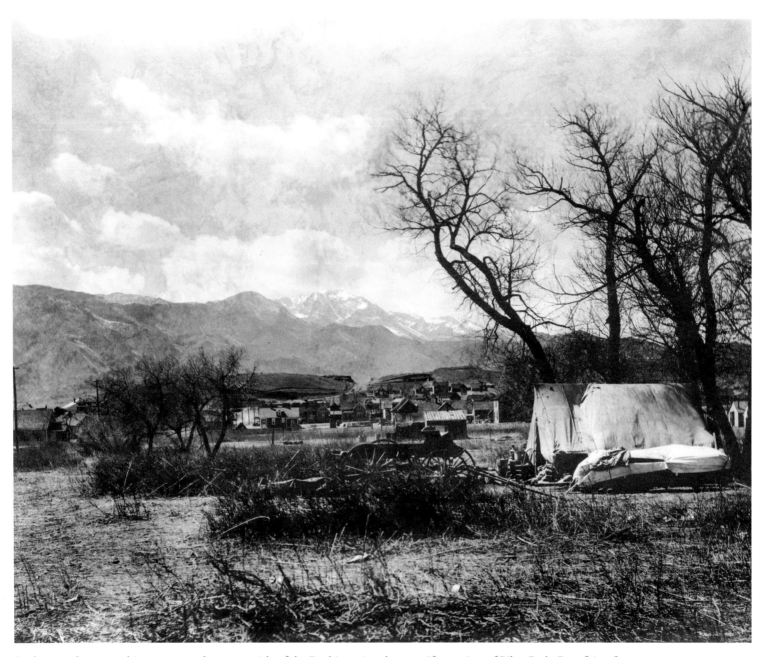

Settlers—in houses and in tents—on the eastern side of the Rockies enjoyed a magnificent view of Pikes Peak. Benefiting from good advertising, Colorado Springs grew so quickly that newcomers could find themselves relying on tents for shelter.

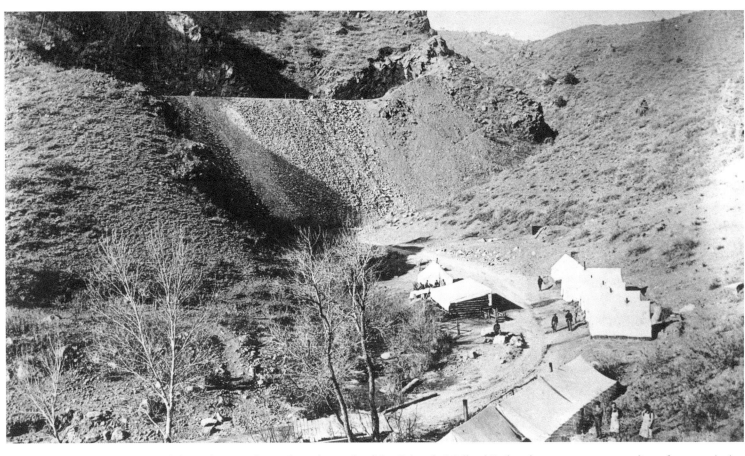

While working on the tracks and tunnels of the Colorado Midland Railroad, contractors set up a line of tents and a log cabin with a canvas roof about 1886. In view is the site of the #7 and #8 tunnels going west.

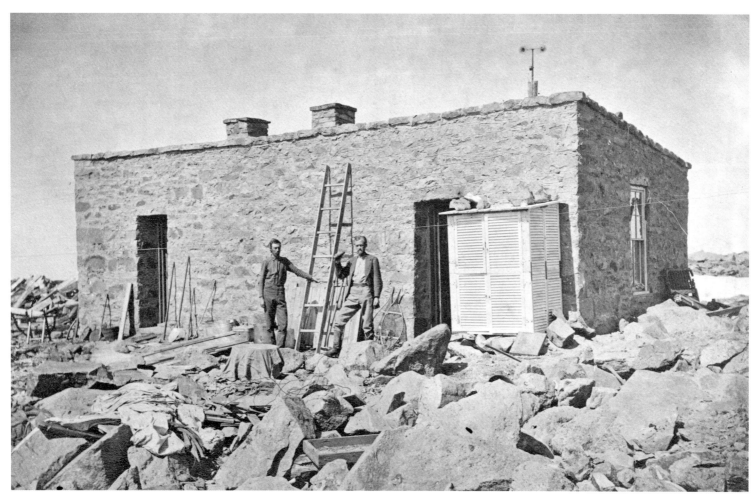

This photograph shows Albert James Myer, holding binoculars, and another man standing outside a stone weather observation station on Pikes Peak. An early telegraph line wound through trees, boulders, and bushes to send weather reports back to the public. At 14,110 feet, the two-room weather station atop Pikes Peak was the highest in the world around 1873. Young men trained by the Signal Corps took turns living year-round on the isolated mountain, where they endured many hardships including loneliness, primitive living conditions, and poor health.

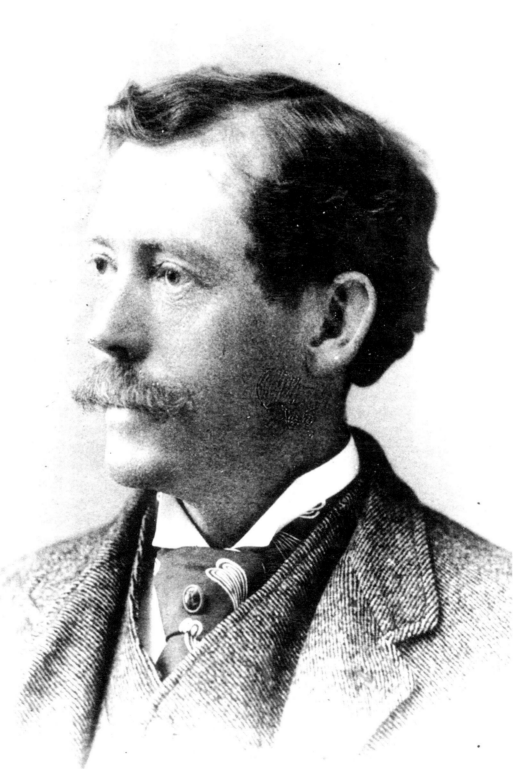

A portrait of Union general William Jackson Palmer (1836-1909), a Civil War veteran, engineer, philanthropist, and founder of Colorado Springs. His fascination with steam locomotives led to a career with the railroads, during which time he founded the Denver and Rio Grande, its original route heading to the Pikes Peak area. In 1871, he acquired 10,000 acres there and platted the new community of Colorado Springs, where he built a home, Glen Eyrie, for his family. Gambling and drinking were illegal in the new town. General Palmer was paralyzed after falling from a horse during a ride in the Garden of the Gods in 1906. He died at his home three years later.

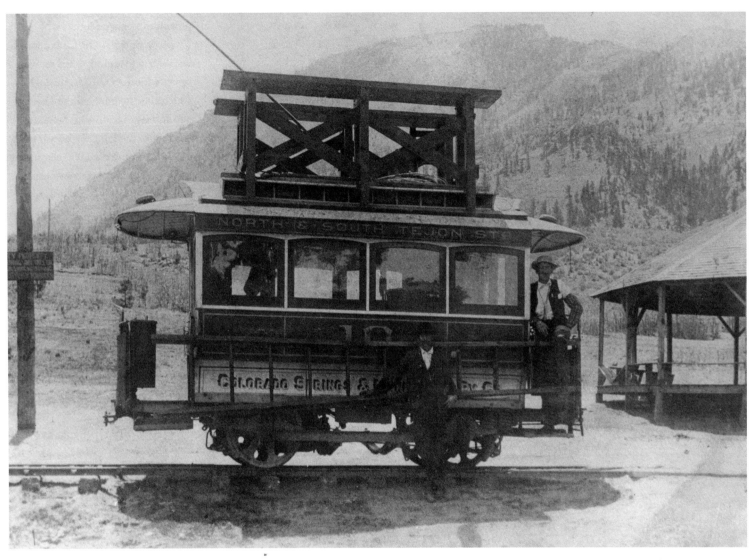

Preceded by a trolley that had been drawn by 10 horses, Colorado Springs & Manitou Railway Company streetcar No. 10 sits on the tracks with the mountains in the background. The streetcar ran up and down Tejon Street north and south from Costilla Street to the Colorado College campus. A second line was built to Colorado City in 1888. Winfield Scott Stratton later bought the line and renamed it Colorado Springs and Interurban Railway, investing approximately $2 million before his death to upgrade the tracks, expand the routes, and replace the cars in an effort to make it the best trolley system in the U.S. The trolley line hauled coal at night and ran a sprinkler car to keep the dust down.

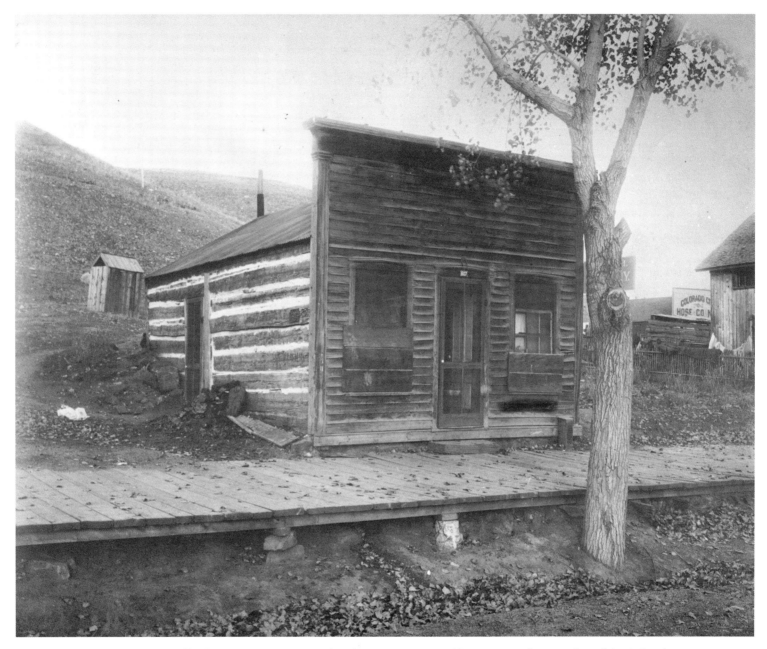

This 1858 cabin was used as an office by Dr. J. P. Garvin in Colorado City. It was owned by M. E. Beach, a member of the Colorado legislature. Later it was used as a Chinese laundry, the office of the first Clerk of the County, and an attraction on the Broadmoor Golf Course. The restored cabin is now located in Bancroft Park on West Colorado Avenue. Early Colorado City promoters referred to it as the Old Capitol Building, a misnomer.

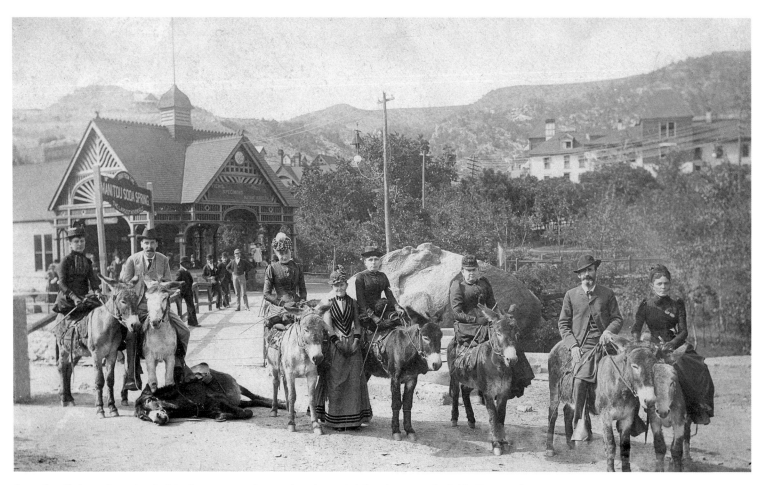

Several well-dressed tourists in Manitou pose on burros (one burro is lying down on the job). Signs at the Manitou Soda Springs pavilion read, "Manitou Soda Spring, the Largest in the World" and "Views Specimens Native Jewelry A. H. Davis."

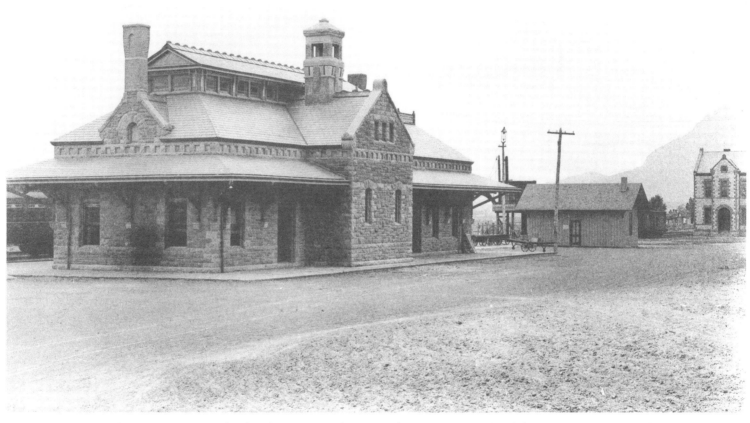

This is an 1889 view of Colorado Springs' Atchison, Topeka, & Santa Fe Railroad depot. A train is shown behind the large stone building with a wagon alongside. ATSF fought General Palmer and his Denver and Rio Grande Railroad for a route through the Royal Gorge. In 1878, the ATSF leased the Denver and Rio Grande tracks running through the Pikes Peak region.

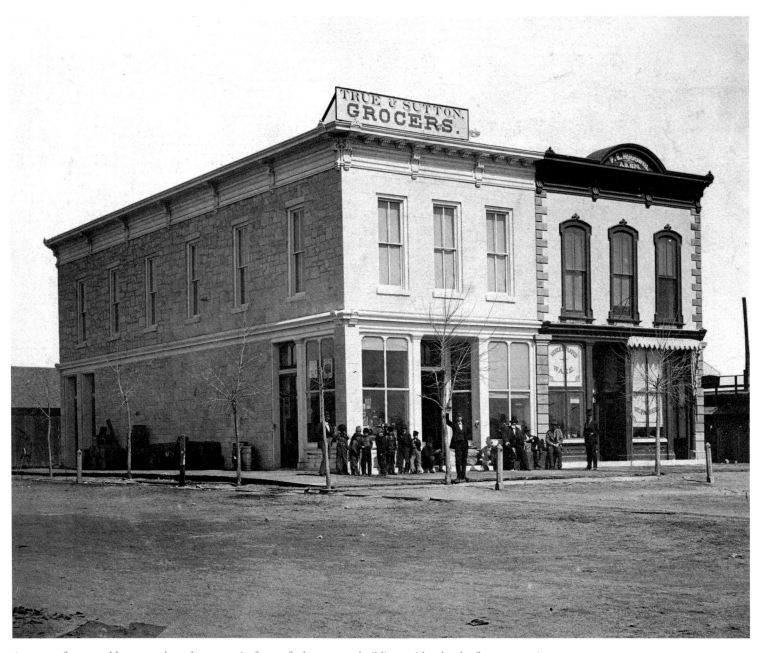

A group of men and boys stand on the corner in front of a large stone building, said to be the first grocery in Colorado Springs. Signage on the building at left says, "True & Sutton, Grocers," on the building at right, "F. E. Huggins, AD 1874."

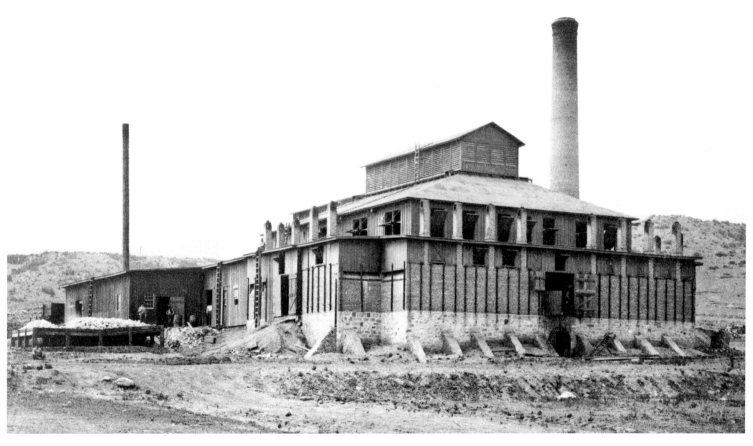

Several prominent settlers built the Colorado City Glass Works in 1889, on twenty acres near present-day Wheeler Street in Colorado City. The Manitou Mineral Water Bottling Company used the Glass Works bottles for their products.

Until 1894, the Colorado Springs fire department was made up of volunteer groups. The various hose companies were given $10 a month for supplies and could choose their own uniforms. Hose Company #3 built their own hose cart and the City Council provided the hoses. They are pictured here at 1820 South Nevada, the Central Fire Station, and City Hall, sometime in the 1880s or early 1890s. In 1894, volunteer groups like this one were replaced with paid fire fighters.

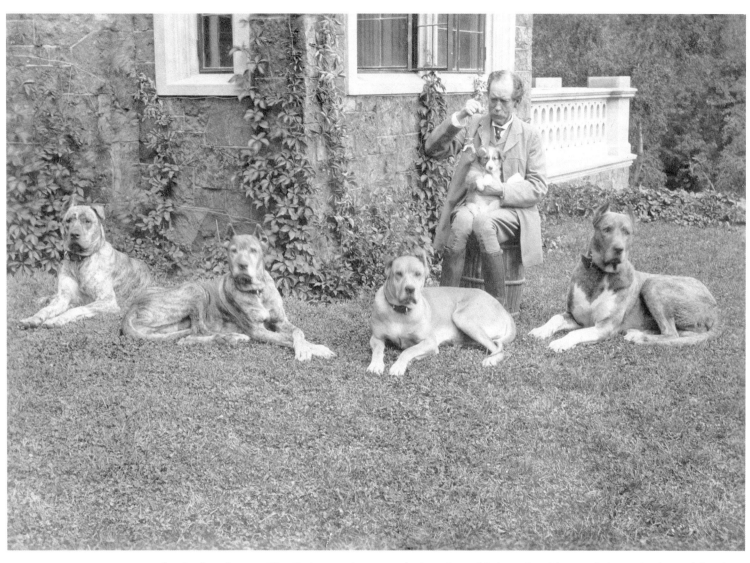

On the front lawn at Glen Eyrie sometime around 1890, General Palmer sits with a small dog on his lap and four large Great Danes on the ground. He is dangling a watch fob, perhaps to attract the interest of the little dog.

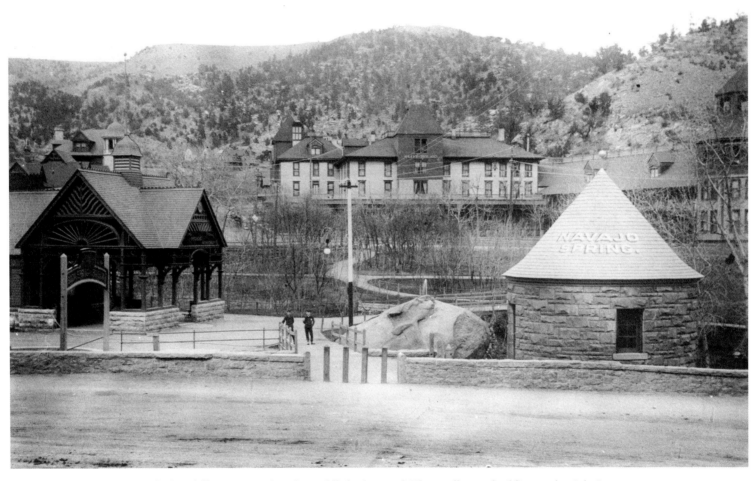

This is a view of Manitou with the Cliff House Hotel in the middle background. The small stone building to the right is labeled Navajo Spring, and the building to the left is the Manitou Soda Spring pavilion. Above the soda springs is Windemere, the home of Aspen mine owner and financier Jerome Wheeler. In recent years, the Cliff House has been renovated and restored to its 1890s elegance.

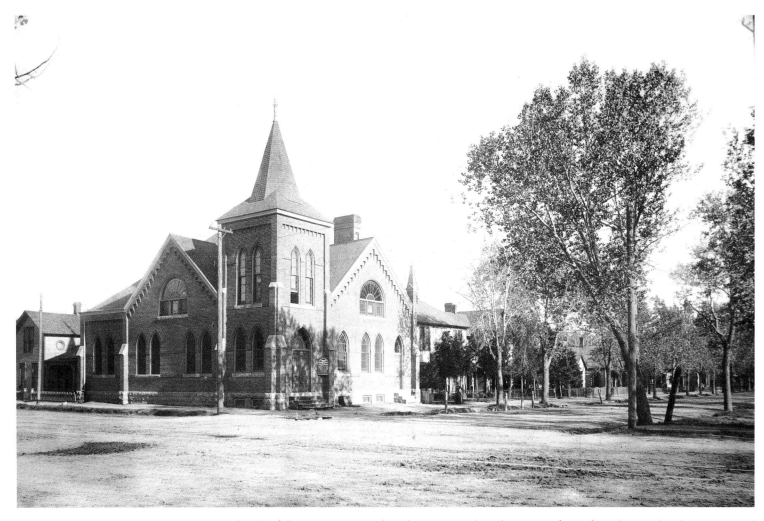

The Church of the Strangers United Presbyterian stood on the corner of Huerfano (later Colorado Avenue) and Nevada. It was a corbelled brick building with a corner entry and steeple. The church was organized in the summer of 1888 and occupied in February 1890. Today, this downtown corner is occupied by businesses.

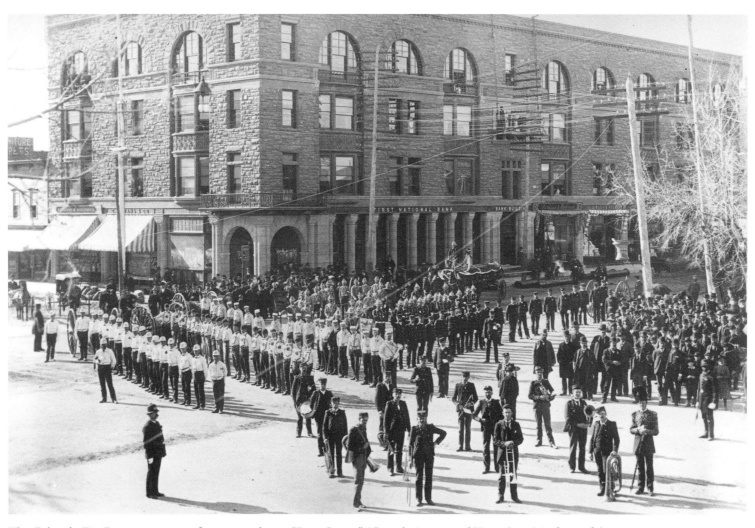

The Colorado Fire Department poses for a group shot at "Busy Corner" (Cascade Avenue and Tejon Street) in front of the First National Bank building sometime in the 1890s. Fire fighters were participating in a parade in full uniform with helmets, conductor's caps, and double-breasted jackets. Some of the members were part of the fire department band, which poses at front holding various instruments. The band member at lower right sports a busby.

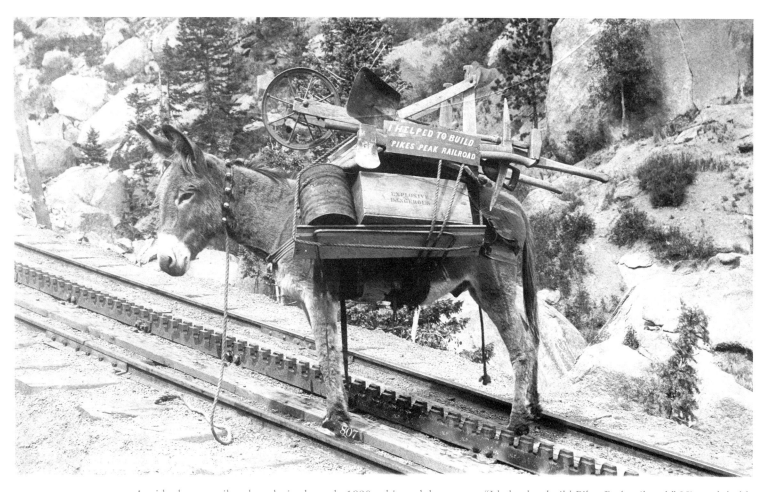

Astride the cog railroad tracks in the early 1890s, this pack burro says, "I helped to build Pikes Peak railroad." His pack holds a wheelbarrow, pick, ax, shovel, sledgehammer, and a box labeled "Explosive, Dangerous," among other tools of the builder's trade. The Pikes Peak Cog Railroad was begun by David Moffat and completed by Zalmon Simmons, founder of Simmons mattress company, in 1890.

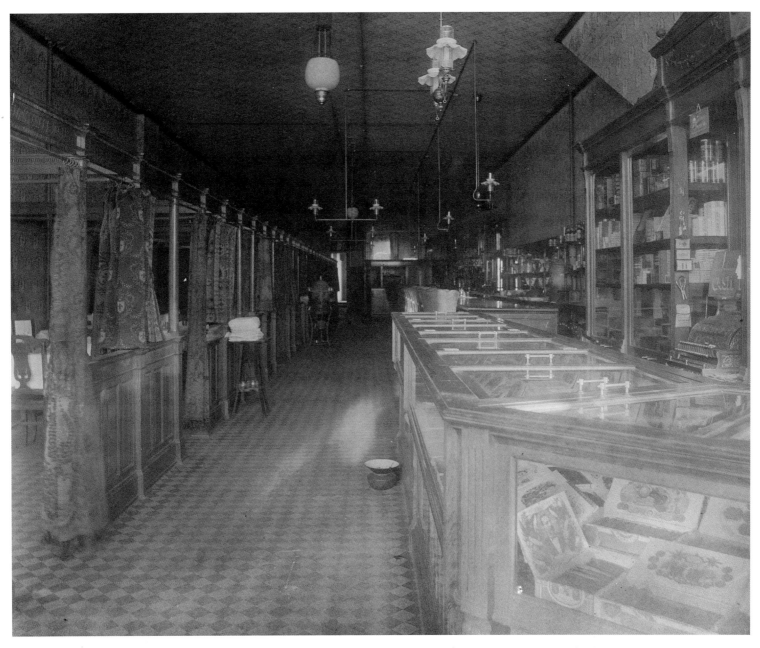

Tucker's Restaurant was located at 110 E. Pikes Peak Avenue. This interior view shows the long rectangular space divided by wood partitions with heavy curtains to separate the service counter from the dining area. At the counter, boxes of cigars are visible inside the glass. Gas fixtures hanging from the ceiling provide light. A table is visible with a stack of towels and a water cooler, high-backed stools for customers seated at the bar, and on the floor, a spittoon.

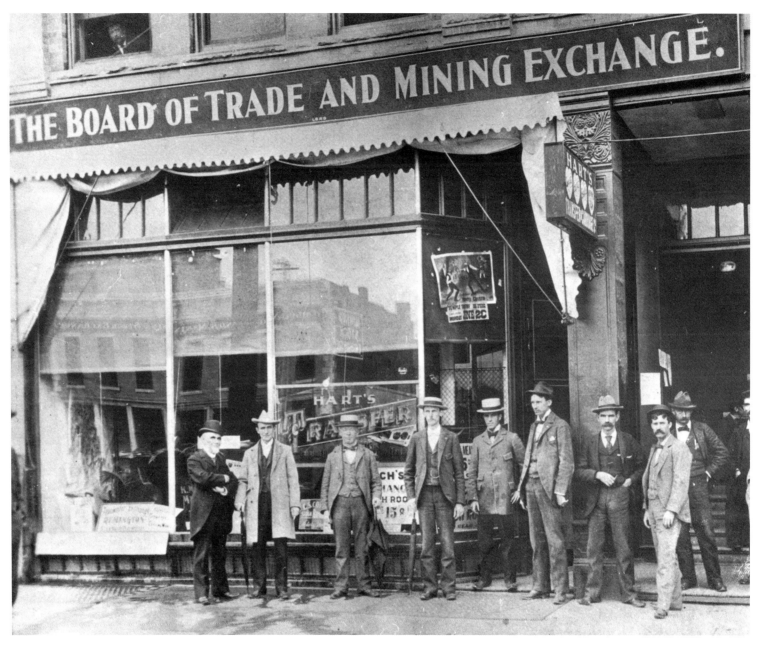

Stockbrokers including Charles Berry, R. S. Zimmerman, and Charles D. Hopkins stand on the sidewalk in front of the Colorado Springs Board of Trade and Mining Exchange on East Pikes Peak Avenue. Organized in May 1894, the board was the largest exchange in the world at that time. In 1899, more than 236,000,000 shares were sold with a value of $34,000,000, prosperity that reflected the Cripple Creek gold boom. The building was a gift to the city from carpenter-turned-millionaire Winfield Scott Stratton.

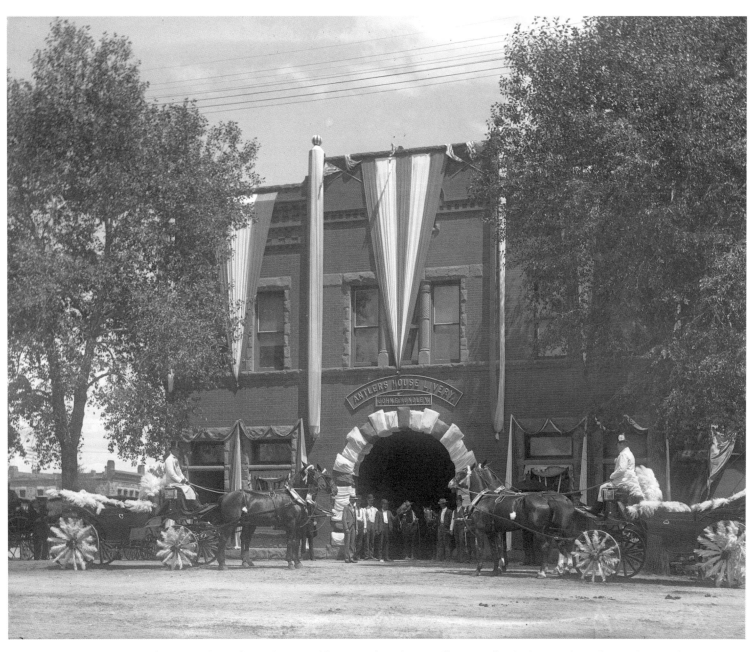

This image shows the Antlers Hotel livery run by John Hundley. Hundley built a rough road 17 miles up Pikes Peak. The road was the predecessor to the Pikes Peak Highway. Each morning at ten past eight, Hundley parked mule-drawn surreys at the Midland Train Station in Cascade offering a trip up Pikes Peak and return before dark. The cost was $2.50 per person.

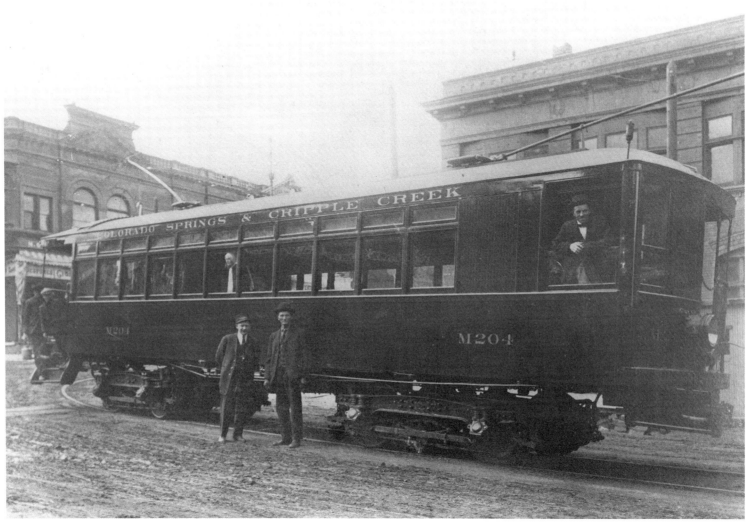

Irving Howbert built the Colorado Springs and Cripple Creek Railway (Short Line) system to compete against the high cost of hauling ore charged by the Colorado Midland Railroad. Originally intended for commercial use, it became popular with passengers who loved the views. Theodore Roosevelt rode the Short Line in 1905, declaring that the views "bankrupted the English language." In 1924, the track was torn up and the road revamped for automobile travel. Today only a portion of the Gold Camp Road can be driven.

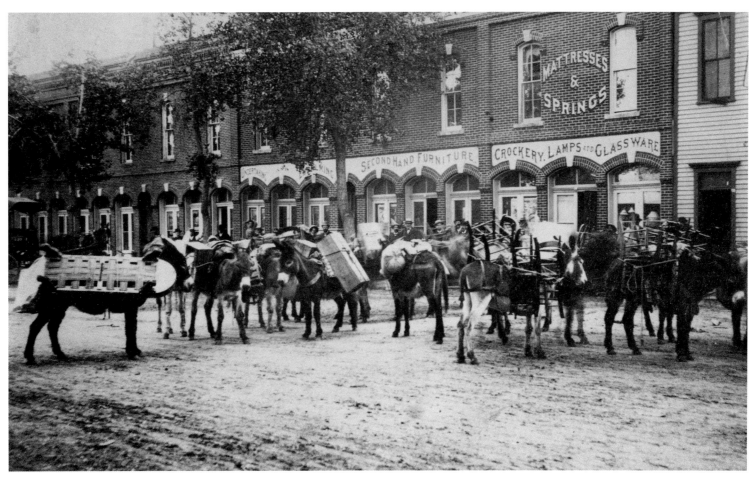

Burros loaded with chairs and assorted furniture bound for the Halfway House Hotel up Pikes Peak stand in the street in front of Fairley Brothers Furniture and Undertaking. Building signage says, "Undertaking, Embalming, Secondhand Furniture, Crockery, Lamps, and Glassware" and "Mattresses and Springs." The climb was arduous. Beginning at the city's elevation of 6,035 feet, the trek would stop short of the mountain's summit, at 14,110 feet.

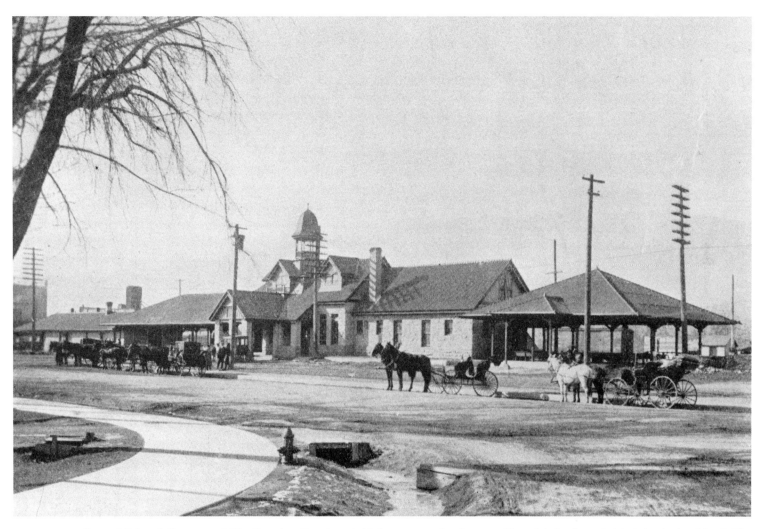

General Palmer's Denver and Rio Grande railroad used this large, attractive depot on Sierra Madre Street behind the Antlers Hotel. The sidewalk in the foreground led to the Antlers. The Denver and Rio Grande was the first train to arrive in the Pikes Peak region. Today and for many years, the depot has served as the very popular Giuseppe Restaurant, with a view of the train yard out the rear window and railroad decor throughout.

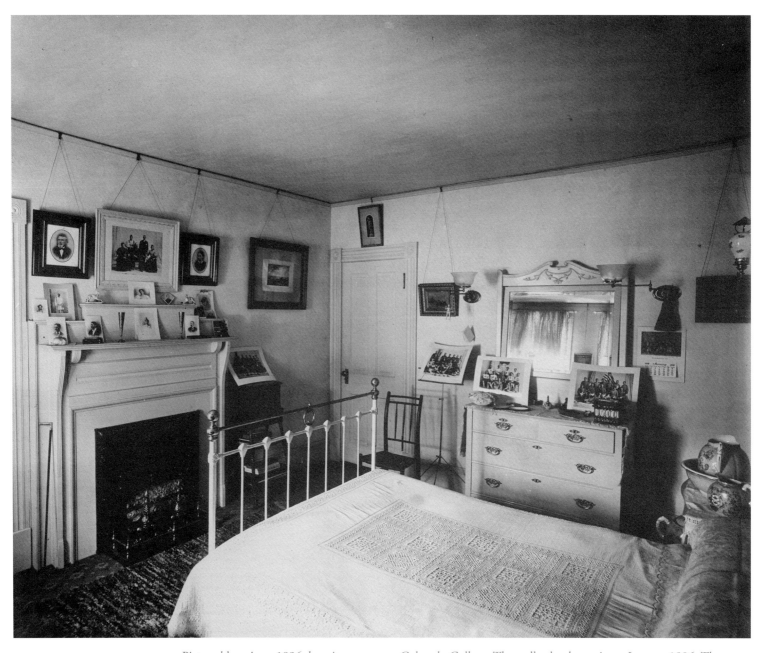

Pictured here is an 1896 dormitory room at Colorado College. The wall calendar registers January 1896. The room included an iron bed, rug, dresser, fireplace, washbasin beside the bed, and various photographs on the walls.

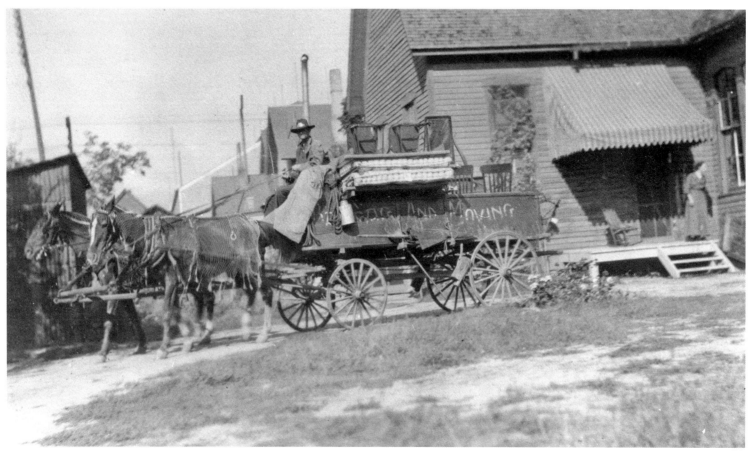

It's moving day at 32 N. Weber as a horse-drawn wagon loaded with furniture sets forth from the alleyway. A woman identified as Anna Easterday stands on the back porch, which is covered with a striped awning to keep the sun off in the days before air conditioning.

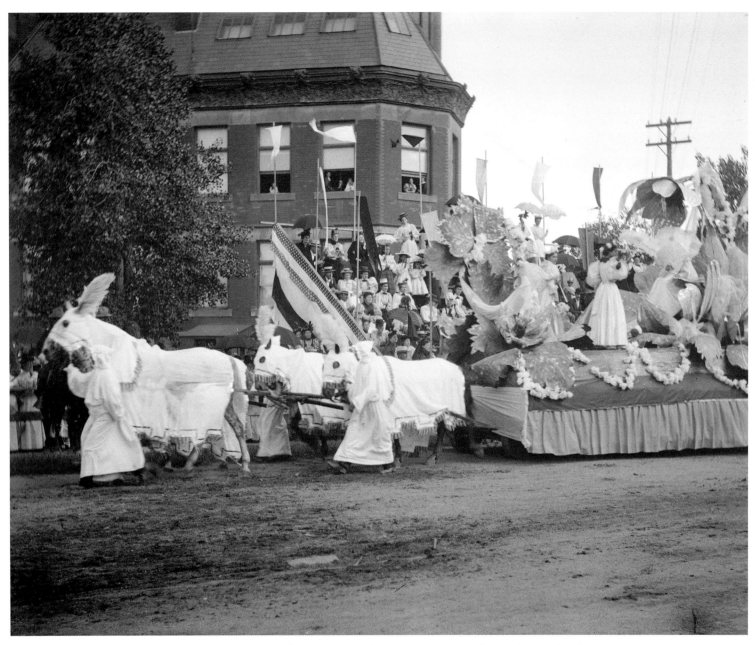

Flower Parade spectators sit on bleachers in front of the first Antlers Hotel in August 1897 as a float with a medieval theme rolls by. The horses are draped in cloth to simulate armor, as are the men. These parades, held to attract tourists, traversed Cascade Avenue in the years surrounding the turn of the century, becoming more elaborate as time went by. They were eventually replaced by the Pikes Peak or Bust Rodeo.

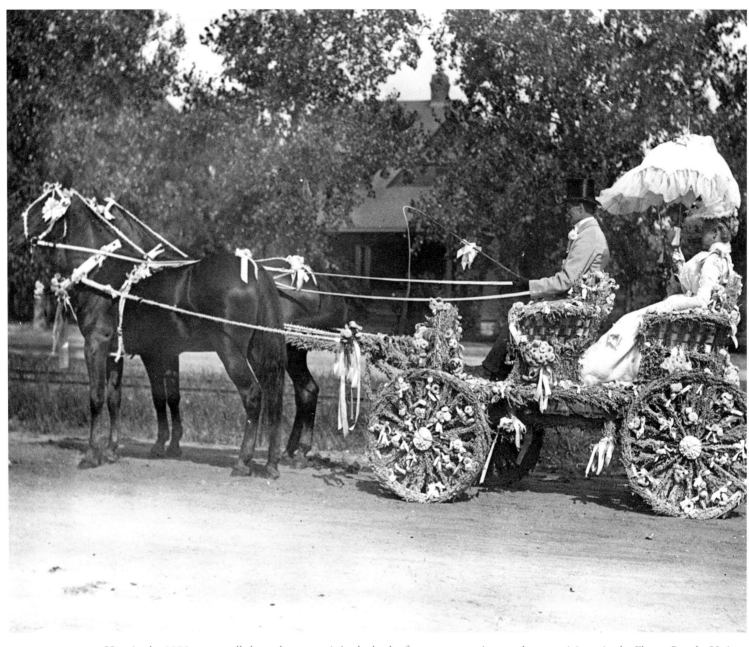

Here in the 1890s, two well-dressed women sit in the back of a two-seat carriage ready to participate in the Flower Parade. Various vehicles adorned with live flowers and greenery joined bands and military units in these events.

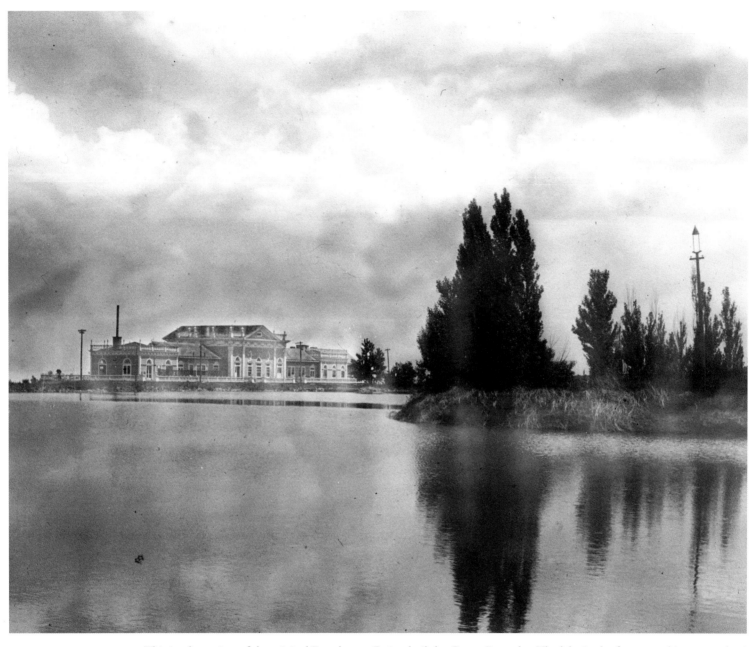

This is a long view of the original Broadmoor Casino built by Count Pourtales. The lake in the foreground is manmade. A note on the original photograph says, "Opened in 1891—burned 1897." The Count began his business with a dairy farm and went on to build the casino and work toward building a small community. Spencer Penrose continued the work years later, constructing the Broadmoor Hotel, a five-star establishment surrounded by upscale homes.

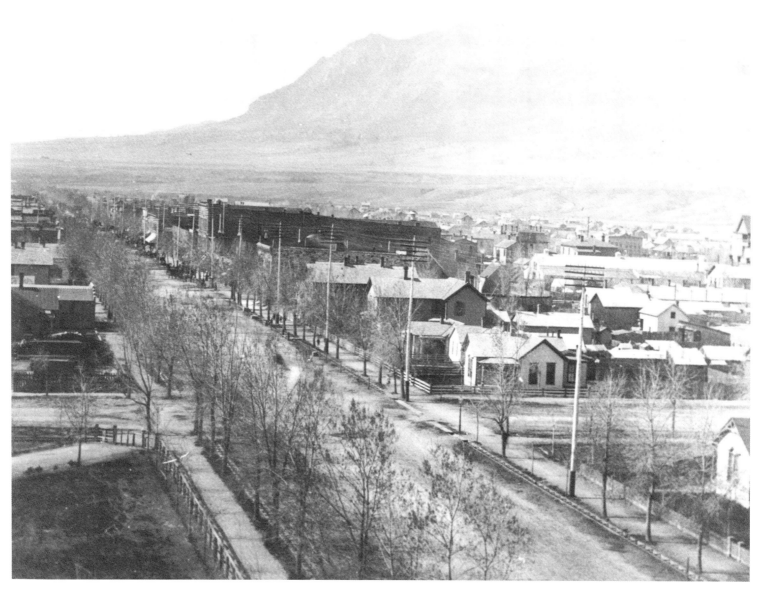

This is a view of a residential street facing south toward Cheyenne Mountain. The El Paso Canal drainage ditches are visible along each side of the street. The canal brought Fountain Creek water to downtown and north-end residential areas for trees and lawns. General Palmer paid fifty cents each to have small, broad-leafed trees planted throughout the city in the 1870s. Shown here half-mature, they have been growing for some years.

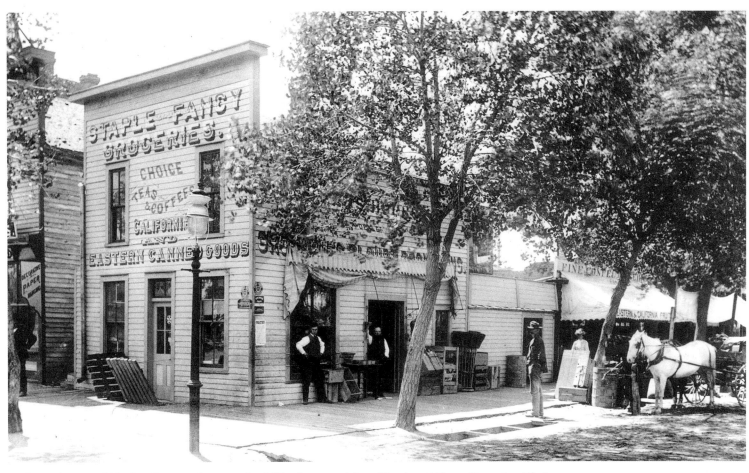

In this early view of Hughes Grocery, the upper-level false front proclaims, "Staple and Fancy Groceries. Choice Teas & Coffees. California and Eastern Canned Goods," an ostentatious appeal to settlers wanting more than rough frontier foodstuffs. Next door to the left, "decorative paper hanging" services are for hire.

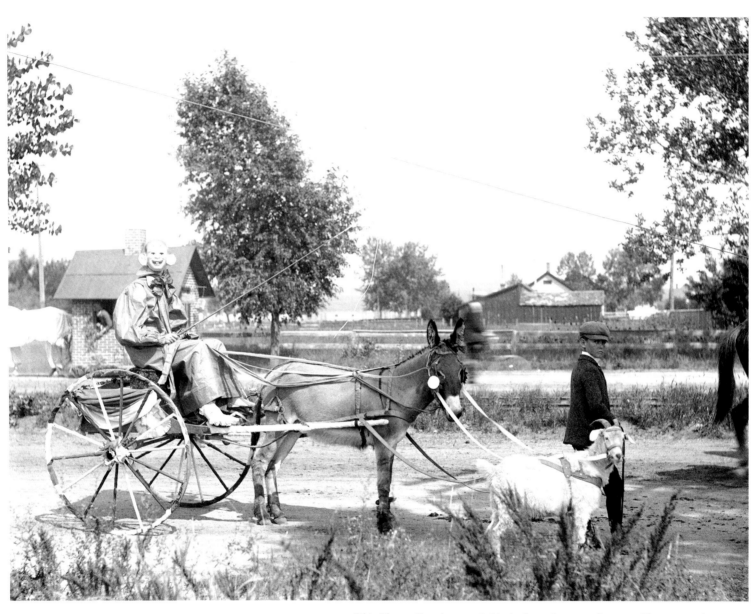

This Flower Parade entry is hitched to a burro and a goat. Flower parades were a big tourist draw during this era.

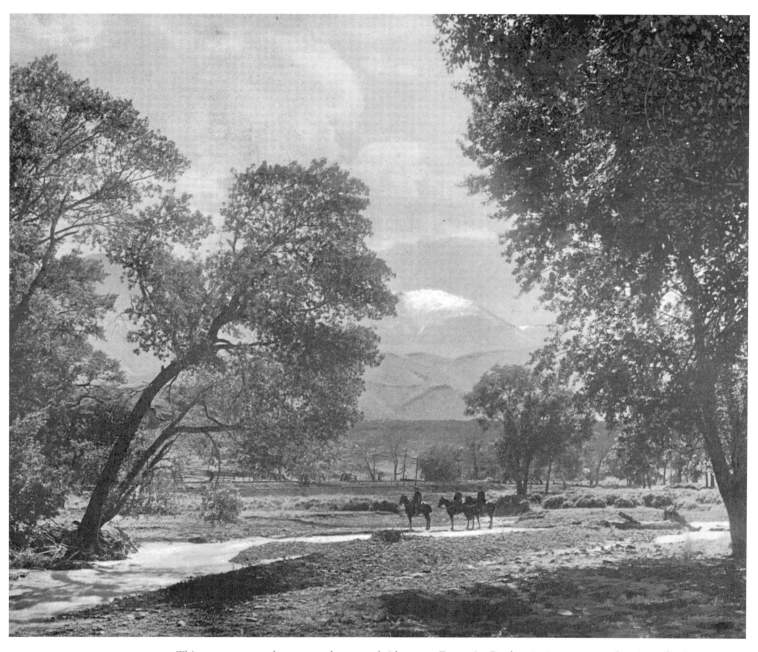

This remote scene shows several mounted riders near Fountain Creek enjoying a spectacular view of a distant snow-covered Pikes Peak. Spelled "Pike's Peak" until 1891, in homage to Zebulon Pike, the first mountaineer to attempt an ascent, the mountain lies 10 miles to the west of Colorado Springs. From great distances it is the most easily discernible of Colorado's tallest mountains, yet falls 300 feet short of being the very tallest peak. After a ride to the summit in the 1890s, Katharine Lee Bates wrote the words to the song "America the Beautiful."

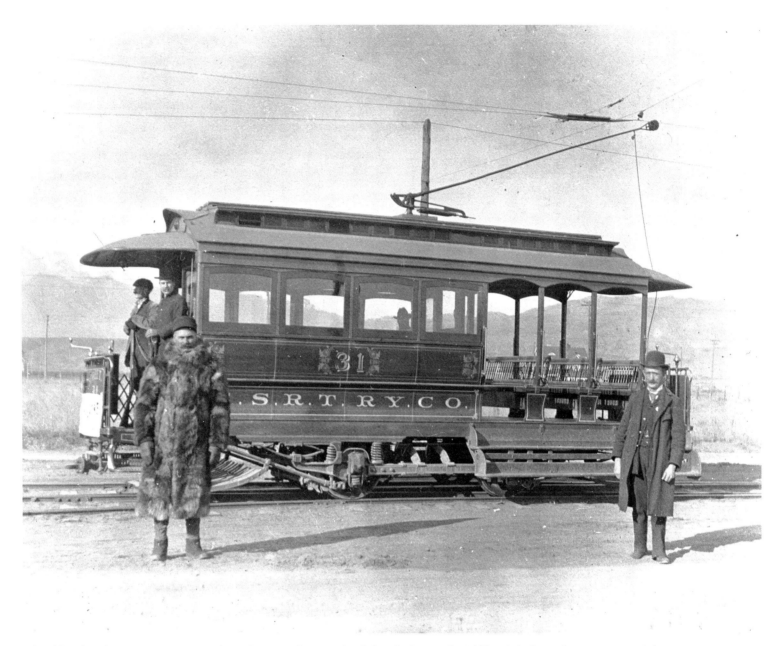

The old Colorado Springs Manitou Railway Company became the Colorado Springs Rapid Transit Railway Company around the end of the century, when W. S. Stratton put $2,000,000 into the company for electricity, better tracks, better cars, expanded routes, employee benefits, and new blue uniforms. The railway ran under various names until 1932 when Colorado Springs bus service began. The new service and an increase in automobile travel put an end to the streetcar system.

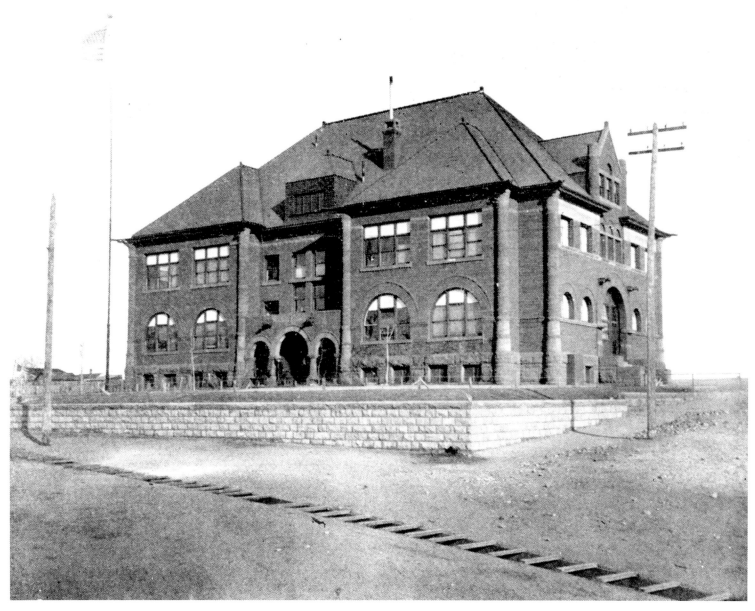

Built in 1891 and shown here some years later, Lowell School was the largest elementary school in Colorado Springs. The red-brick, Romanesque-style building is located at 831 South Nevada. It closed in 1982 after falling enrollment, standing vacant for many years. Now on the Registry of Historic Places, it is occupied by Colorado Springs Housing Authority offices. Today the entire Lowell neighborhood is undergoing renovation and revitalization.

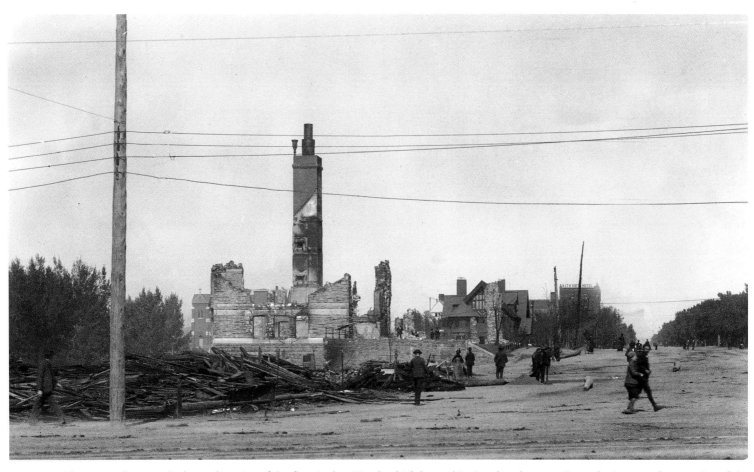

This 1898 photograph shows the ruins of the first Antlers Hotel, which burned in October that year. Passersby inspect what remains of the once grand accommodations. The original hotel cost $125,000 to build, a hefty price tag in the 1890s, but General Palmer was not fazed by the calamity. An improved Antlers Hotel was soon under construction at the same location on Cascade Avenue.

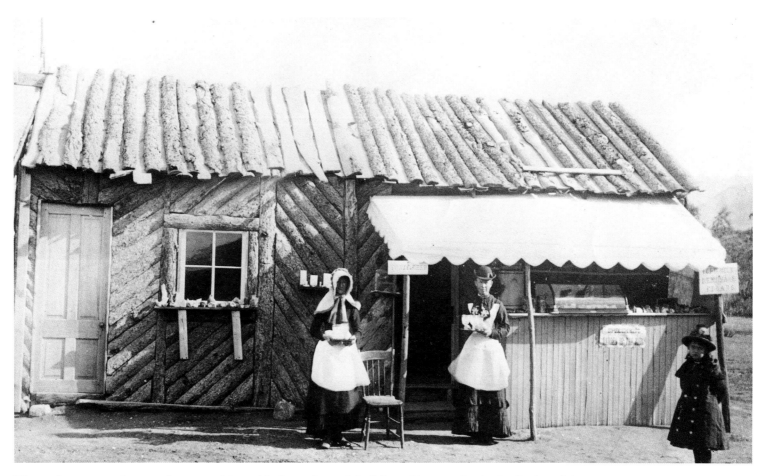

Women in aprons and caps and a young girl stand in front of a rustic building with an awning in the Garden of the Gods in 1897. For sale are tonic beer, iced milk, lemonade, cigars, and specimens from the Garden of the Gods. Notes on the original photograph say, "Left side of Garden Road coming from Mesa to Gateway Rock," indicating that the locale was close to today's entrance to the park from 30th Street.

BOOM TIMES

(1900–1919)

With the gold discoveries at Cripple Creek, Colorado City became the town that it had wanted to be—a supply center for the miners' needs, both business and social. Seventeen saloons and numerous brothels lined Colorado Avenue. Mills such as the Golden Cycle with its cyanide extraction process were built. Overnight, men like Winfield Scott Stratton, who went from three dollars a day as a carpenter to a millionaire with his Independence Mine, grew wealthy. Others, like Bob Womack, who had discovered gold in the Cripple Creek area in 1878, died broke. The region produced 30 millionaires in all, and by 1916, $340 million in gold.

Lucky prospectors made their money at places like Cripple Creek, but they built their homes in Colorado Springs. The town was the beneficiary of this new wealth—enjoying new opera houses, a stock market, lovely buildings, schools, streetcars, and churches. On Wood Avenue and Cascade Avenue, mansions sprang up along the wide dirt streets. By 1901, the city's population had swelled to 30,000.

Prospectors were not the only group adding to that number. Health seekers were also coming to town. Besides tourists seeking the mineral waters as a cure for gall stones, constipation, and other ailments, there were "lungers." Having no cure for tuberculosis, doctors suggested their patients find fresh dry air, rest, and good food. Many visitors with TB—commonly known as consumption—arrived to breathe the fine air. Those who survived often stayed on to enrich the city. While men like Dr. Gerald Webb searched for a cure for the disease, 17 sanatoria were built.

Tourism also soared. People wanted to be entertained. Men such as Spencer Penrose were happy to oblige with diversions like the Cog Railroad, the Pikes Peak Hill Climb, the Flower Parade, and the Broadmoor Hotel. Tourists, settlers, rich miners, and lungers—the Colorado Springs region beckoned to all and all came.

One of the few sobering effects on the city's high spirits was the advent of World War I, which put a strain on local resources and industry as the war effort was engaged. The founders of Colorado Springs were also passing. In two decades, General Palmer (1909), Henry McAllister (1921), Stratton (1902), Charles Tutt (1901), Jackson (1910), and William Bell (1921) would all breathe their last.

This is the second Colorado City city hall, built in 1892. Located at 115 South 26th Street, it held offices, a jail, and a fire station, and over the years served as home to a commercial stable, a gym, and various businesses, including the Colorado Springs Mattress Company. In 1917, Colorado City was annexed by the city of Colorado Springs. John Bock, a city pioneer, purchased the building and turned it into a museum of western artifacts. When the museum fell on hard times, the contents were sold at auction and today are housed primarily at the Old Colorado City History Center. The building burned in the 1980s. Today Old Town Guest House Bed and Breakfast occupies the site.

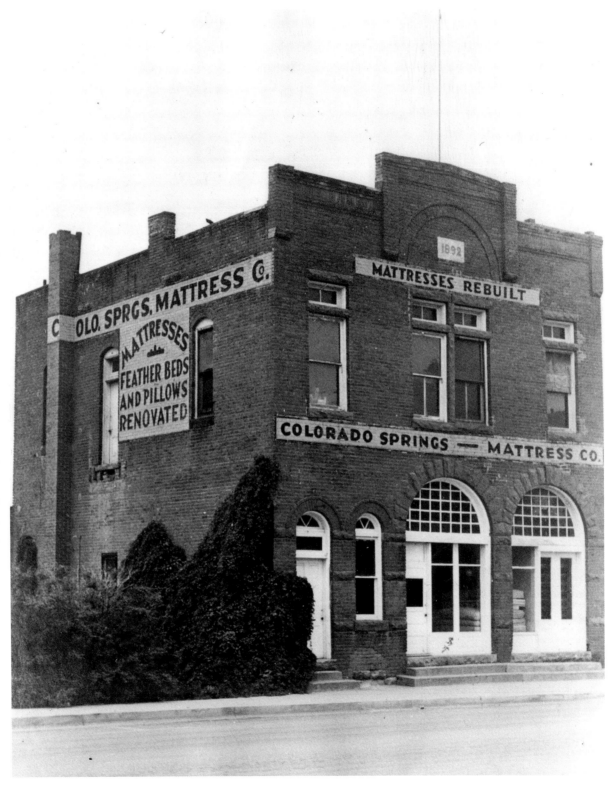

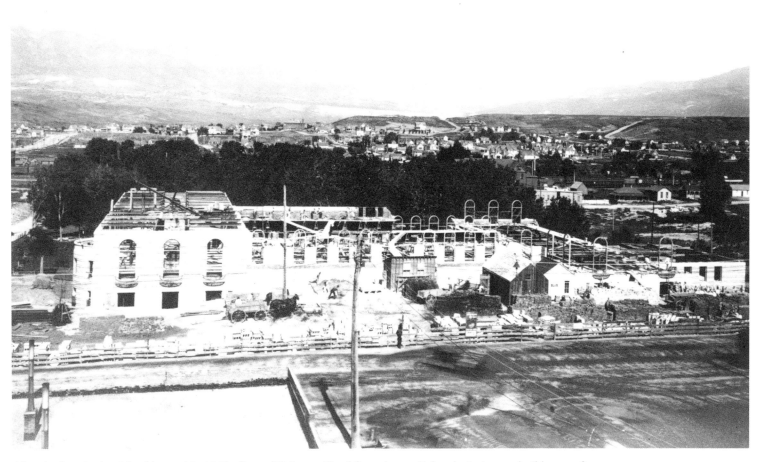

After the first Antlers Hotel burned in 1898, General Palmer offered financing to Colorado Springs to build a new five-story Antlers Hotel, shown here under construction around 1900. Its twin towers framed Pikes Peak to the west. At a cost of $600,000, its beautiful Italian Renaissance style was much admired. The hotel would be razed in 1964 to build the third Antlers Hotel, which stands today.

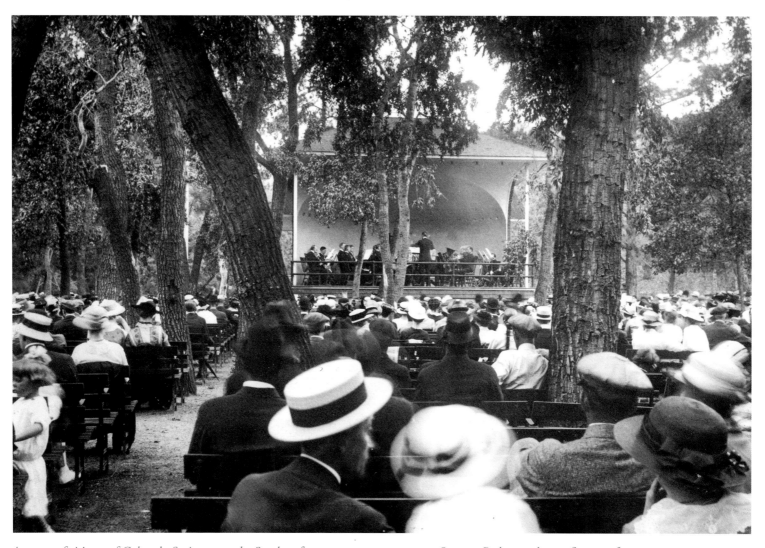

A group of citizens of Colorado Springs attend a Sunday afternoon summer concert at Stratton Park near the confluence of North and South Cheyenne creeks. W. S. Stratton, the carpenter who became a gold king, gave the park and the concerts to the city for the ordinary family to enjoy. The band concerts each summer cost Stratton approximately $4,000. Floods and neglect have taken their toll—today few traces of the park remain.

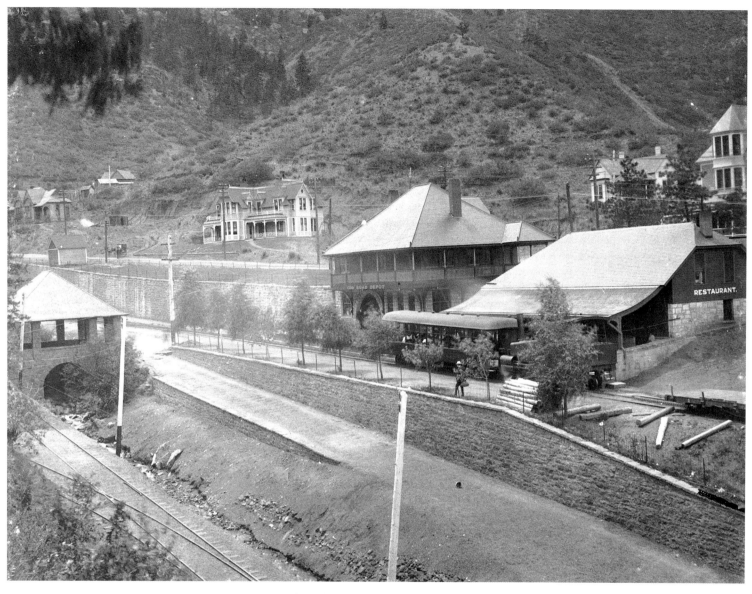

On the right is the Cog Road Depot in Manitou Springs at the west end of Ruxton Avenue. The tracks in front are for the streetcar line.

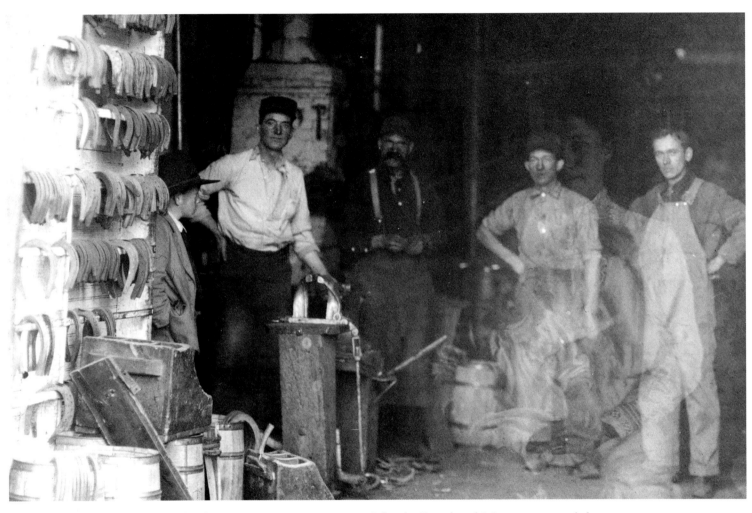

Dilts Blacksmith Shop on West Colorado Avenue was very important to Colorado City when this image was recorded, around 1900. There were fewer than 100 automobiles at this time in the area. Most people used horses or walked. Four men and one boy are shown inside the blacksmith shop. On the left is a rack holding various sizes of horseshoes. The "apparition" to the right is a faint reflection or double exposure of a young woman.

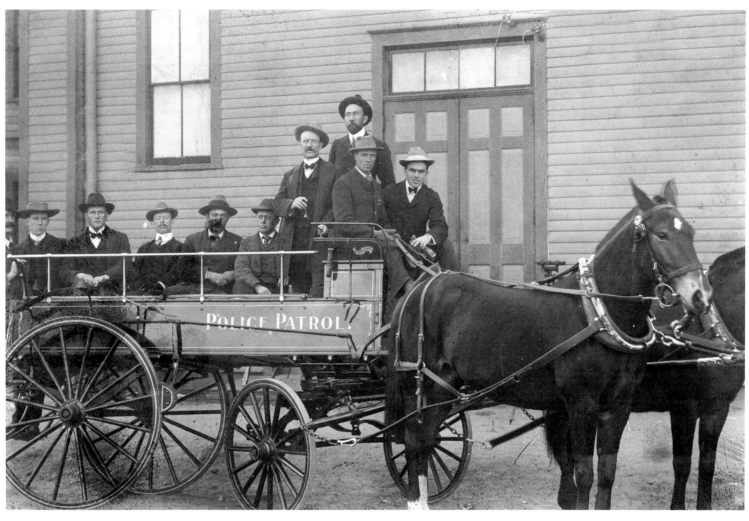

In 1901, Colorado Springs, by law, was designated a "first-class city," which made possible an upgrade in the police force. The first police chief was hired (previously a constable and then marshal) along with 2 drivers, 2 detectives, 1 sergeant, 1 captain, and 10 patrolmen. The 10 men in this patrol wagon are probably the new patrolmen, each of whom worked 12-hour shifts and enjoyed one day off a month.

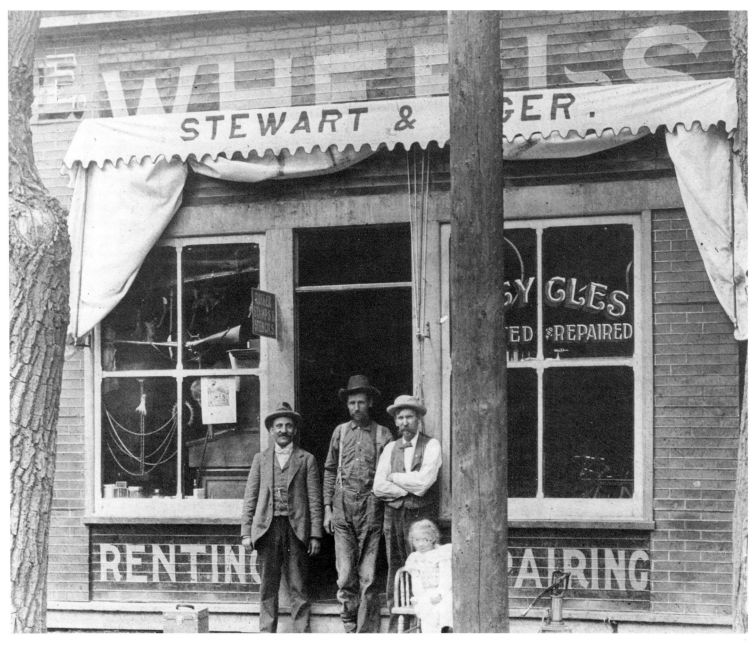

Three men and a child pose for a photograph outside the Stewart & Tiger Bicycle store at 106 East Huerfano (later Colorado Avenue) in 1901. Expensive toys for the well-heeled when first invented, bicycles became an inexpensive method of transportation, although difficult to use during Colorado winters.

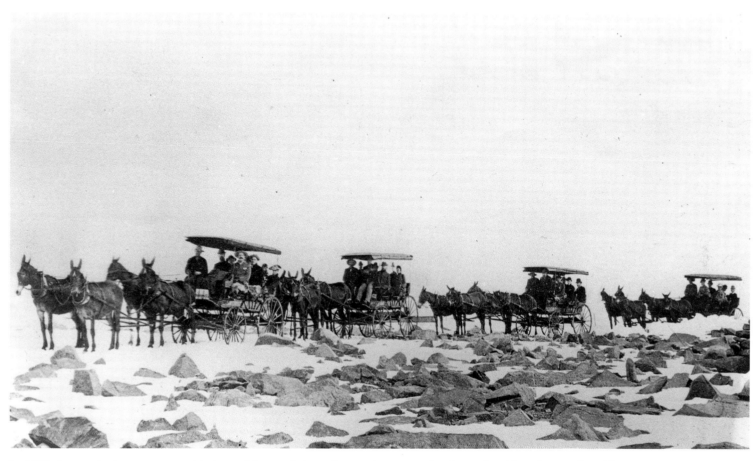

In 1901, four mule-drawn wagons with six to eight people in each pause in snow and rocks on the old carriage road up Pikes Peak. John Hundley promoted these day tours, which departed the Midland Railroad station in Cascade each morning.

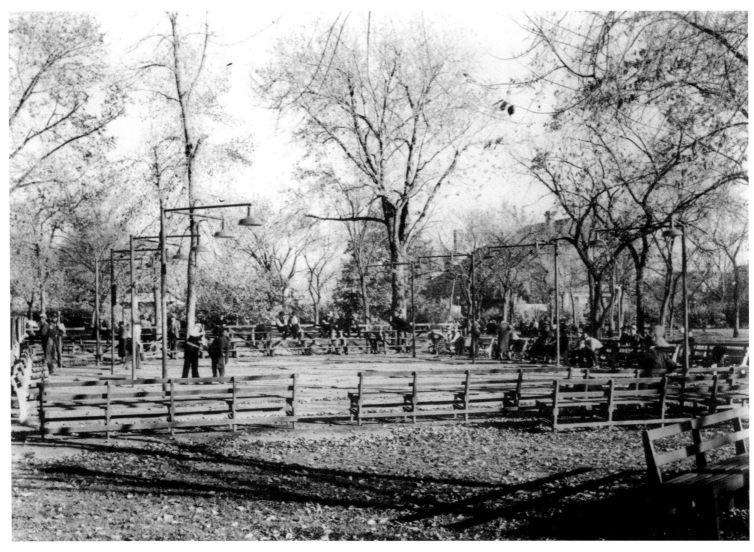

Acacia Park is one of the two main downtown parks set aside by General Palmer when Colorado Springs was founded.
People are shown here playing shuffleboard in the early 1900s while spectators look on from wooden park benches.
Shuffleboard can still be played in this park today.

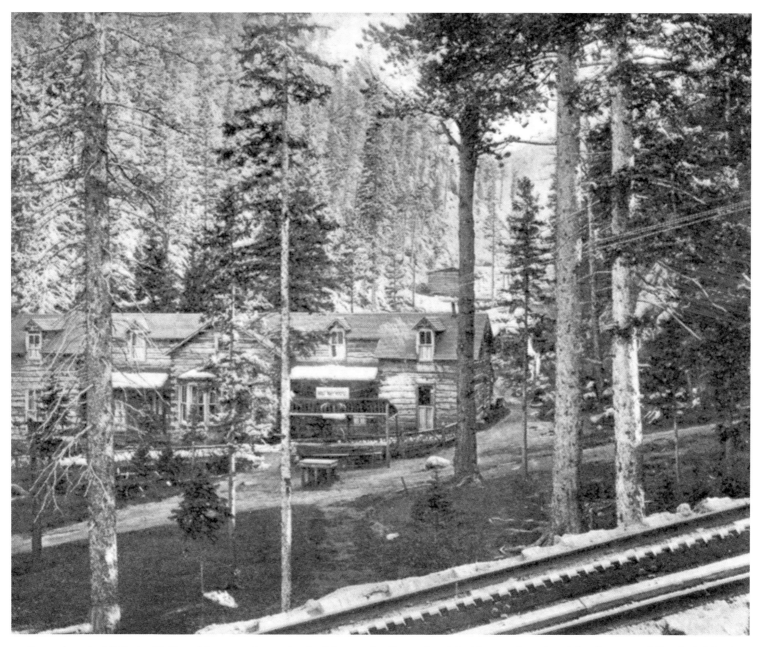

Shown here in 1902, the Halfway House was begun by the Palsgrove family as a hotel for hikers and tourists riding burros up Pikes Peak. The Cog Railroad made a stop there daily. The hotel held a post office and a souvenir shop. The retreat was damaged in January 1922 when hikers started a fire in the abandoned building. In 1926, what remained was torn down and the wood reused by a construction crew at Big Tooth Reservoir.

President Theodore Roosevelt speaks to the crowds during a visit in 1905. He had come to the area to hunt big game, but found time for other activities, including a visit with Dr. Donaldson, a former member of Roosevelt's Rough Riders. The much-admired president was back in Washington, D.C., around May 8.

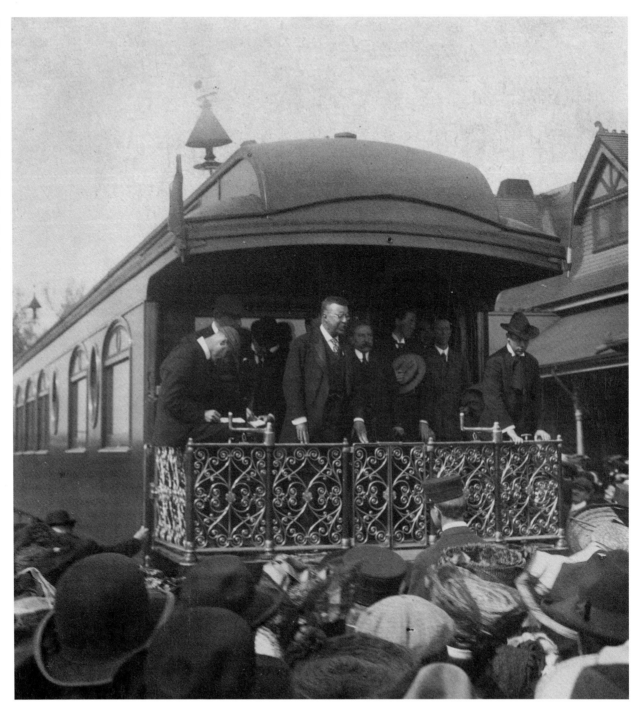

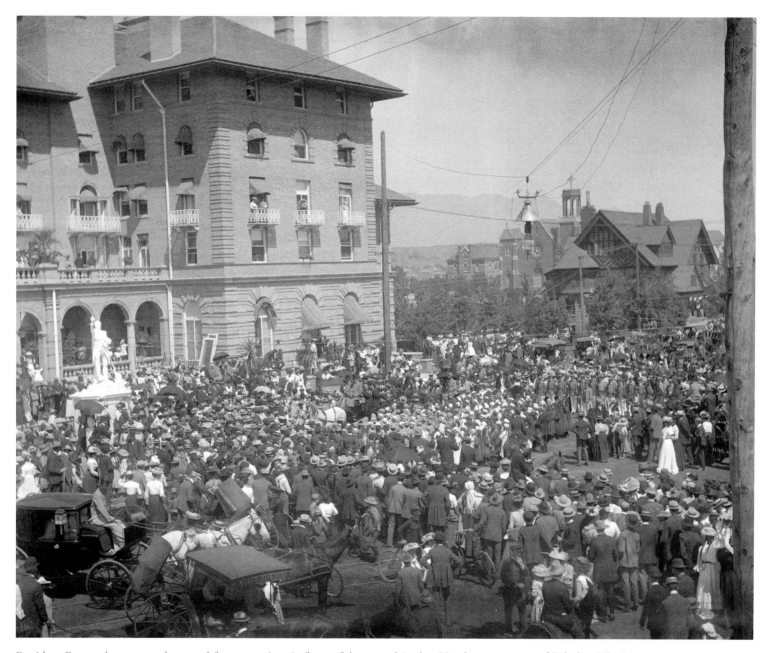

President Roosevelt waves to the crowd from a carriage in front of the second Antlers Hotel, near a statue of Zebulon Pike (at far-left, with Roosevelt's carriage to the right). Americans of the era used umbrellas, visible in this image, to shield themselves not only from rain but also from the sun.

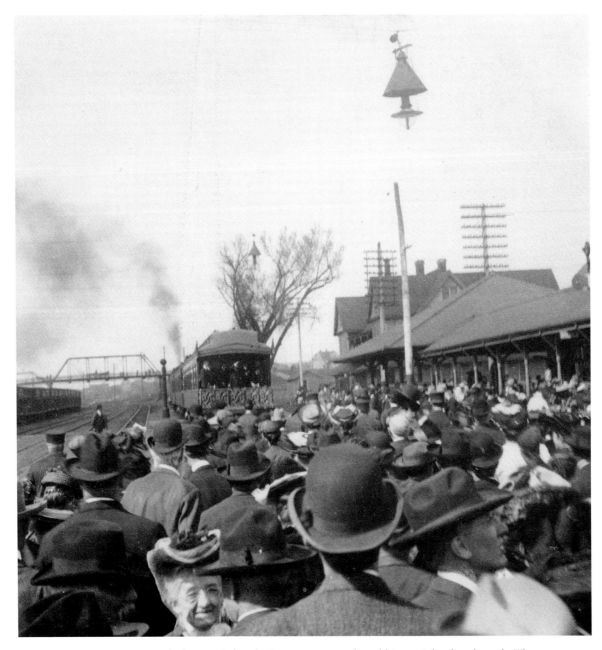

Roosevelt departs Colorado Springs in 1905 aboard his special railroad coach. That same year, always concerned for wilderness areas like those he found in the West, Roosevelt urged Congress to create the U.S. Forest Service to manage government-owned forest reserves.

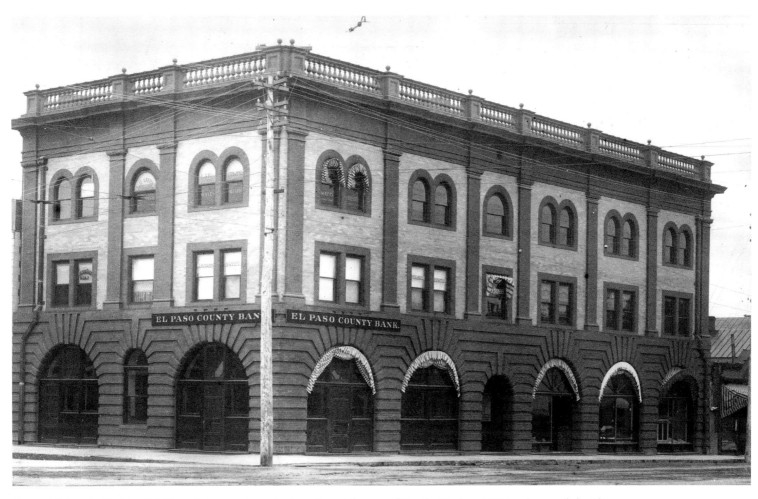

General Palmer's old friend William S. Jackson bought the safe and fixtures of Peoples Bank in 1873 and opened the El Paso County Bank along with D. H. White and J. S. Barbour. The three-story stone-and-brick building, at the southeast corner of Pikes Peak Avenue and Tejon Street, is shown here in the early 1900s. The bank featured arched windows, awnings, and a flat balustrade roof. Several businesses, along with the bank, were housed in the building.

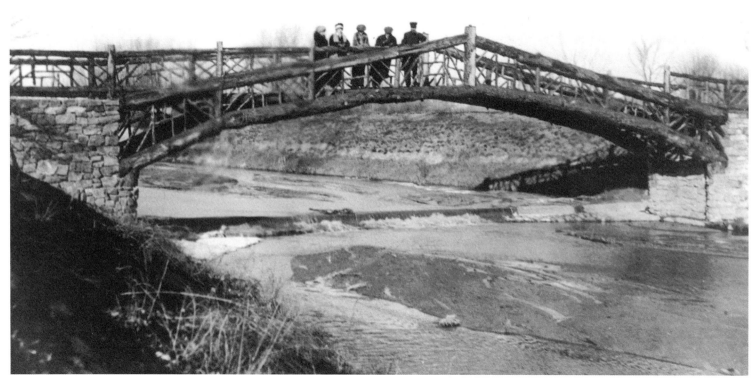

In 1907, General Palmer gave 165 unused acres to the city for another park. The land straddled Monument Creek running through the middle of town. Palmer's engineer, Edmond Van Diest, laid out gardens, walkways, bridges, and ponds. Monument Valley Park opened to the public November 19, 1907. In 1914, Spencer Penrose added a public swimming pool. Today the park and pool are still lovely, still protected, and used extensively.

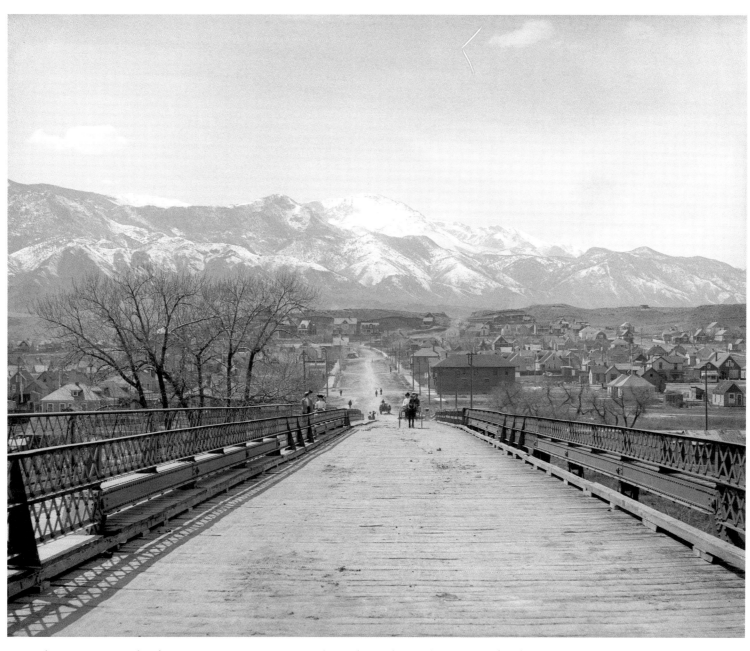

Horse-drawn carriages and pedestrians cross West Bijou Avenue's wooden viaduct in downtown Colorado Springs, as snow-covered Pikes Peak towers upward from behind. During the great 1935 flood, Monument Creek waters would wash this bridge away.

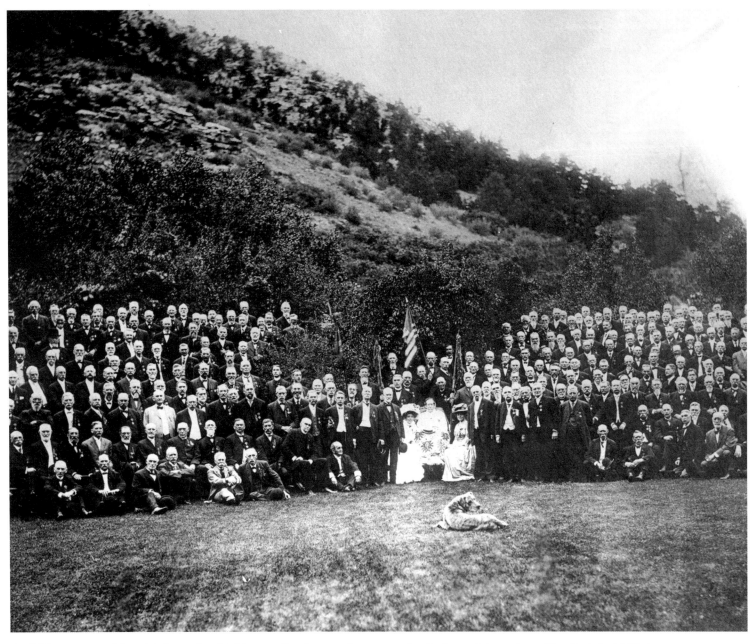

Civil War veterans of the 15th Pennsylvania Volunteer Cavalry pose for a group shot in front of the rocks at Glen Eyrie in 1907. A paralyzed General Palmer sits at center with his daughters at his side and one of his Great Danes on the ground in front. Unable to travel following his riding accident the year before, General Palmer hosted the reunion at Glen Eyrie and at the Antlers Hotel.

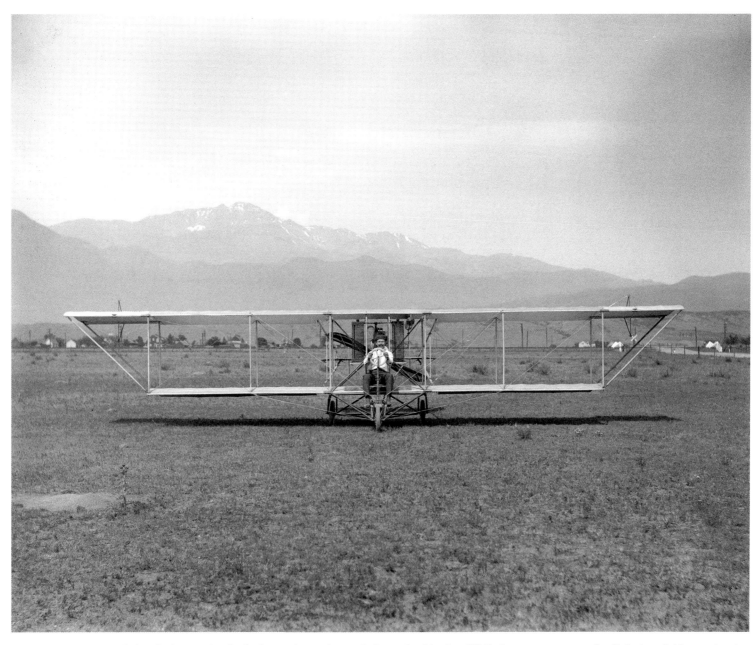

Colorado Springs has had a long relationship with flying. In this view, W. E. Bowersox prepares for flight in a field near the city. Early aircraft designs put the engine and propeller behind the pilot, whose open-air "cockpit" consisted of nothing more than a seat and a steering wheel. At one time, Manitou had a campground and cottage city with an airfield attached called McLaughlin. In the 1920s, Alexander Aircraft Company developed the Eaglerock biplane. These accomplishments would clear the way to selecting the city as home to the U.S. Air Force Academy in the 1950s.

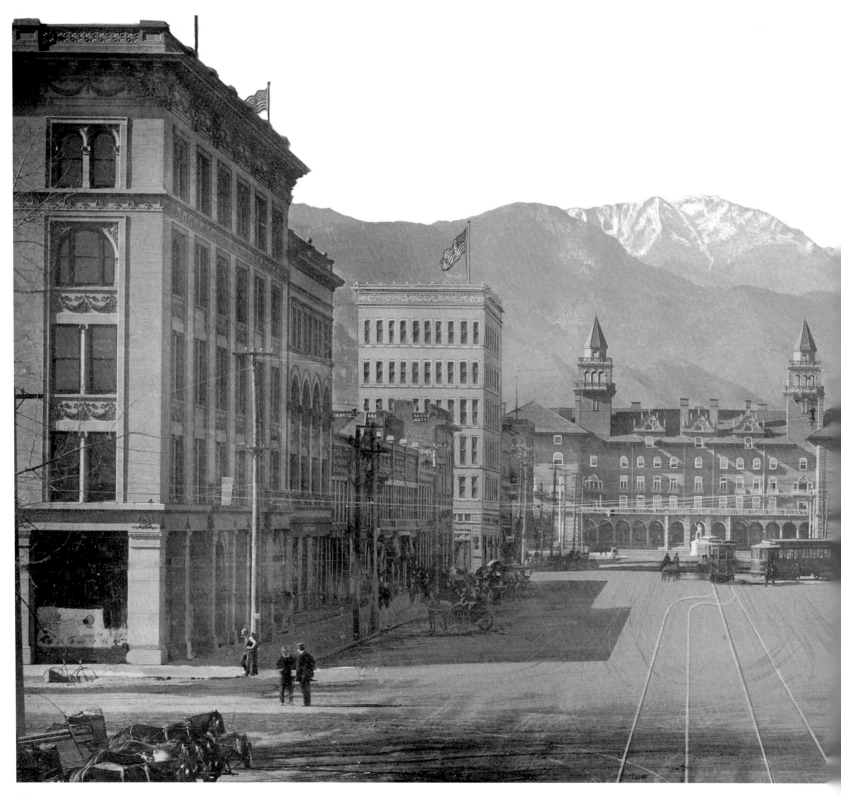

This is Pikes Peak Avenue as it appeared around 1908, facing west with the second Antlers Hotel at the end of the street. The second Antlers was five stories tall on the Cascade Avenue side and seven stories tall on the west side, with two towers that framed the landmark mountaintop beyond. Interurban Railway tracks and trolleys, the Elk Hotel, and a restaurant are visible.

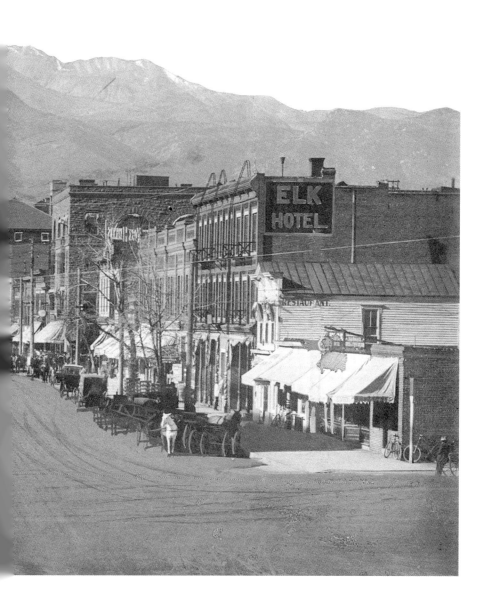

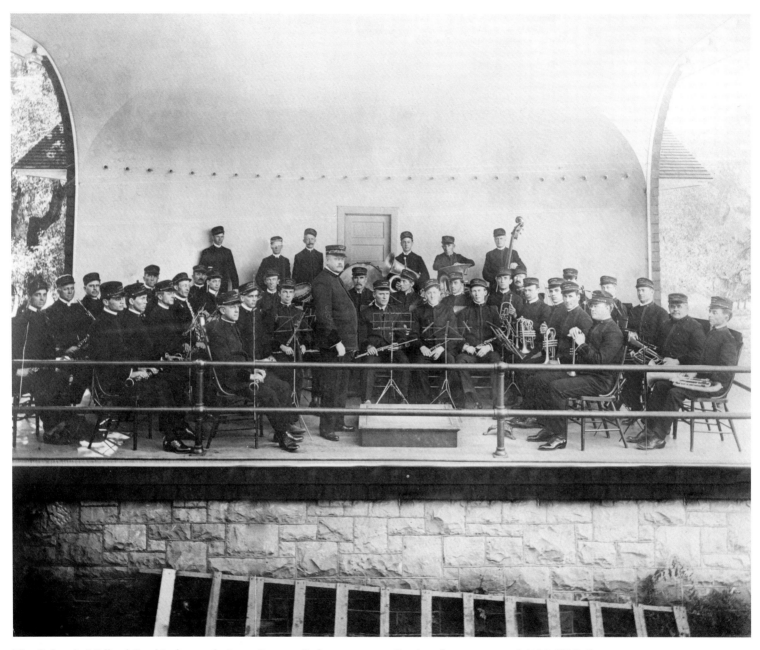

The Colorado Midland Band is shown playing at Stratton Park on a summer Sunday afternoon around 1908. W. S. Stratton, the Cripple Creek millionaire, built the 20-acre park at the wooded junction of North and South Cheyenne creeks on the south side of Colorado Springs for city residents. He then built a trolley line to take them there.

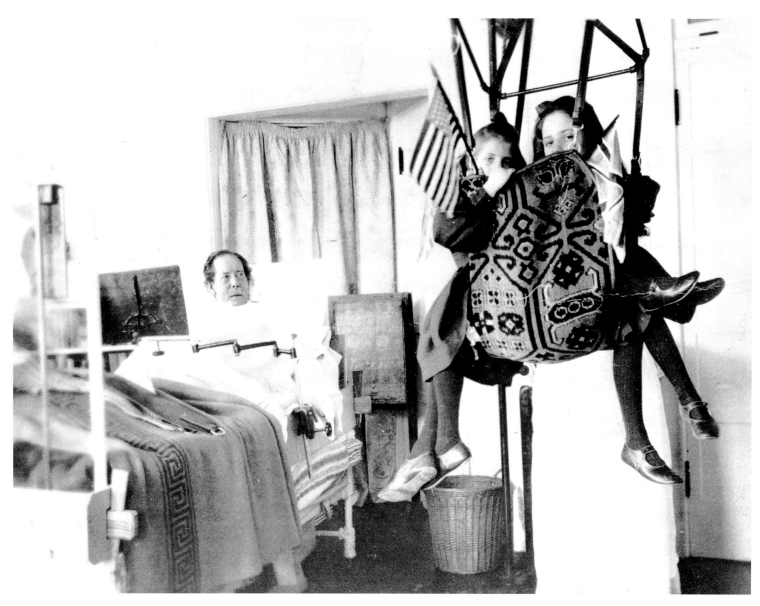

General William Jackson Palmer's 1906 horse-riding accident in the Garden of the Gods left him paralyzed. During the next three years, he tried to maintain some measure of a normal life. Because of his paralysis, he bought a car, hired a driver, installed a waterbed for comfort, and brought his Civil War unit to Colorado Springs for a reunion. Here he watches his grandnieces dangle from a sling attached to the ceiling.

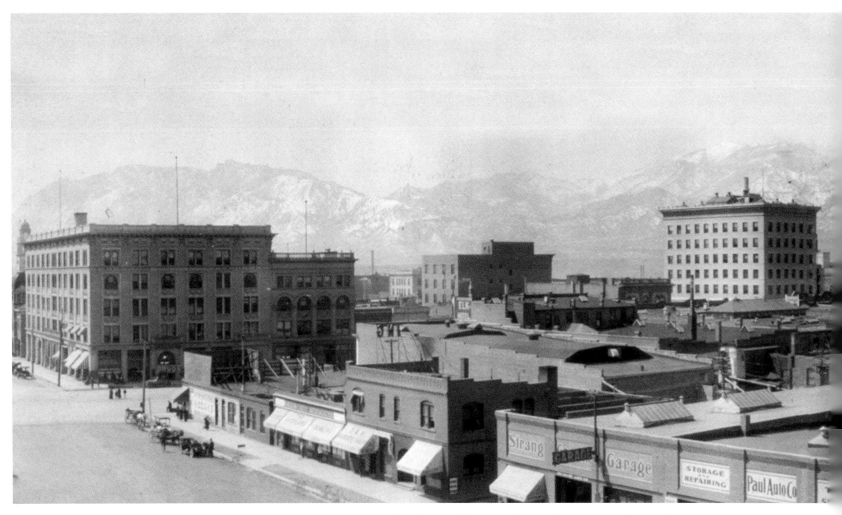

This early 1900s panorama shot from the El Paso County Court House includes the central business district, the three-story brick Alamo Hotel at the intersection of Cucharras and Tejon streets, and the rebuilt Antlers Hotel with its two towers.

In 1908, ten passengers sit in an open car on the Incline Railway, which ran from the depot at the west end of Ruxton Avenue in Manitou Springs, up Mount Manitou where it connected with the Barr Trail for hikers. Built in 1907 to haul pipe to a water plant, the incline traveled a 41 percent grade. In 1915, Spencer Penrose purchased the tourist attraction. The incline closed in 1990 and the tracks were removed, but the long scar on Mount Manitou, which tops out at 9,439 feet, remains visible.

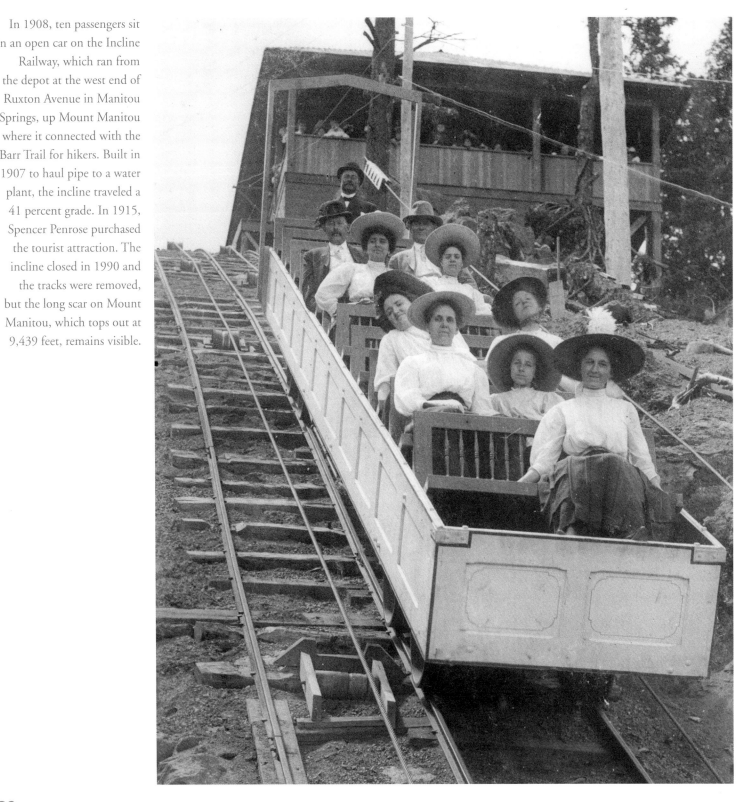

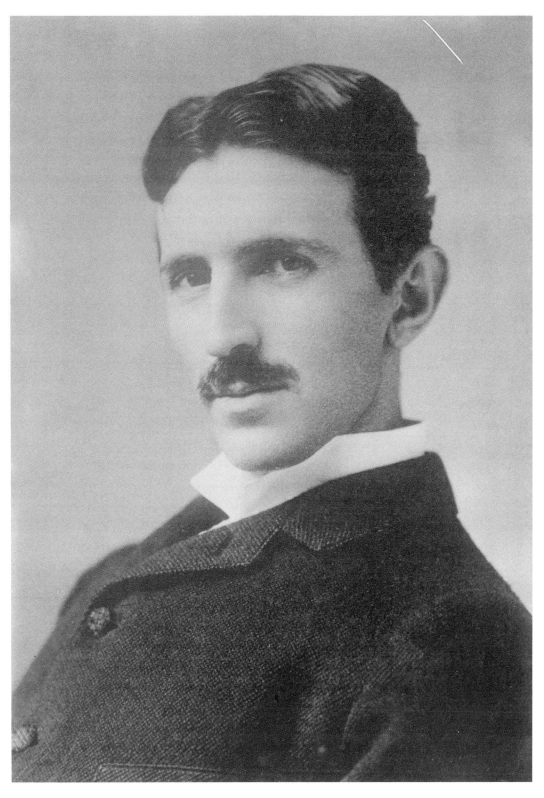

The great Nikola Tesla lived and worked briefly in Colorado Springs, building a lab here in 1899 to conduct experiments in long distance power transmission. During one experiment, he inadvertently blacked out the city. He once remarked to a reporter that he intended to send telegraph transmissions from Pikes Peak to Paris. It was also here that the likable but eccentric genius observed unusual radio signals he later suggested might have come from Venus or Mars. When Tesla departed the city in 1900, his lab was demolished and its contents sold to cover his debts. In 1943, the year he died impoverished and alone in New York City, the Supreme Court upheld his patent on a cordless communications system, in effect recognizing his work over Marconi's in the invention of radio.

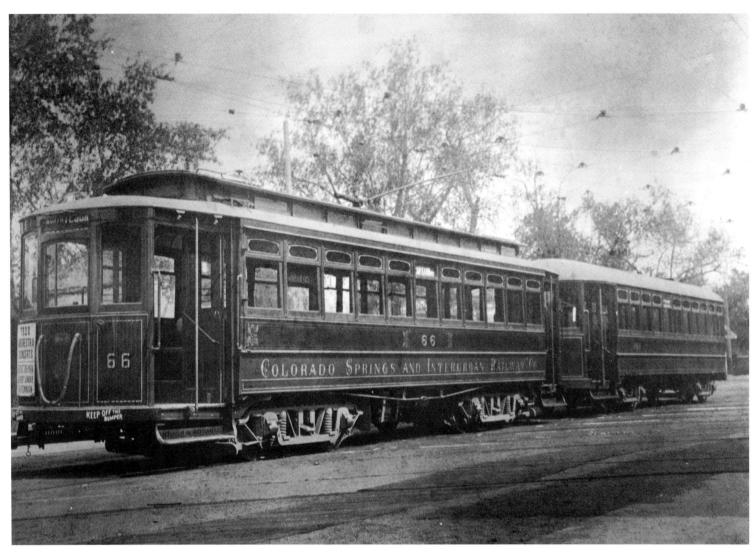

In service here in 1911, the Colorado Springs and Interurban Railway Company was Winfield Scott Stratton's expanded version of the original streetcar system. A caution on car #66 at front says "Keep off This Bumper."

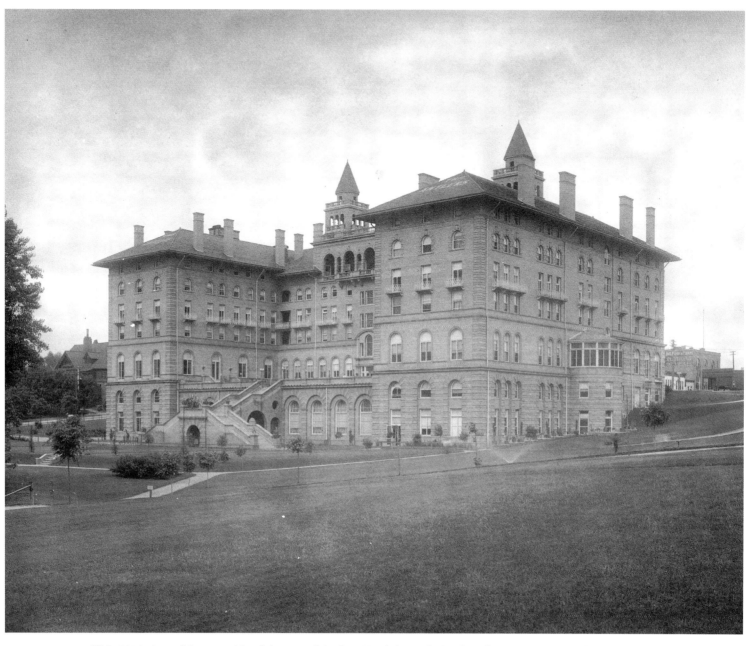

This 1910 view of the west side of the second Antlers Hotel shows the brick-and-stone structure with hipped-gable roofs, chimneys, towers, bays, arched windows, a solarium, a terrace, stairways, a loggia, and landscaped lawn with new trees, sidewalks, and even sprinklers. This is the view of the hotel that guests saw as they arrived at the Denver and Rio Grande depot across the park.

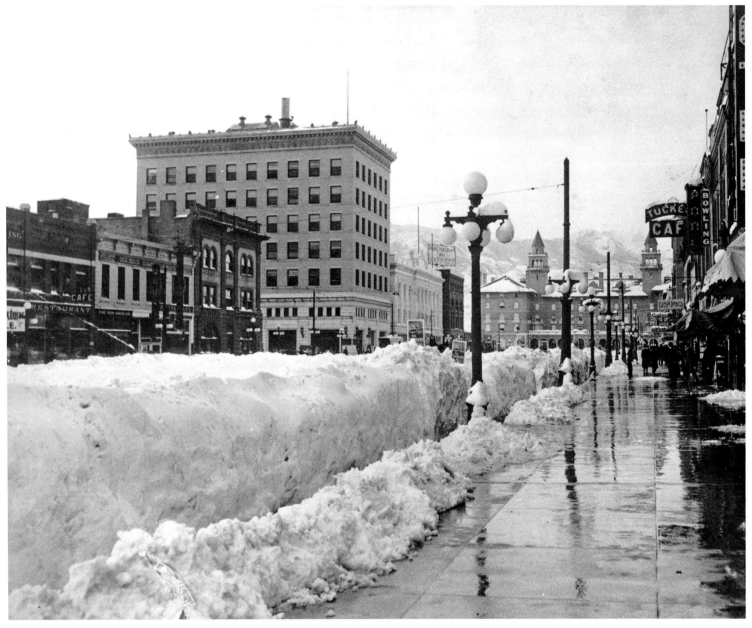

On December 4, 1913, the local newspaper forecast clouds and a few flurries. Three days later, 45.5 inches of snow lay on the ground. Streetcar service was suspended, and horses, sleighs, and snowshoes became the most reliable modes of travel. In this photograph, sunshine has begun to melt snow from the sidewalks.

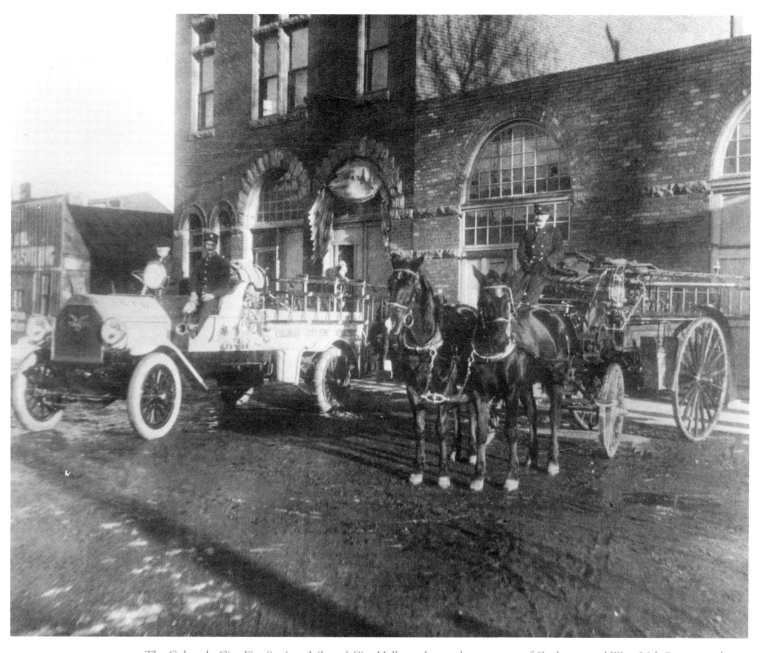

The Colorado City Fire Station, Jail, and City Hall, on the northeast corner of Cucharras and West 26th Street, are shown here as they appeared around 1912. The first city hall was located three blocks north of Colorado Avenue. Benjamin Franklin's creation of the first fire department in 1736 was an idea Americans emulated ever after. Once a new town was established, a fire department, usually volunteer at first but later paid, was sure to be organized.

Advertising in the form of graffiti appeared one year on the rocks in William Canyon near the Cave of the Winds. The canyon must have echoed as passersby pronounced, "Elite Photos Are Fine" and "The Elite Photos Will Make the Baby Smile."

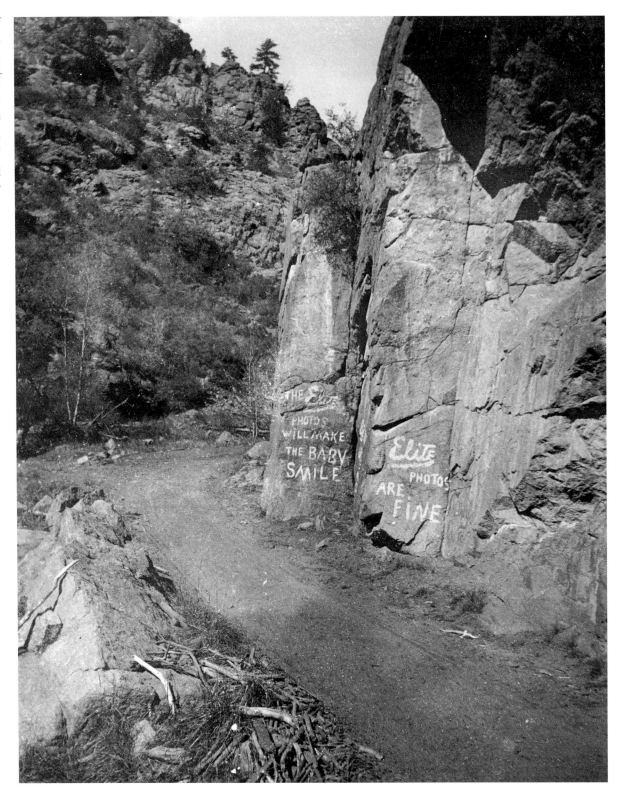

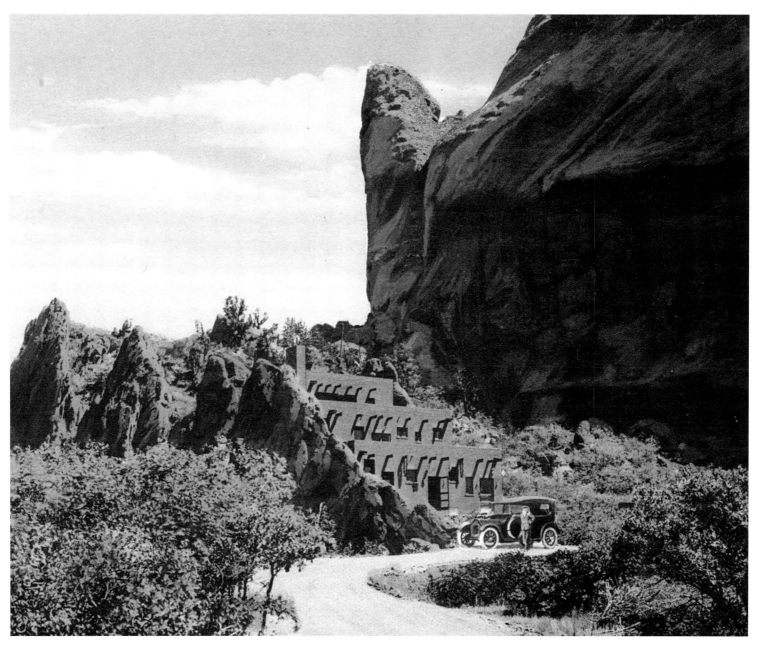

The Charles Perkins family gave the city of Colorado Springs 480 acres of land, which became the Garden of the Gods Park. This adobe structure is the Hidden Inn as it appeared in 1912. Intended to be a caretaker's home, the structure evolved into a gift shop. In order to protect the park, Colorado Springs rerouted traffic in 1994 and the Hidden Inn was demolished. A new visitor's center and gift shop today stands just outside the park entrance.

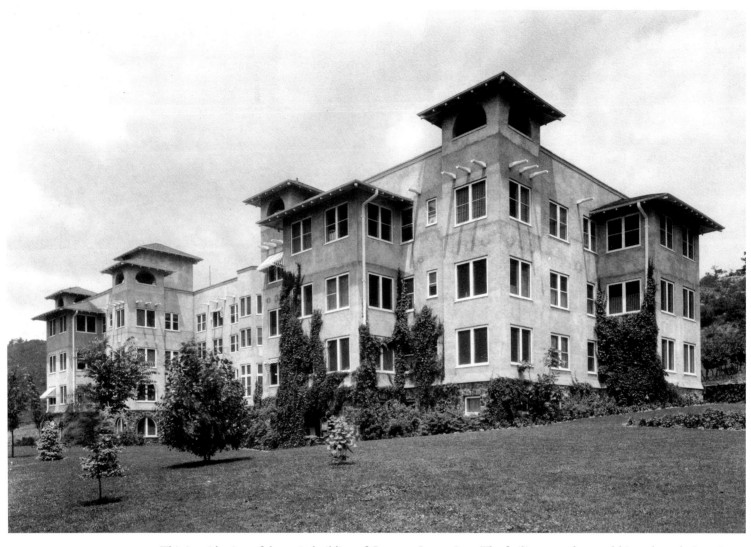

This is a side view of the main building of Cragmor Sanatorium. The facility catered to wealthier tuberculosis patients. These buildings are now a part of the University of Colorado at the Colorado Springs campus.

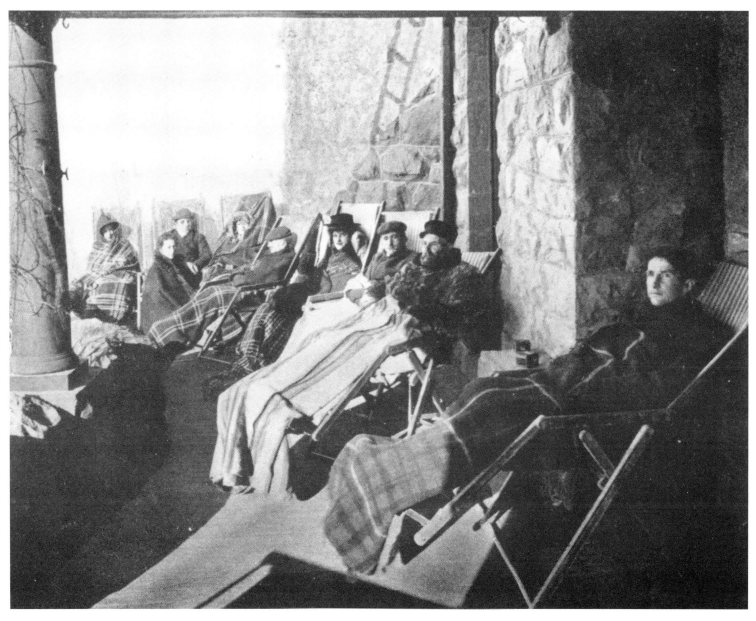

Cragmor opened in 1904-5 on 100 acres of land donated to the city. Dr. S. E. Solly was medical director. Sun, fresh air, rest, and good food were the cures available to patients hoping to recover from tuberculosis.

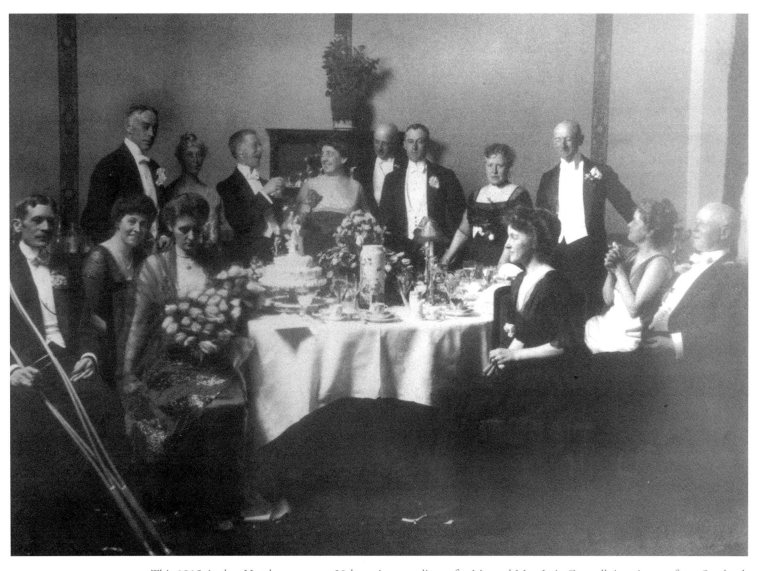

This 1915 Antlers Hotel scene was a 20th anniversary dinner for Mr. and Mrs. J. A. Connell, immigrants from Scotland. Mrs. Connell holds the large bouquet. In proper dinner attire, guests pose at a table decorated with flowers, a large cake, and white linens. Mrs. Helen B. Anderson, hostess, is standing at center in the background talking to Mr. Connell. When his attempts to thrive as a cattle rancher failed, Mr. Connell turned to real estate, reaping much success.

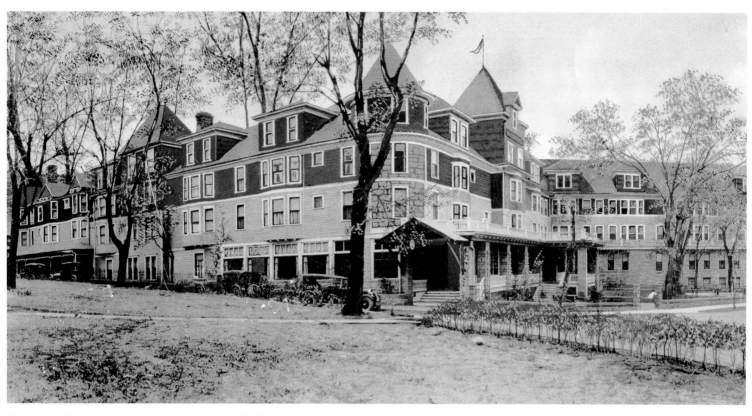

The E. E. Nichols family built the core of the Cliff House in 1873. The magnificent structure has survived economic difficulties, urban renewal, and fire, and stands today a remodeled gem of Americana in Manitou Springs.

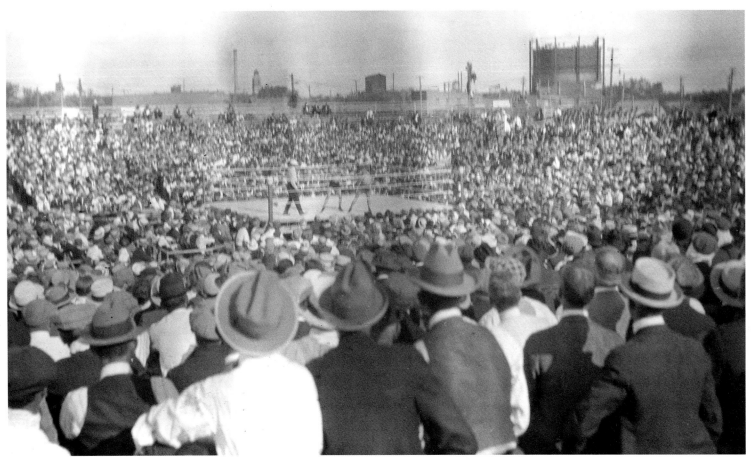

A large crowd watches a battle for the lightweight boxing crown on Labor Day 1916, between Freddie Welch from Wales and Charlie White of Chicago. The excited crowd diverted its focus from the ring when bleachers supporting 500 spectators gave way. The collapse resulted in many injuries and one death, but the fight continued with Welch winning in a 10-5 decision. The match took place in an open area at Colorado Avenue and Spruce Street.

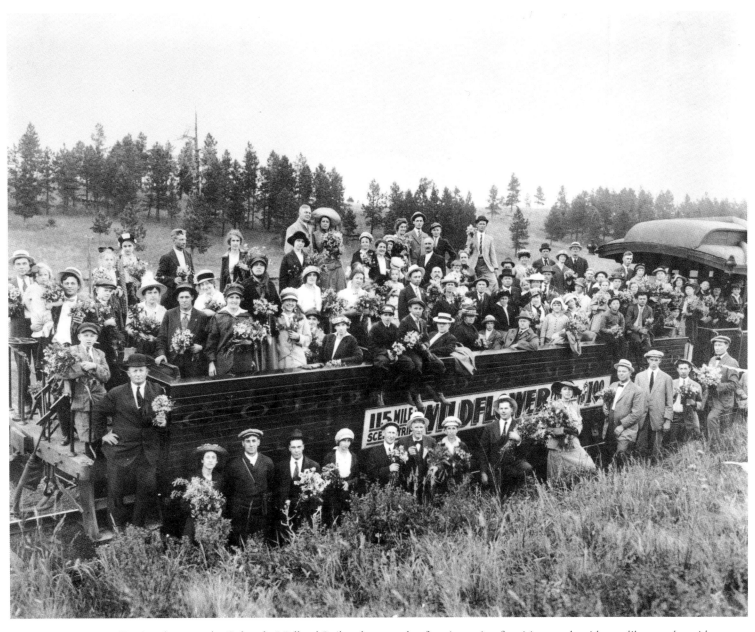

During the years the Colorado Midland Railroad operated, a favorite outing for visitors and residents alike was the midsummer wildflower excursion. The trip was usually an all-day event with people returning home with armloads of wild alpine flowers. This group displays their dainty pickings in 1915.

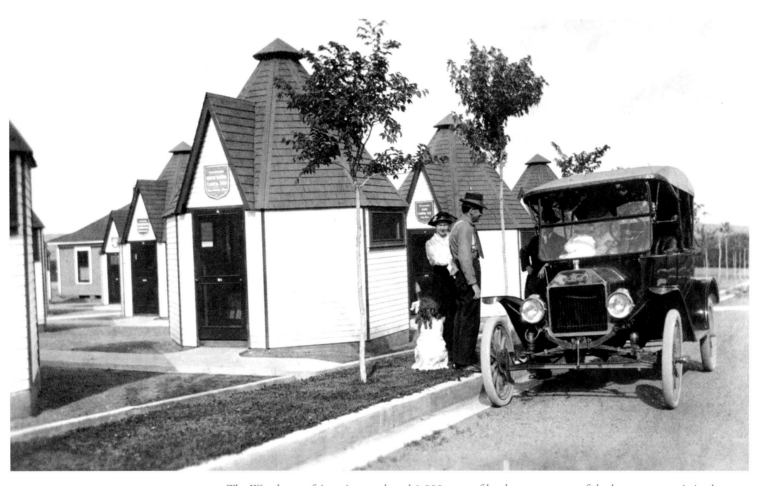

The Woodmen of America purchased 1,000 acres of land to set up one of the largest sanatoria in the area. Patients were housed in Gardiner tent cottages (seen here). The sanatorium was a self-contained community with a complete infrastructure—paved streets with curbs, grass, trees, electricity, a water system, and more. The Woodmen Sanatorium in Woodmen Valley grew as the TB cure rate increased. It closed in the 1940s when antibiotics became highly effective as a treatment.

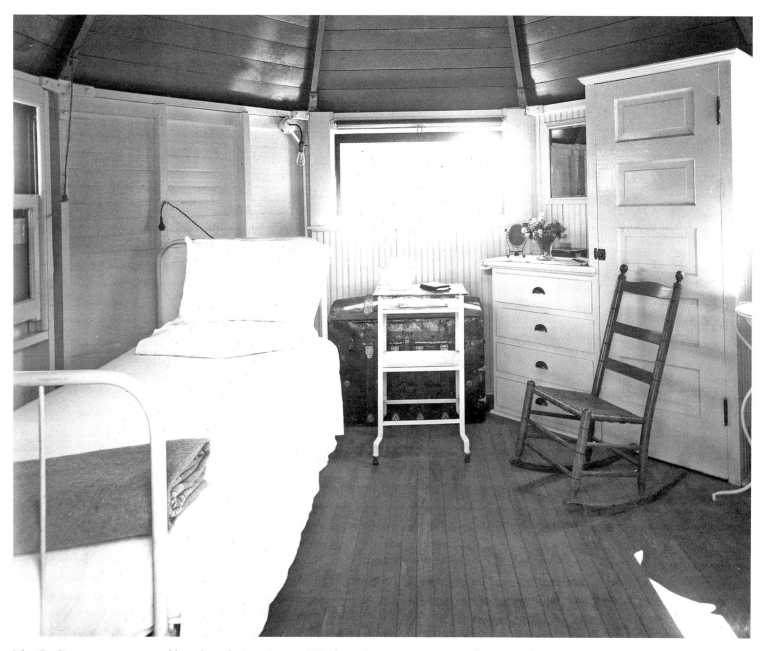

The Gardiner tent cottage, used by tuberculosis patients at Woodmen Sanatorium, was a small, octagonal structure with a hole in the roof for air circulation summer and winter. Two hundred of these cottages were built at the sanatorium. Shown here is the interior of one of the cottages, which held a bed, dresser, washstand, chest, and rocking chair. The wooden ceiling is also visible.

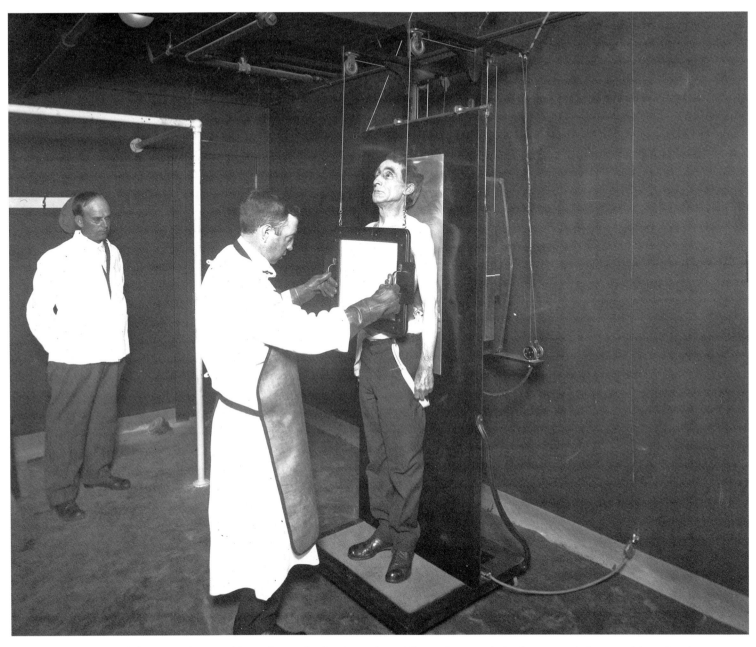

In 1915, a patient stands between a hanging X-ray plate and reflective surface while another man in lead apron and gloves positions the plate. With the newly developed machine, tuberculosis could now be diagnosed but a cure would not be discovered until 1943. Once known as consumption, the infectious bacterial disease was widespread throughout human history and before the advent of sanatoria it was almost always fatal. Its resurgence in recent years, in strains resistant to antibiotics, has been widely publicized. Cautionary pleas to the public to complete antibiotics prescriptions for maladies of any kind, to help prevent the spread of antibiotics-resistant pathogens, have also been issued.

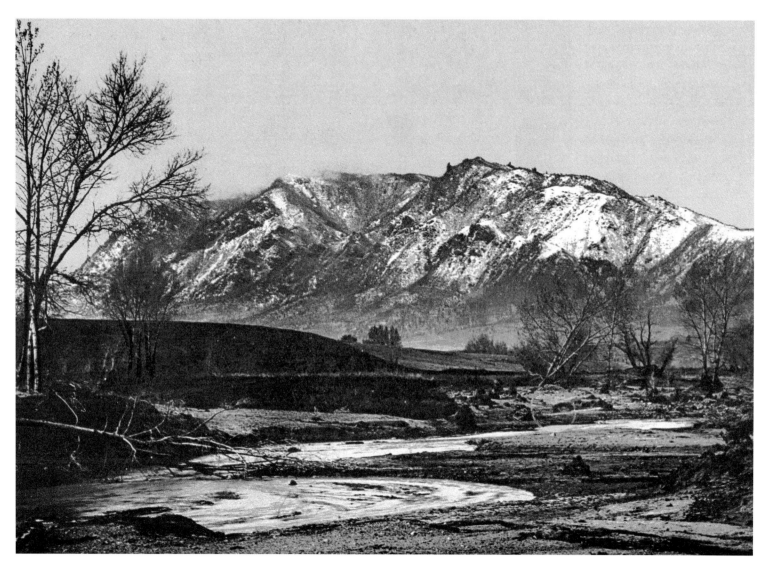

In this view west, Cheyenne Mountain rises snowy and majestic. Today, the mountain shelters the NORAD underground defense facility.

Shown here in the 1910s, Hibbard's Department Store at 17 South Tejon was the most complete place to shop in Colorado Springs beginning in the early 1900s. It featured wooden floors, bright display cases, a hand-operated elevator, and pneumatic tubes for sending money to a central cashier upstairs. Hibbard's closed in the 1990s, and today the building is occupied by restaurants.

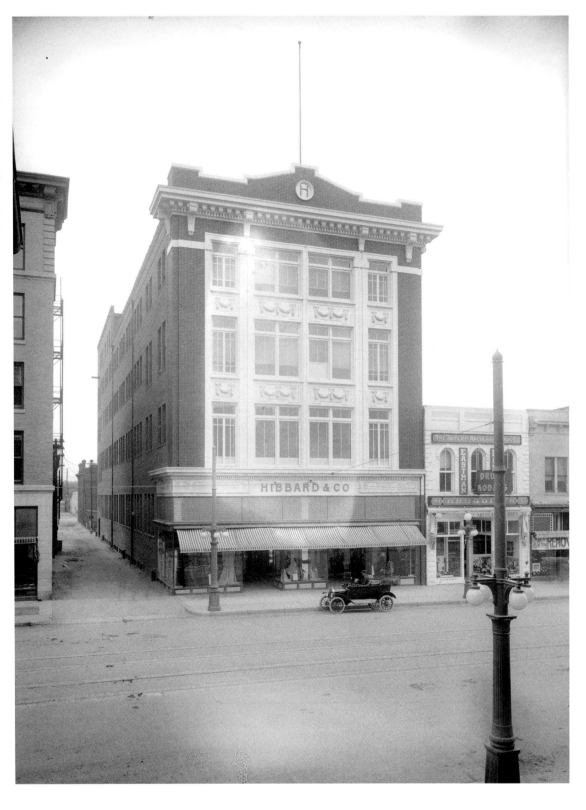

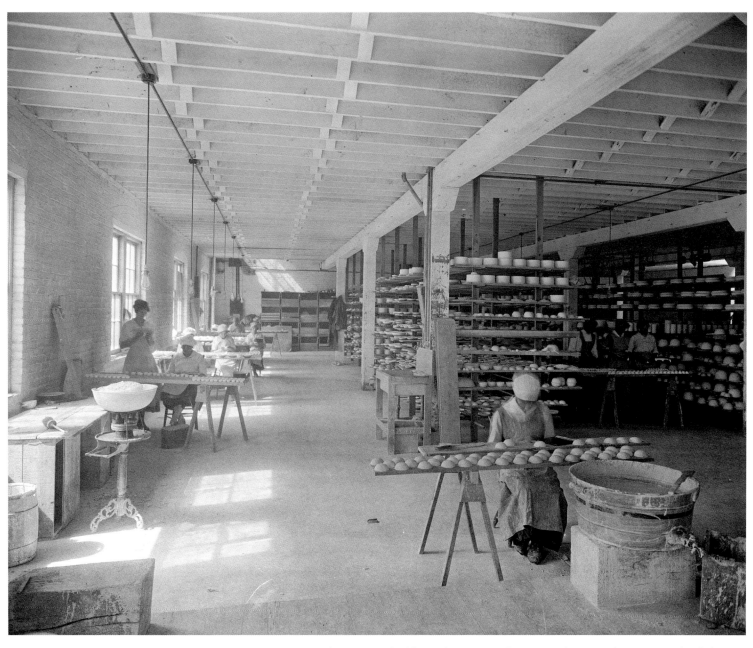

Women are shown at worktables at the Van Briggle Memorial Pottery about 1910. The shelves are full of bisque ceramic pieces. The woman in front with a large tub of water is probably smoothing out the seams of the green ware.

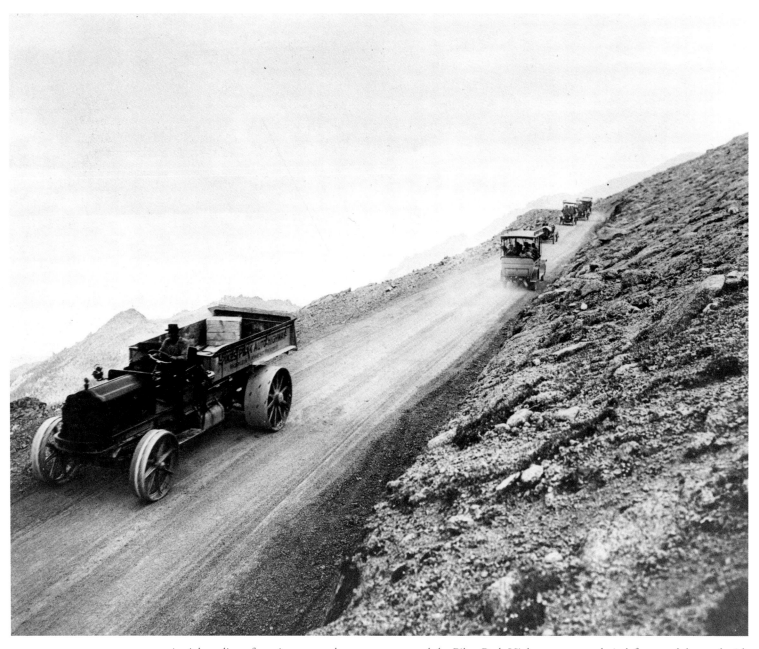

At right, a line of touring cars and one racecar ascend the Pikes Peak Highway auto road. At left, a truck lettered with the words "Pikes Peak Auto Highway, World's Highest Highway" pursues its journey downslope. A note with the original photo dates the scene to the summer of 1916, the year the auto highway opened. Today the road is closed to tourist travel when the Pikes Peak Hill Climb race is in progress.

Two thousand feet above Manitou in the 1910s, four women, two men, and a boy pose with a touring car at a bend in the Crystal Park Auto Road. The seven-mile trail up to Crystal Park was built in 1879. It was later improved to become an auto road, which required turntables to move the tourist and automobile around several hairpin curves. The drive provided a view of Manitou, Garden of the Gods, and Williams Canyon.

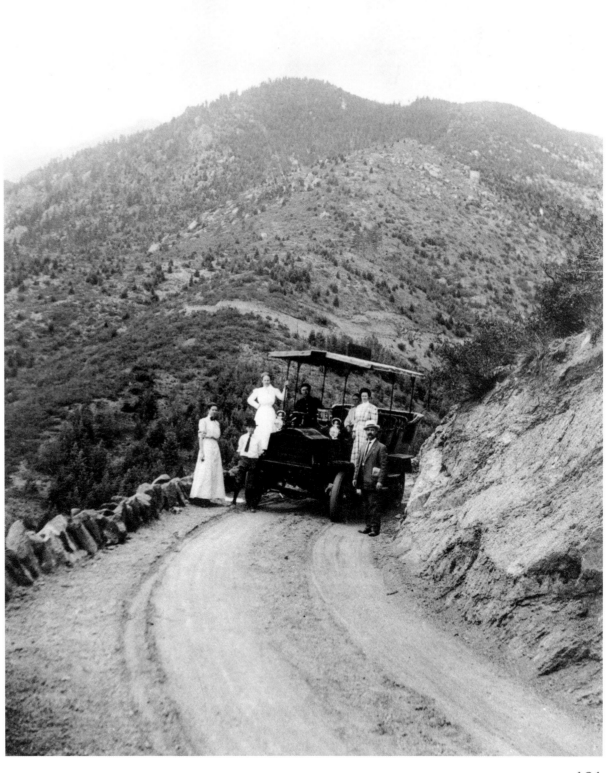

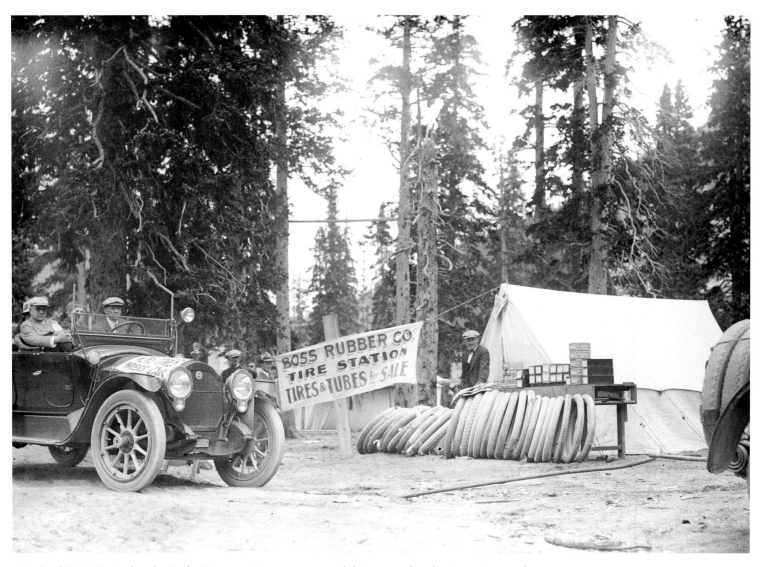

A Packard Twin Six used as the *Rocky Mountain News* press automobile is stopped at the tire station on the Pikes Peak Highway around 1915, where a large number of tires are stacked out front. Clear evidence that the remote road was very hard on tires.

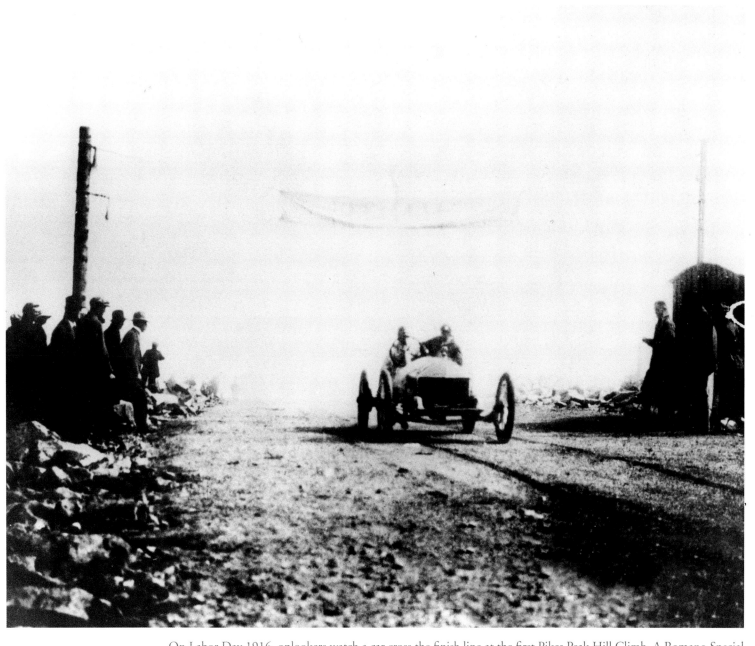

On Labor Day 1916, onlookers watch a car cross the finish line at the first Pikes Peak Hill Climb. A Romano Special driven by Ray Lentz of Denver won the first-ever race.

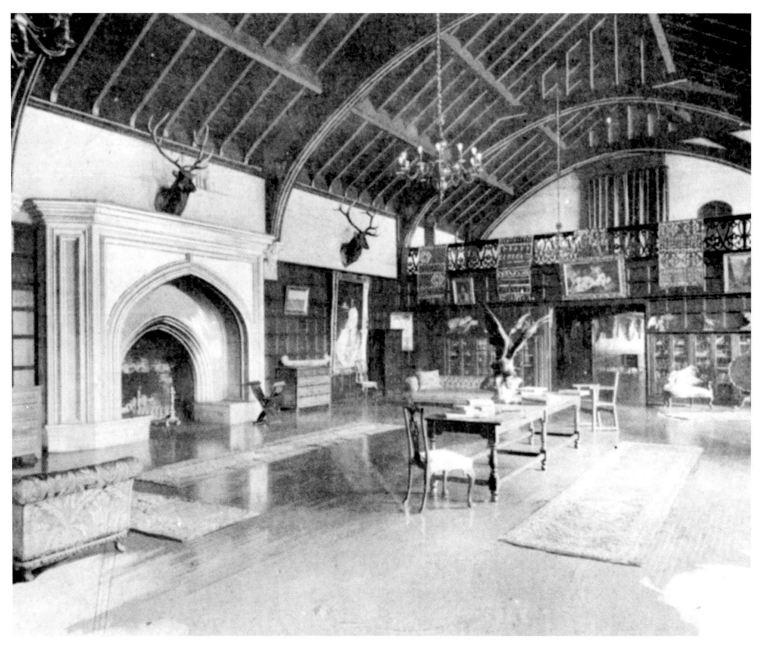

This interior view of the Great Hall at General Palmer's home, Glen Eyrie, reveals the opulence of the mansion even in the wilds of early Colorado. The balcony at the far end was used for bands playing at dances and children's Christmas parties. The original lodge at Glen Eyrie was built in 1871 and expanded to a castlelike home. Ornate wooden floors and paneling, a Gothic carved-stone fireplace, taxidermy birds, oriental rugs, and expensive furniture adorned the residence. Antlered stag heads reflect the decorating style of the times. Conversely, Glen Eyrie had electricity, a very advanced amenity for the western United States of that day. Today, Navigators Christian organization owns the facility and conducts regular tours. The home has been well preserved.

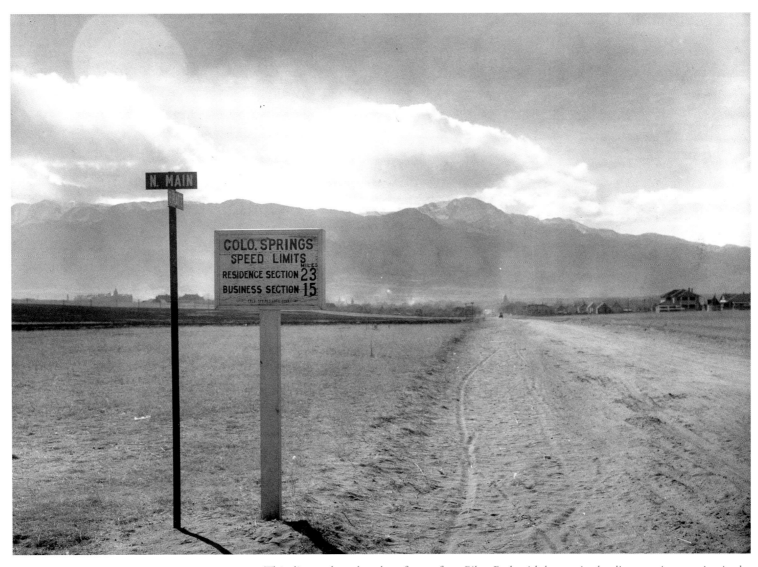

This dirt road on the edge of town faces Pikes Peak with houses in the distance. A street sign in the foreground identifies it as the corner of North Main and East Platte. The speed limit here in the 1910s was 23 M.P.H. on residential streets, 15 M.P.H. on business streets.

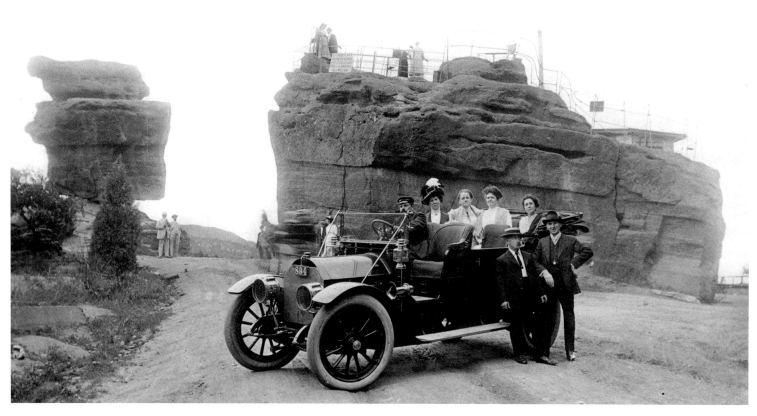

A car filled with tourists is parked in the Garden of the Gods near Balanced Rock. Until recent years visitors were allowed to climb to the top of the rock to view Steamboat Rock just opposite. The sign on top says, "Steamboat Rock Observatory. Use of the Telescopes Free to the Visitors. All Welcome." The old sandstone stairs and metal railings once used by tourists are still visible today.

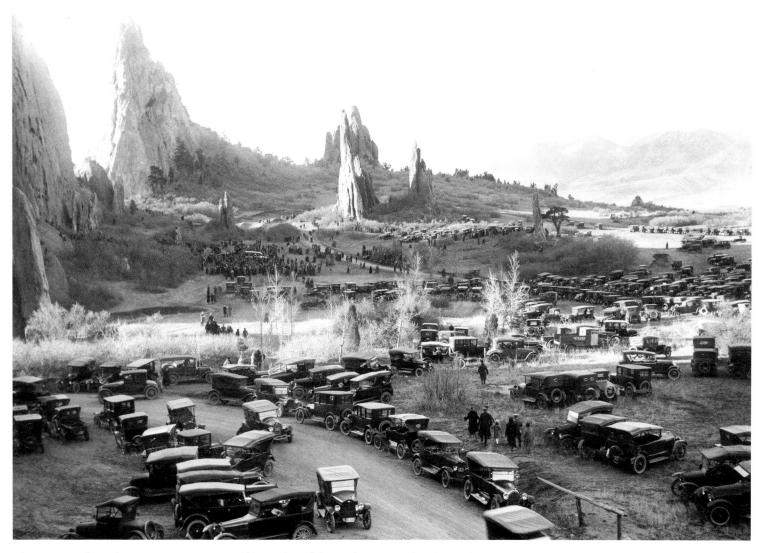

This is an April 1924 Easter sunrise service in the Garden of the Gods. Various churches in the city sponsored the annual event until the early 2000s, when the services were discontinued.

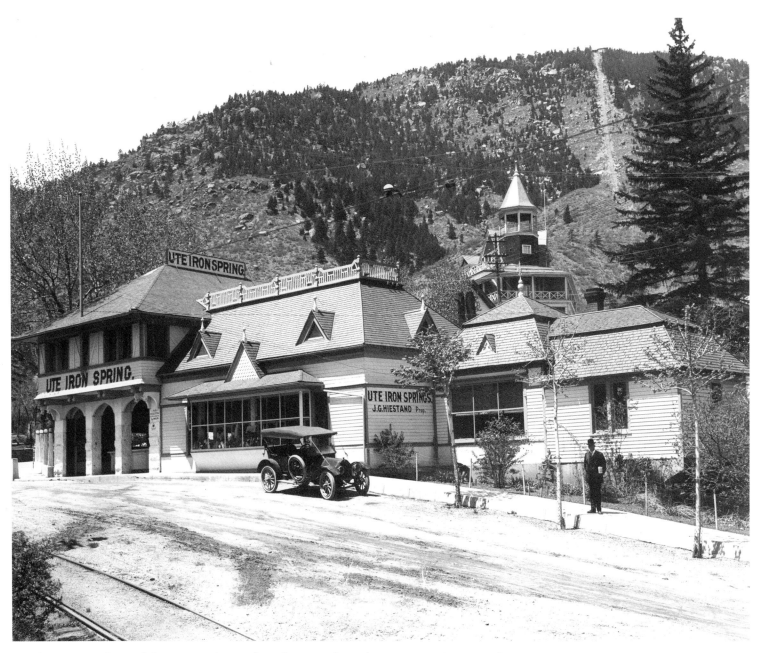

Joseph G. Hiestand owned the Ute Iron Springs from the 1880s forward, running a curio store with photographs there until his death. Hiestand consistently added on to the structure, which is shown here as it appeared in 1916. The track in the foreground is for the Manitou Electric Railway or the "Dinky Trolley" as it was called, and the Mount Manitou Incline is visible in the background.

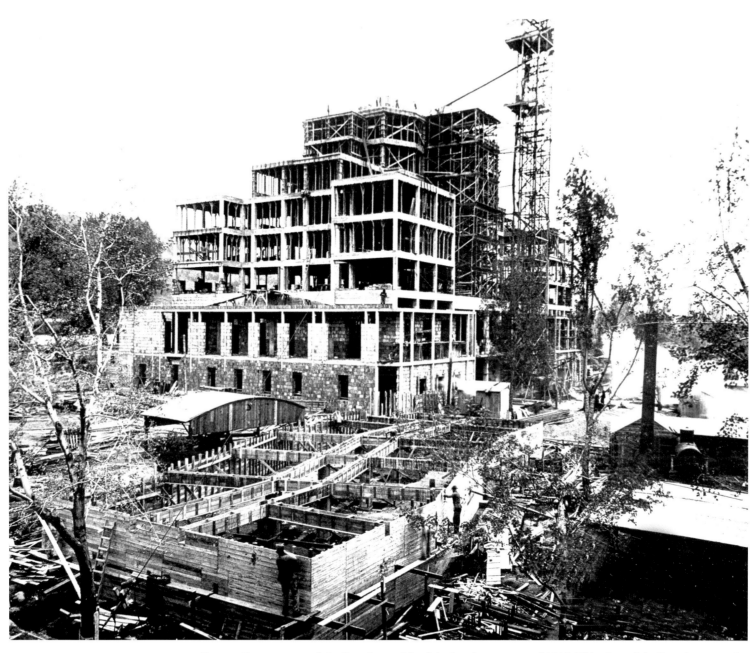

Spencer Penrose opened the Broadmoor Hotel during the summer of 1918. This view of the Broadmoor under construction is from October 1917. The image shows the framework and lower levels with a crane alongside. Architects Warren and Wetmore also designed New York's Grand Central Station and Plaza Hotel, as well as the Royal Hawaiian Hotel in Honolulu. The Broadmoor resort included a pool, golf course, lake, gardens, and a zoo.

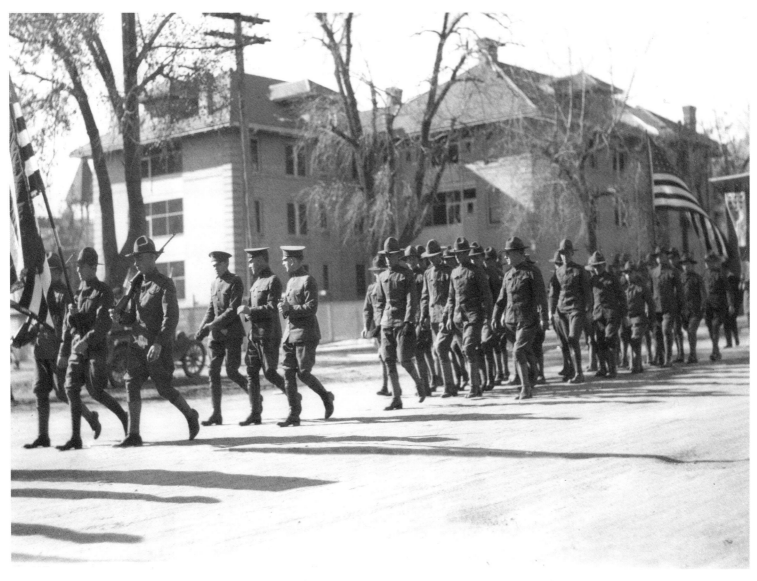

Tejon Street is the site of this 1918 Victory Day (Armistice Day) parade celebrating the World War I Allied victory over the Central powers. Bands, horsemen, floats, and military groups took part. These soldiers may have been members of the 148th Field Artillery, a unit formed in Colorado Springs.

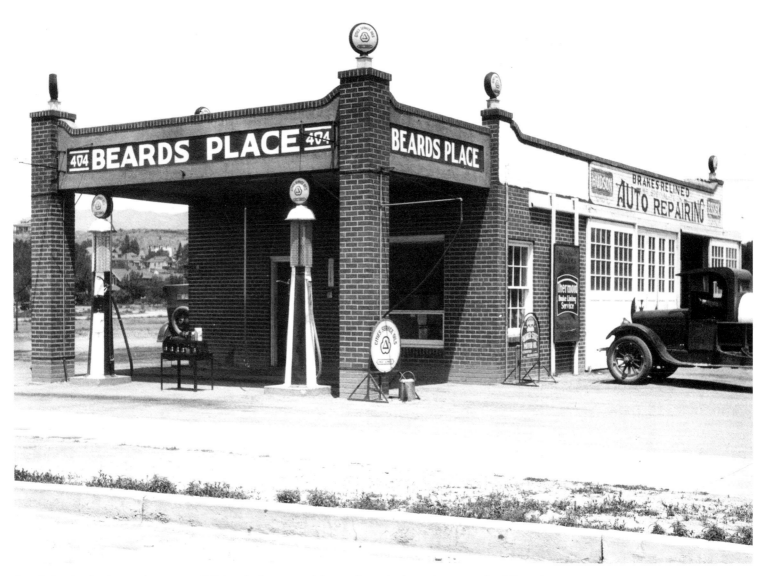

Beards Service Station at the corner of Colorado Avenue and Spruce Street is shown here open for full-service business. The station was located on the site of the 1916 prizefight between Charlie White and Freddie Welch during which bleachers holding 500 spectators collapsed.

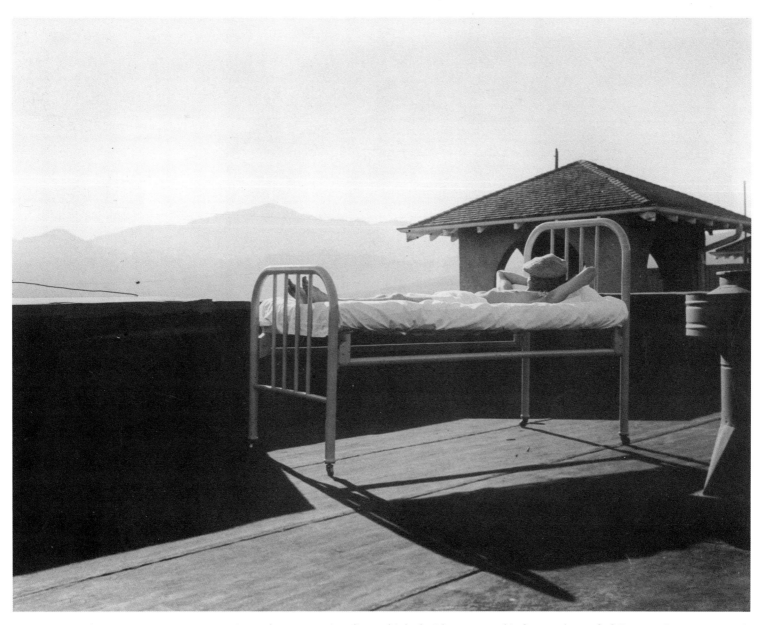

Around 1920, a patient lies on his bed with a cap over his face on the roof of Cragmor Sanatorium, with Pikes Peak visible in the background. He is taking a sunbath.

CHANGING TIMES

(1920–1939)

The years between the world wars offered good times for the city and bad. The Pikes Peak Hill Climb continued to draw onlookers. George Stokes ran a chili counter on Pikes Peak Avenue so popular that he had difficulty managing the crowds, and the Venetucci family raised pumpkins, offering free specimens to area schoolchildren willing to come pluck them from the fields. On New Year's Eve 1922, a group of five intrepid adventurers made an ascent up Pikes Peak to found the AdAmAn Club, which has repeated the exploit every year since, setting off fireworks at the summit visible from a hundred miles away.

Eight hundred tons of gold ore a day were still being processed by the Golden Cycle Mill. The Manitou Mineral Water Company bottled and marketed the spring waters there, touted for their mineral content and associated healing properties. Van Briggle Pottery continued creating its prized ware, and the Cheyenne Mountain Zoo was founded by Spencer Penrose, becoming the highest altitude zoo in the United States. Auto parks, forerunners of the motor hotel (motel) offered tent camping to tourists visiting the area, and shredded wheat, invented by the Colorado Springs Cereal Food Company in the late 1890s, was popular on breakfast tables everywhere.

The year 1929 is well known for the stock market crash on Wall Street. Colorado Springs was not immune to the effects of the Great Depression, which followed. Tourism plummeted and, though the Golden Cycle Mill continued processing a little ore until 1940, the gold business flattened out. To add to the mischief, nature found other ways to chastise the town. A 1935 flood hit businesses and individuals hard. People drowned, bridges washed away, and two hundred blocks of town were under water. Franklin Roosevelt's New Deal policies offered respite. Members of the Civilian Conservation Corps, one of the organizations formed to create jobs for out-of-work Americans, undertook numerous building projects in the region. And over at the City Auditorium, the Salvation Army distributed food to the needy at Christmas time.

Colorado Springs weathered the worst, biding its time. The region still beckoned to Americans and the hardier still came to climb the mountains and build the city—a shining example of which was the opening of the Fine Arts Center in 1936. A great park system bequeathed by General Palmer and others, colleges and universities, an invigorating climate, and other amenities together constituted a great foundation. The coming of World War II would yield victory for the United States and postwar prosperity for Americans.

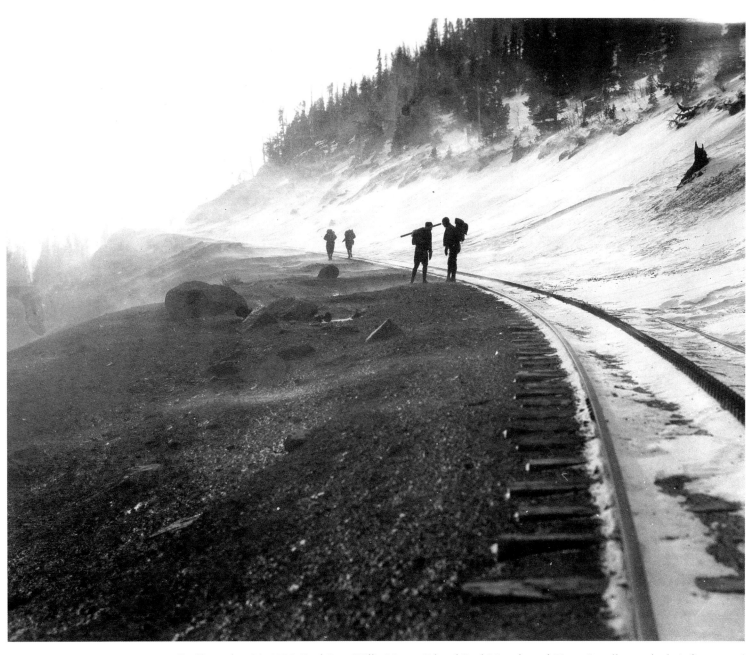

On December 31, 1922, Fred Barr, Willis Magee, Ed and Fred Morath, and Harry Standley made their first annual climb up Pikes Peak. These five are the founders of the AdAmAn Club, which has climbed Pikes Peak every New Year's Eve since 1922, setting off fireworks when it reaches the summit. Standley was the official photographer of the group as well as a member. Four of the five are shown here following the cog railroad track, while the fifth (Standley) takes the photograph. Each year one new member is added to the group.

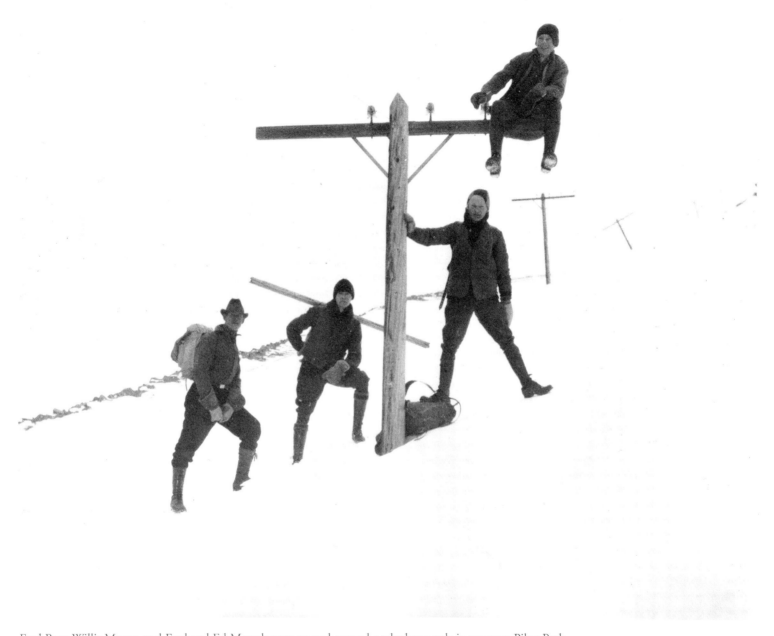

Fred Barr, Willis Magee, and Fred and Ed Morath pose on and around a telephone pole in snow on Pikes Peak, while Harry Standley records this image of the ascent.

This patient at Cragmor Sanatorium is recovering from tuberculosis. She flourishes a cigarette holder. These devices served both as fashion statements and as practical tools, holding a filter for the smoker in the days before filtered cigarettes were manufactured. Smoking was permitted in TB facilities of the era.

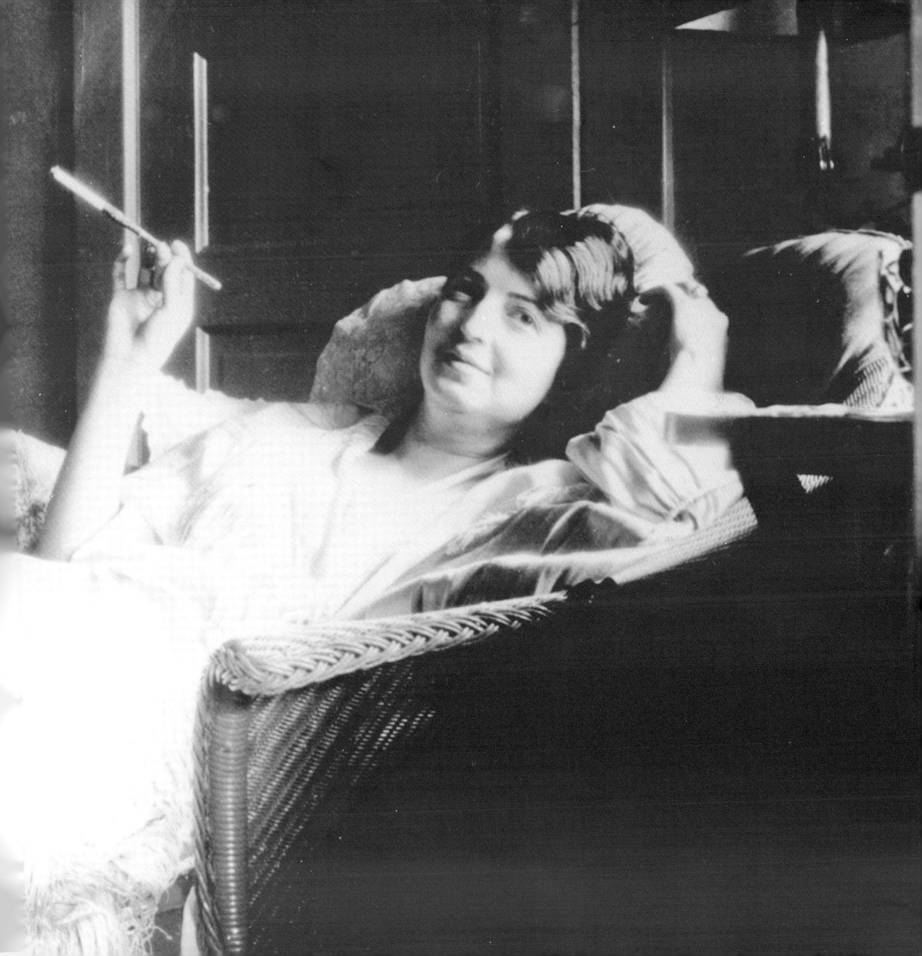

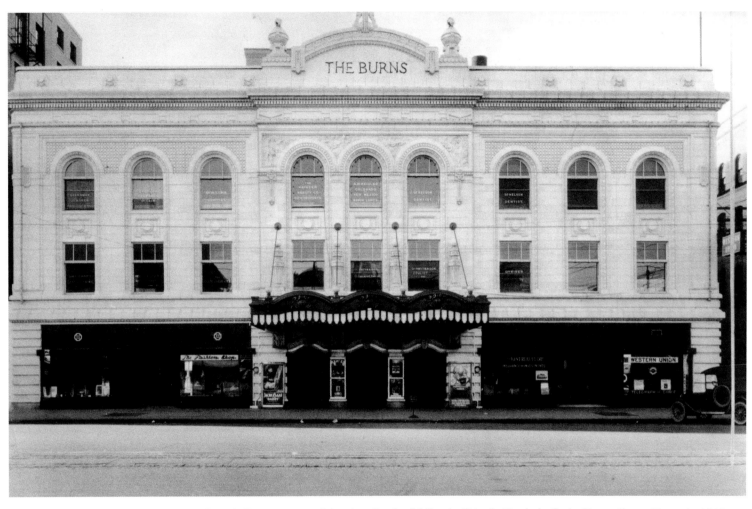

Jimmie Burns, owner of the giant Portland Mine in Cripple Creek, built the Burns Opera House in 1912 at a cost of $500,000. The Pikes Peak Avenue landmark is shown here in 1921.

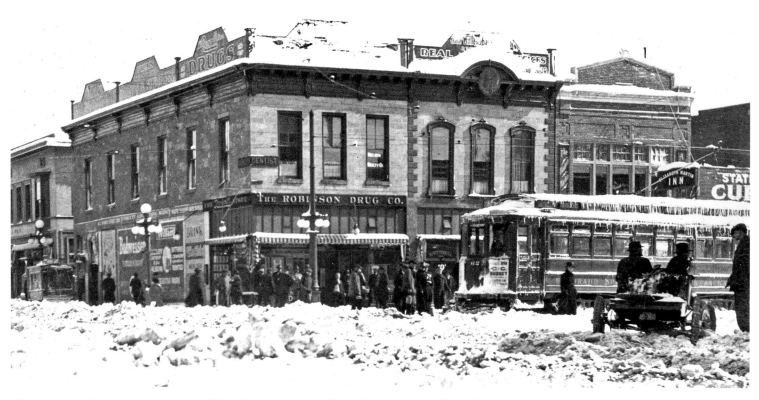

This is a view of the northeast corner of Pikes Peak Avenue and Tejon Street known as "Busy Corner," following the April 1921 snowstorm which dropped 15 to 20 inches of the white stuff on the area. "Meet me at Busy Corner" was a phrase commonly heard among early residents, some of whom are shown here boarding a snow and ice covered streetcar in front of the Robinson Drug Company.

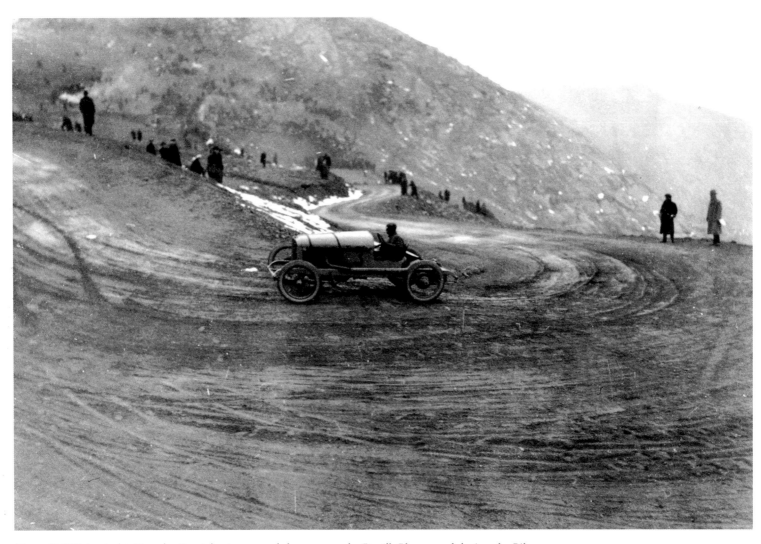

Henry F. O'Brien in his Templar Special spins around the curve at the Devil's Playground during the Pikes Peak Hill Climb in 1920. He finished eighth in the race. Templar Motors Corporation out of Lakewood, Ohio, made three types of autos—a sedan, a touring car, and two sporty versions. In business from 1917 to 1924, Templar produced a total of 6,000 units during its brief existence.

This two-lane wooden bridge was part of Highway 85-87 to Denver as it appeared around 1920. Cheyenne Mountain is visible in the background. Interstate 25 later replaced Highway 85-87 as the main route north.

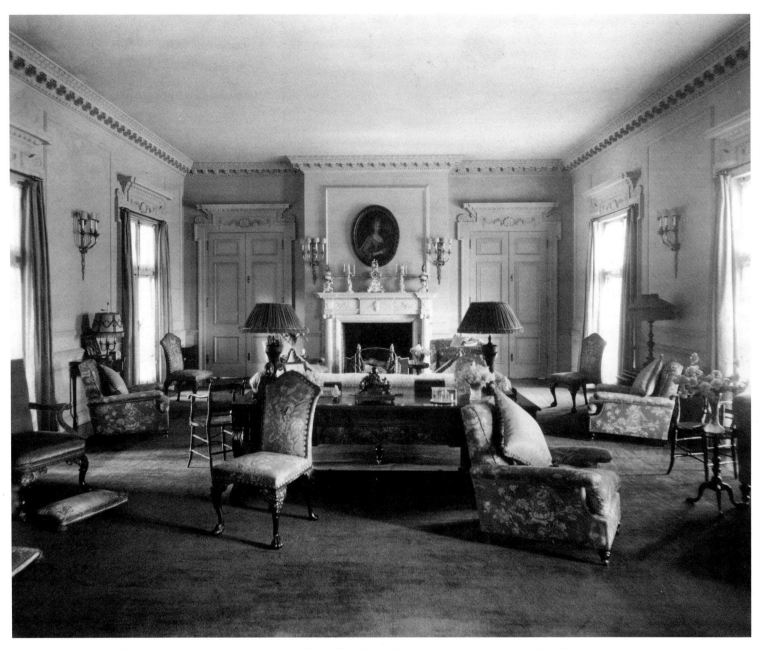

When gold tycoon and philanthropist Spencer Penrose and his wife Julie decided to move closer to their beloved Broadmoor Hotel, they chose as their home El Pomar, an estate below Cheyenne Mountain. This rectangular room has a fireplace flanked by two double doors, ornate plaster door, window, and cove molding. Many celebrities have visited in this home including President and Mrs. Calvin Coolidge, who spent their summer vacation at El Pomar.

Toddler Georgia Jean Southcotte sits in a child's wagon around 1922 in front of the Capitol Crispette Shop, possibly the old log cabin that housed the El Paso County office around 1869.

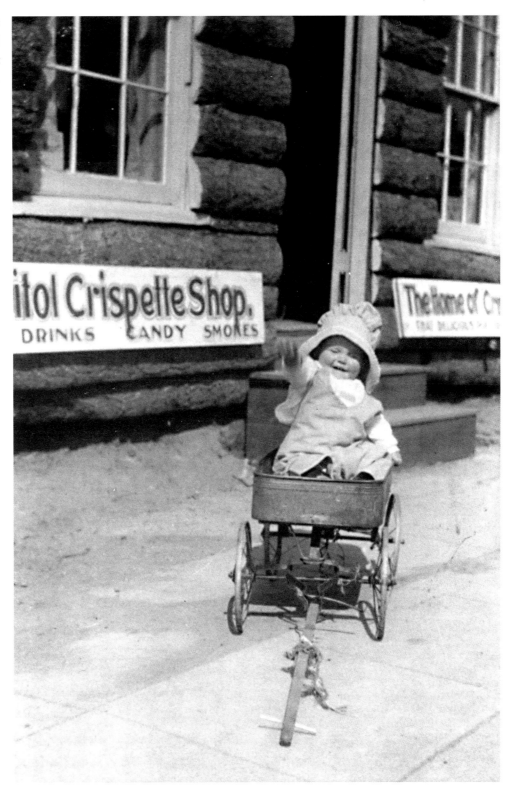

The year this image was recorded, Austin Bluffs Road was only a rutted path of dirt. The bluffs are visible in the background. On the left are several "powder houses" where blasting powder was stored. Today the road is a multi-lane parkway.

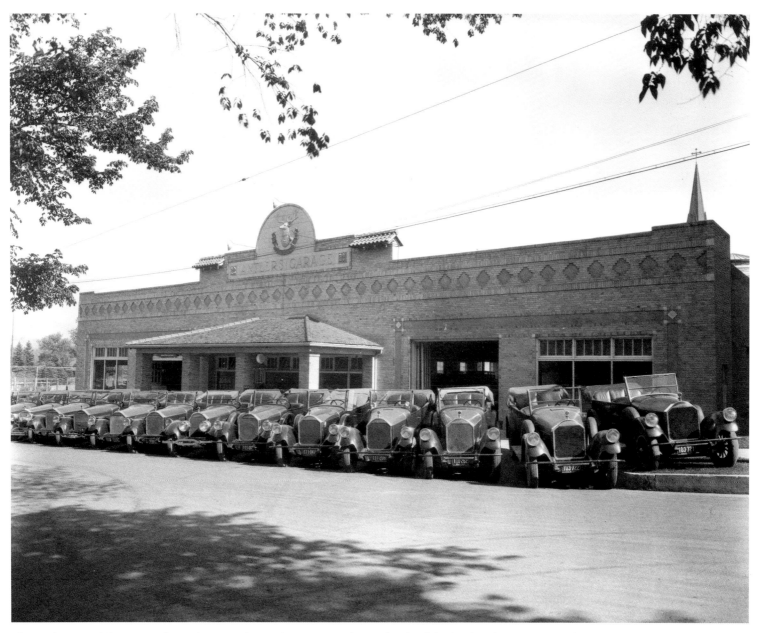

The Antlers Hotel Garage was located across Pikes Peak Avenue on the north side of the hotel. When the new Colorado Springs library and parking lot were built, the garage was demolished, but its facade, with bas-relief deer emblem made of Van Briggle tiles, was saved and used as the entrance to the library parking lot.

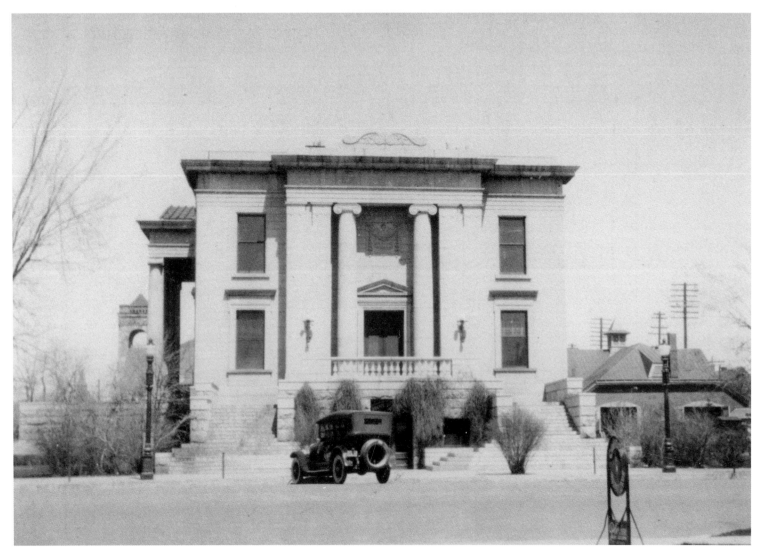

Colorado Springs City Hall is located on the northeast corner of Kiowa Street and Nevada Avenue. It sits on land purchased from the Methodist Church Association with money borrowed from W. S. Stratton in 1902. Originally, City Hall included a jail in the basement. It has recently been remodeled and remains an impressive structure in the downtown area.

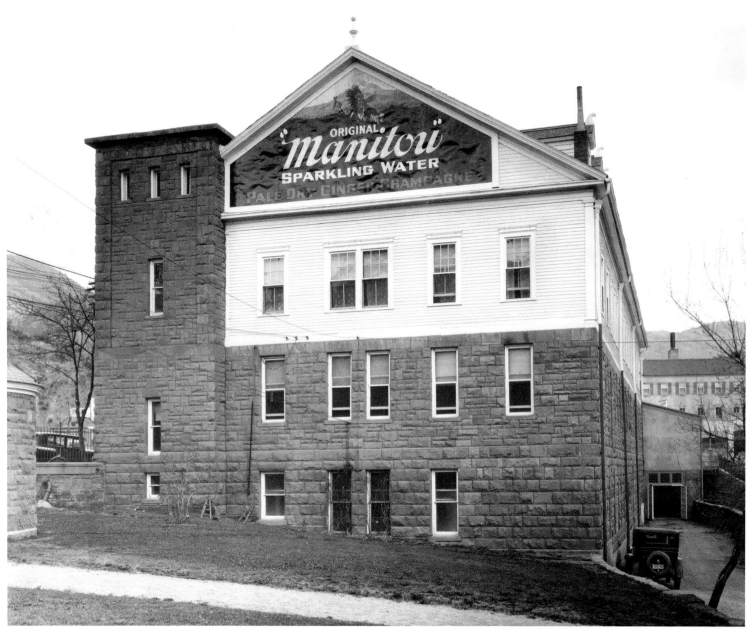

This is the Manitou Mineral Water Company building as it appeared in 1926. The company bottled and marketed the naturally carbonated mineral waters common to the area. It offered two internationally known specialties—Manitou Table Water and Ginger Champagne.

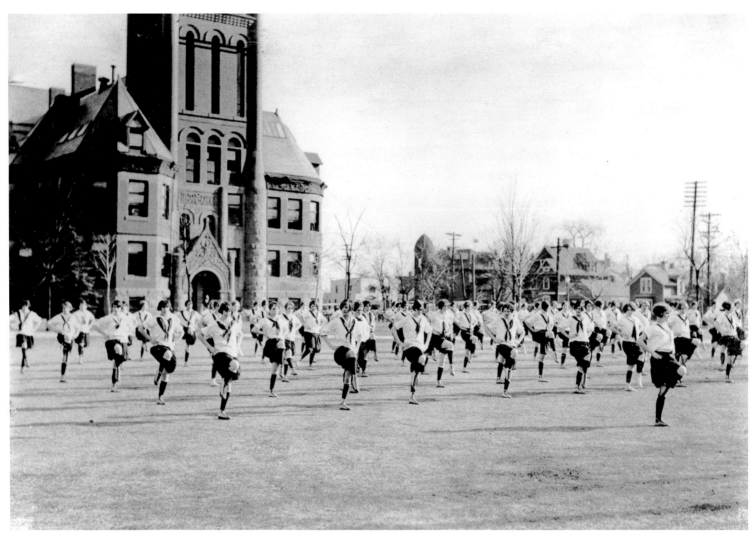

Students in gym uniforms exercise in the field at Colorado Springs High School at the corner of Nevada and Platte avenues in 1927. They are dressed in 1920s-style exercise clothing—white blouses with dark ties and dark bloomer pants. The old Colorado Springs high school was demolished in 1938 and rebuilt in a more modern style the next year.

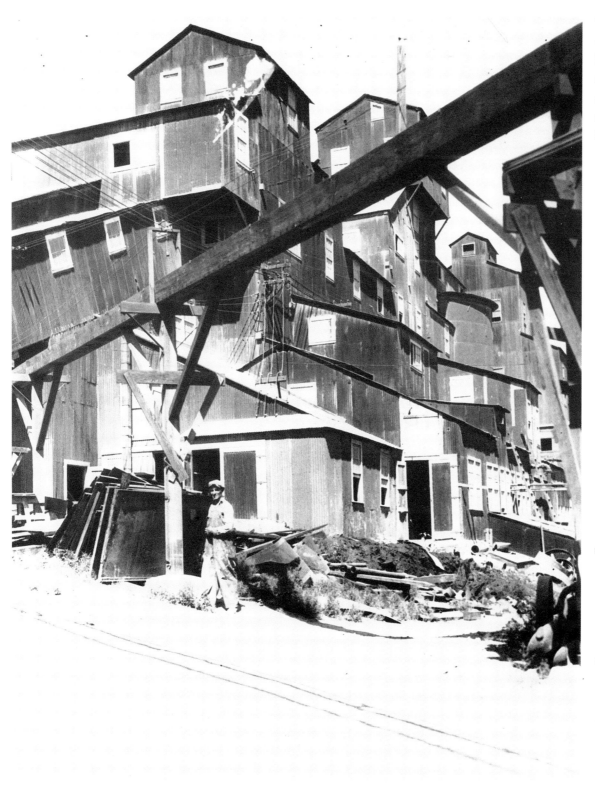

The comminuter building at the Golden Cycle Mill complex housed a machine that shredded and pulverized waste materials. The man standing at front helps convey the immense size of the building.

Following Spread: Gold was discovered in Cripple Creek in 1890, following which the need arose for facilities to process the ore. Five reduction mills grew up in Colorado City, the Golden Cycle the largest among them. From 1908 to 1949, this mill processed 800 tons of ore a day and was the largest employer in Colorado City. Coal to run the mill came from the Golden Cycle mines in present-day Rockrimmon. All that remains of the mill is a large smokestack. A residential development is under construction in the area.

129

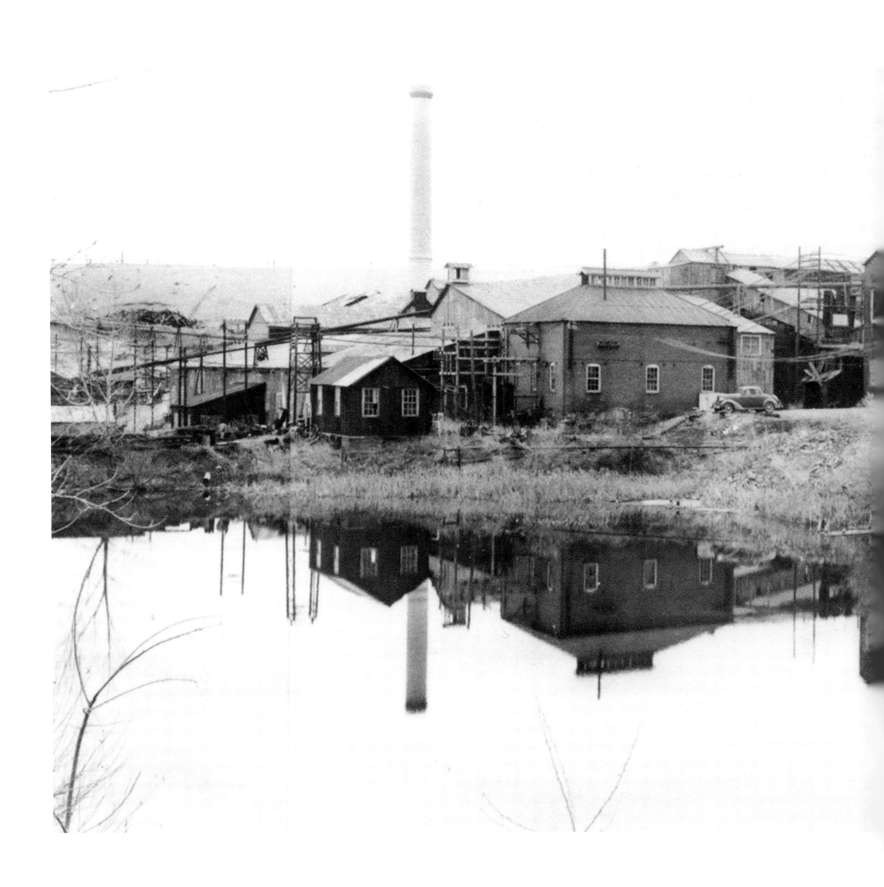

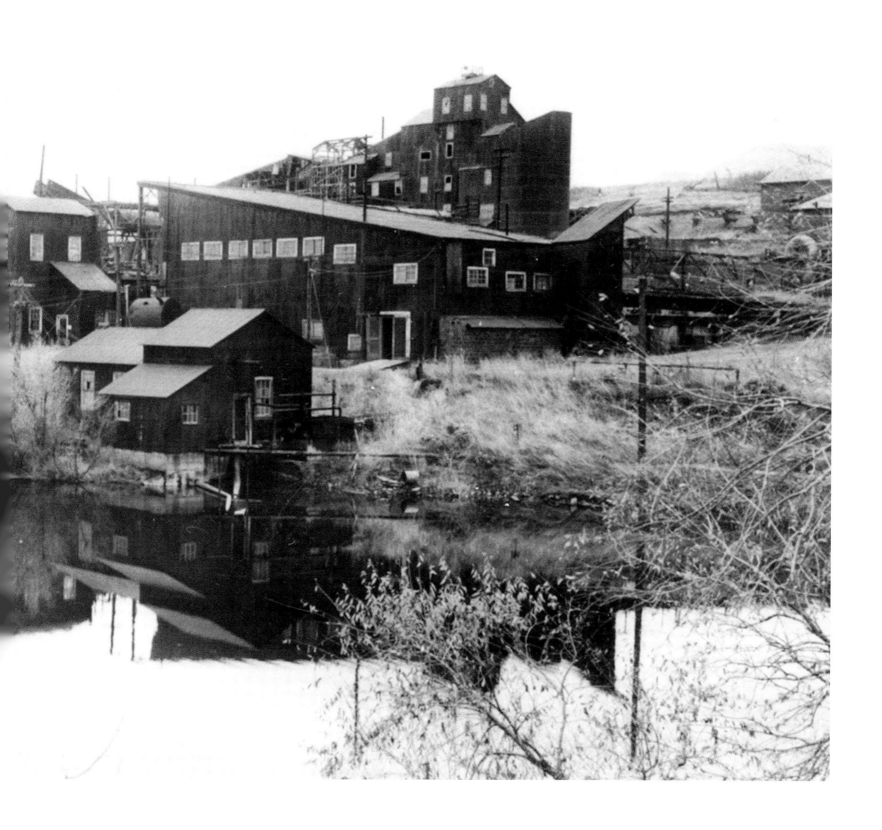

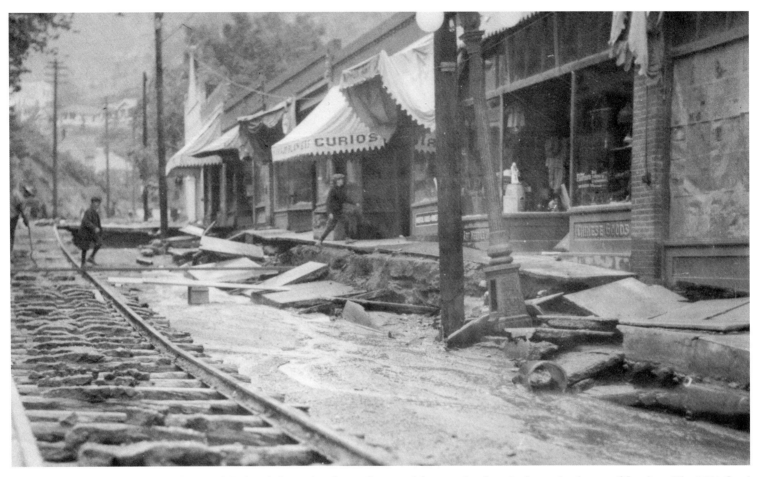

Because Manitou is located at the confluence of three creeks, there is always the danger of flooding. The 1921 flood was particularly hard on the tourist resort. A local newspaper reporting on the event declared that a flash flood had "thundered down Williams Canyon, west of Manitou." In order to reach storefronts, the children shown here must cross buckled sidewalks and exposed streetcar tracks.

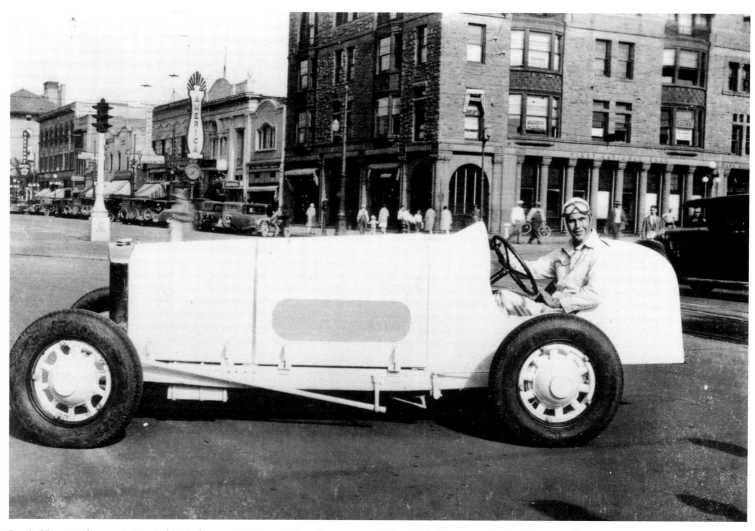

Louis Unser is shown sitting in his Coleman FWD Special at the corner of Pikes Peak Avenue and Tejon Street in downtown Colorado Springs during Pikes Peak Hill Climb race week activities in 1930. A caption accompanying the original photograph quips, "Did I take the wrong turn?" Three Unsers regularly participated in the "Race to the Clouds."

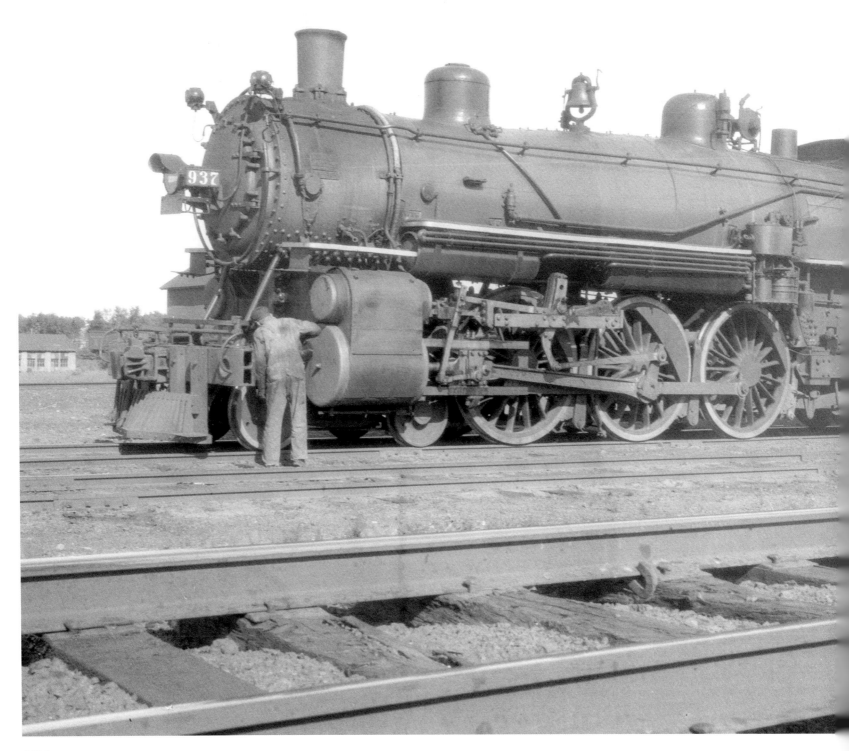

The Chicago, Rock Island, and Pacific Railroad (shortened to Rock Island) started building from Topeka, Kansas, toward the Rocky Mountains in 1888. When the railroad decided to make Colorado Springs their western terminus, the town erupted in celebration. This 1929 photograph shows coal-fired steam engine #937, a 4-6-2 wheel, on the tracks.

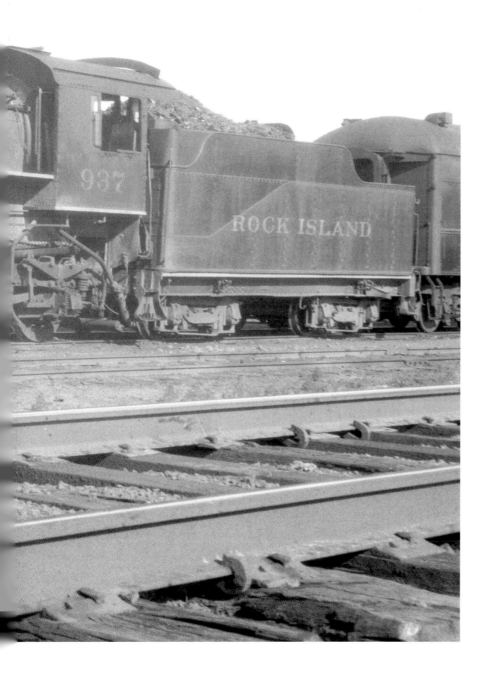

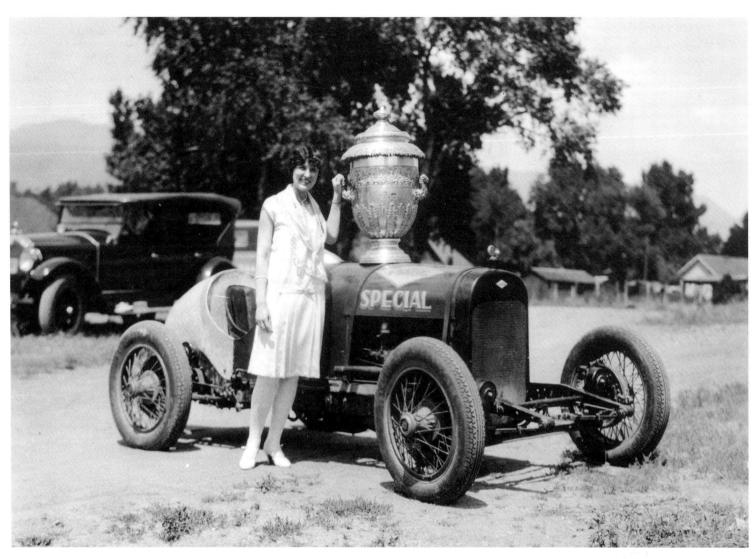

Princess Power of the Pikes Peak Hill Climb is seen with the Penrose Trophy around 1931, standing beside a Paige Special racecar. The trophy is named for Spencer Penrose, who established the automobile race in 1916. Many famous drivers have been attracted to the race including Barney Oldfield, Rick Mears, Parnelli Jones, Mario Andretti, and several Unsers.

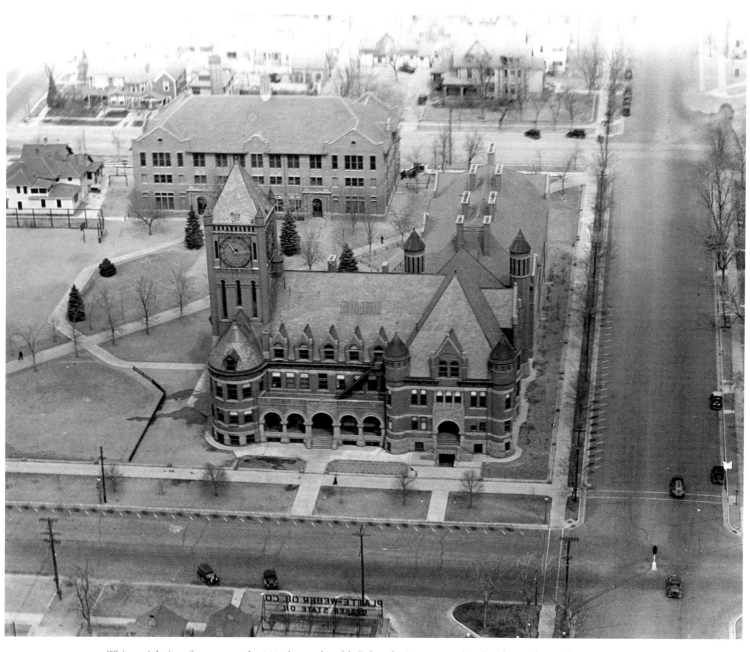

This aerial view from around 1930 shows the old Colorado Springs High School once located at Nevada and Platte avenues. The beautiful building opened in 1895 but was razed in 1938 to make space for a new school. Overcrowding forced School District 11 to build a second high school in 1959 (Wasson High School), and Colorado Springs High School changed its name to Palmer High School in honor of the General. Even today, the school's letters are "CS," in honor of the old name.

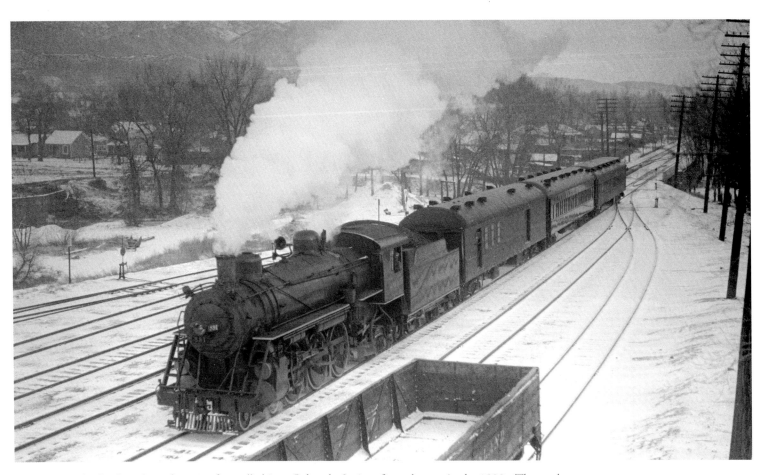

Chicago, Rock Island, and Pacific trains first rolled into Colorado Springs from the east in the 1880s. The tracks paralleled present-day Highway 24. The towns of Ramah, Calhan, and Peyton grew up along the route. This is engine #891 pulling the Rock Island's Colorado Express in 1931.

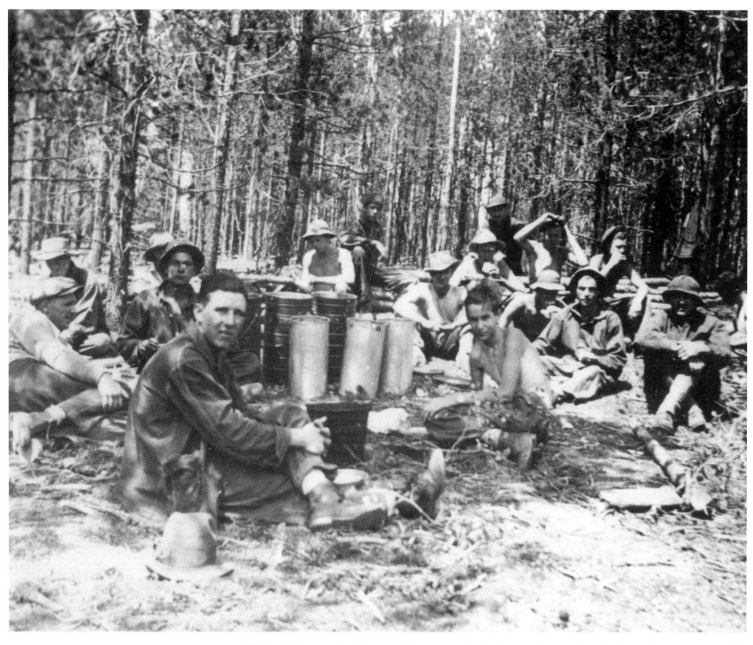

Civilian Conservation Corps workers are resting in the woods sometime in the mid-1930s. During the years of the Great Depression, Franklin Roosevelt's CCC built many trails, stone walls, bridges, and flood control systems in the Pikes Peak region.

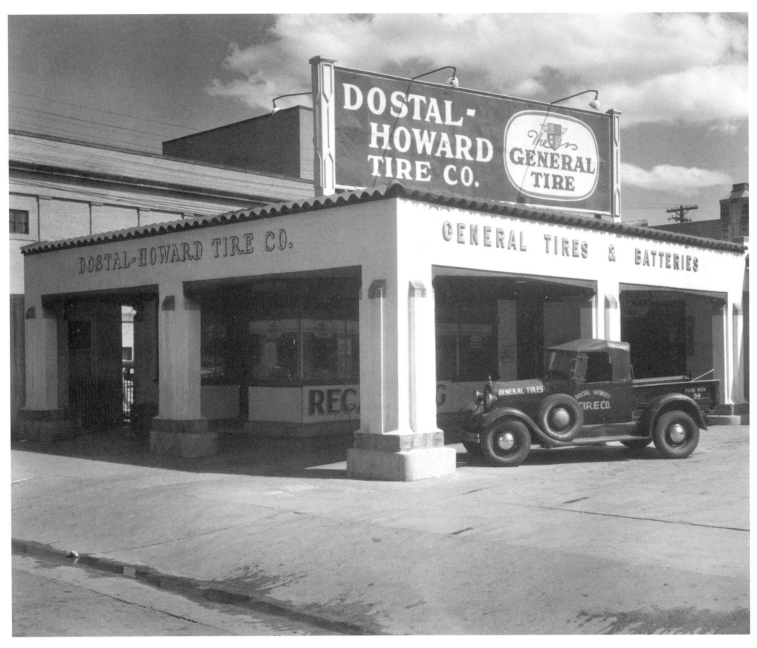

Shown here in the 1930s, the Dostal-Howard Tire Company did business at 211 East Kiowa Street. Typical of many businesses catering to motorists in the early years of the automobile, the Dostal-Howard building features distinctive architectural detailing—prominent here is its arcaded shelter with terra-cotta trim.

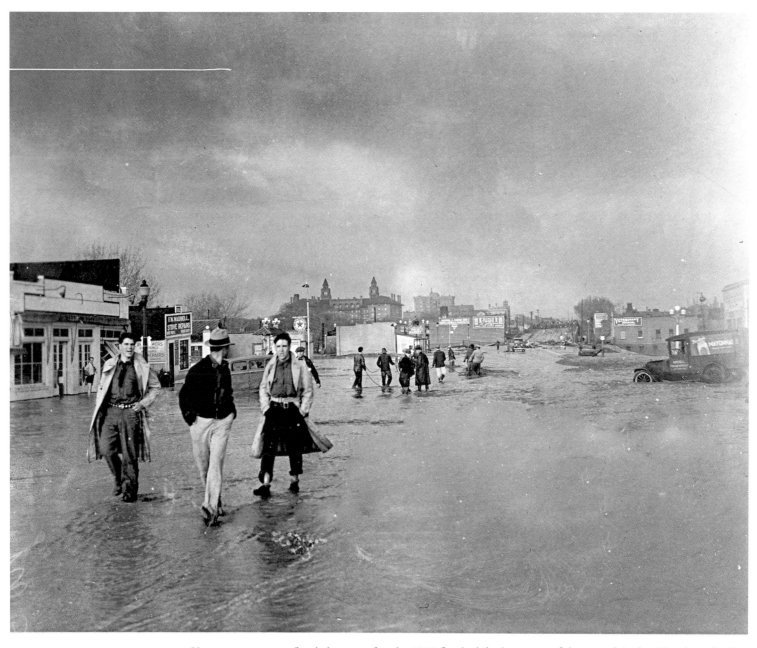

Young men traverse flooded streets after the 1935 flood while the towers of the second Antlers Hotel stand tall in the distance. One of the vehicles to the right is up to its axles in water on West Colorado Avenue as men with a rope attempt to reach out to marooned motorists. The Memorial Day flood washed away buildings and bridges and parts of Monument Valley Park, killing a number of people.

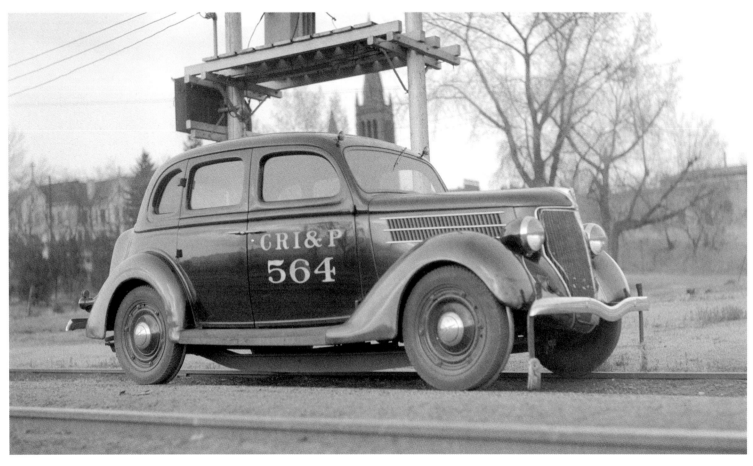

When the Chicago, Rock Island, and Pacific Railroad came from the east into Colorado Springs in the 1880s, the town enjoyed an economic boon. Shown here is Rock Island car #564 in 1936, a Ford sedan V-8 rigged to fit the tracks for use in rail inspections.

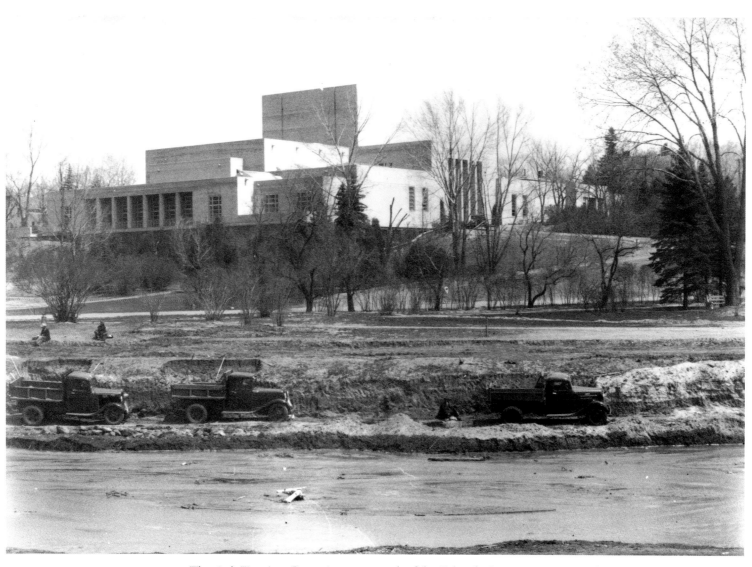

The city's Fine Arts Center is an outgrowth of the Colorado Springs Art Society. The Penrose and Taylor families helped establish the museum in 1936 on the site of the old Spencer Penrose home at 30 W. Dale. It houses an extensive collection of Native American and western art, a theater, and a concert hall. Monument Creek and Monument Valley Park are visible in the foreground in this image.

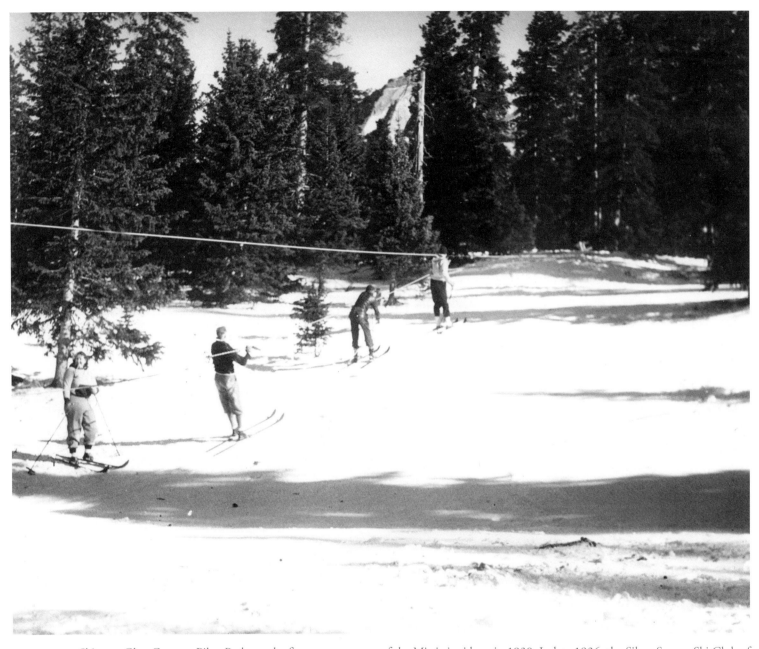

Skiers at Glen Cove on Pikes Peak use the first rope tow west of the Mississippi here in 1938. In late 1936, the Silver Spruce Ski Club of Colorado Springs moved their activities to Pikes Peak, offering a 300-yard slope and a ski school. In 1983, the Pikes Peak Ski area closed after many lean snow years, hefty expenses for maintenance, and competition from new Colorado resorts.

Russian immigrants named Lefkowsky built the Russian Arms Apartments in 1939 at 624 North Cascade Avenue. Originally planned as a home, the Lefkowskys configured the building into luxury apartments when money became short. It features decorative stone-and-brick arches and window openings, wrought-iron balconies, and tile ornaments. Today the building is called the Cascade Park Apartments and still operates as an apartment complex.

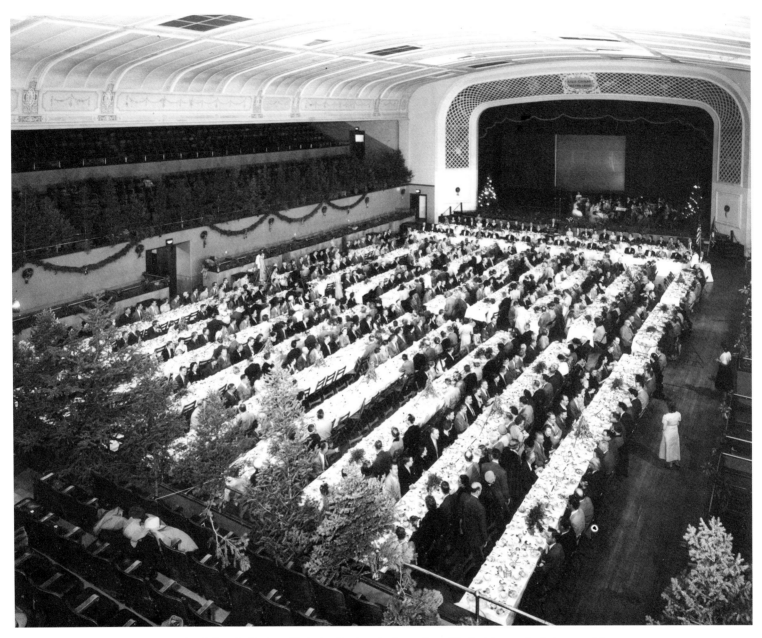

Built in 1923 as a concert venue, the Colorado Springs Civic Auditorium is shown here filled with people sitting at tables set for a lavish banquet. In recent years, the Pikes Peak Center and World Arena have hosted events that were once held here, while the historic Civic Auditorium has been used for graduations, flea markets, and small concerts. The auditorium includes a main floor and two balconies on three sides as well as a cafe and small theater.

THE MODERN ERA

(1940–1970S)

The attack at Pearl Harbor on December 7, 1941, changed America and Colorado Springs forever. Within days, the United States was in a world war and Colorado Springs was about to become a military town. On January 6, 1942, Camp Carson was born. The city purchased 5,500 acres of Cheyenne Valley Ranch south of Colorado Springs for an army post, constructing 1,300 buildings at a cost of $30,000,000. The municipal airport became Peterson Air Field, to be used as a base for training heavy bombers. There were two gravel runways, two hangars, one small lounge, and an administration building. Soldiers, aviators, and construction workers came. The Navy honored Colorado by commissioning a BB34 fighting ship as the USS *Colorado.* Two liberty ships honored pioneers—the *General William Palmer* and the *W. S. Stratton.*

Following the war, Ent Air Base was established, Peterson Air Field was renamed Peterson Air Force Base and provided its own facilities, and Camp Carson was upgraded to Fort Carson. Ent used the old Methodist Sanitorium for its activities. In the 1950s, Colorado Springs was chosen as the home of the premier training facility for Air Force officers—the Air Force Academy—from which the first class graduated in 1959. Cheyenne Mountain was hollowed out to make room for the North American Air Defense Command (NORAD).

The future looked bright for Colorado Springs as the postwar world began to unfold. Tourism was on the upswing and Americans were enjoying an era of peacetime prosperity far different from a decade of depression and a world war. For more than a hundred years, Americans in every decade had been called to the area to live their lives and play their role as United States citizens. Today, the city holds tightly to its colorful past while looking forward to what the future holds in store.

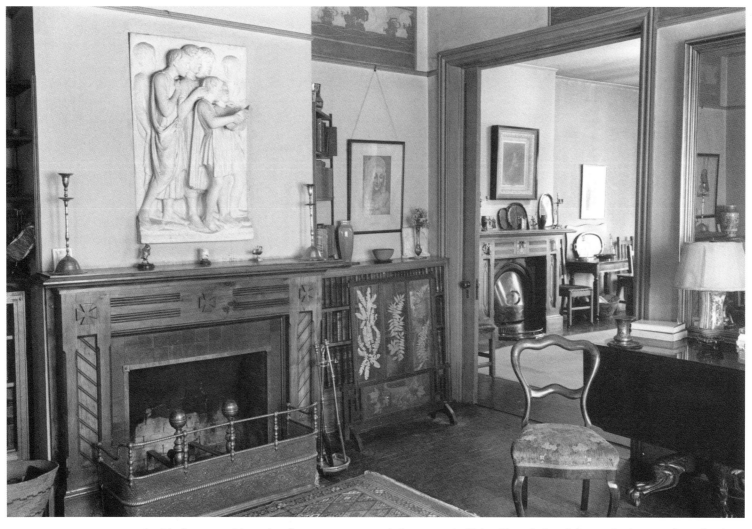

A wide doorway with pocket doors separates two sitting rooms in Helen Hunt Jackson's house. Both rooms have fireplaces with carved wooden mantels. A bas-relief sculpture is hanging on the wall above the fireplace at left. Several rooms from this lovely old home are on display at the Colorado Springs Pioneer Museum, saved before demolition of the structure.

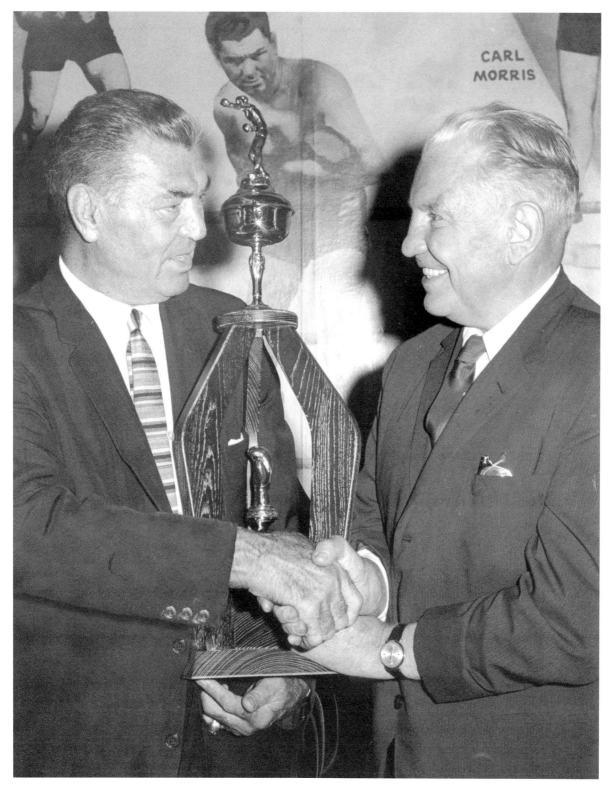

Boxer Jack Dempsey (at left) accepts the Foot Printer Award from Eddie Egan in Colorado Springs. Struggling to rise from an impoverished childhood, as a youth Dempsey worked the mines in Victor, Colorado, along with Lowell Thomas, the distinguished newspaperman. Discovering his talent for boxing, Dempsey went on to score 66 victories during a career of 84 professional fights. Spencer Penrose once invited him to train for several fights at the Turkey Creek ranch south of Colorado Springs.

Dr. Pepper Bottling Company employees in company khaki uniforms and ties hang a 1944 Dr. Pepper calendar on an office wall. The calendar features a woman in gardening togs and wide-brimmed hat relaxing against a wheelbarrow. Advertising art, especially from the 1940s and earlier decades, has long been a popular and widely collected bit of Americana.

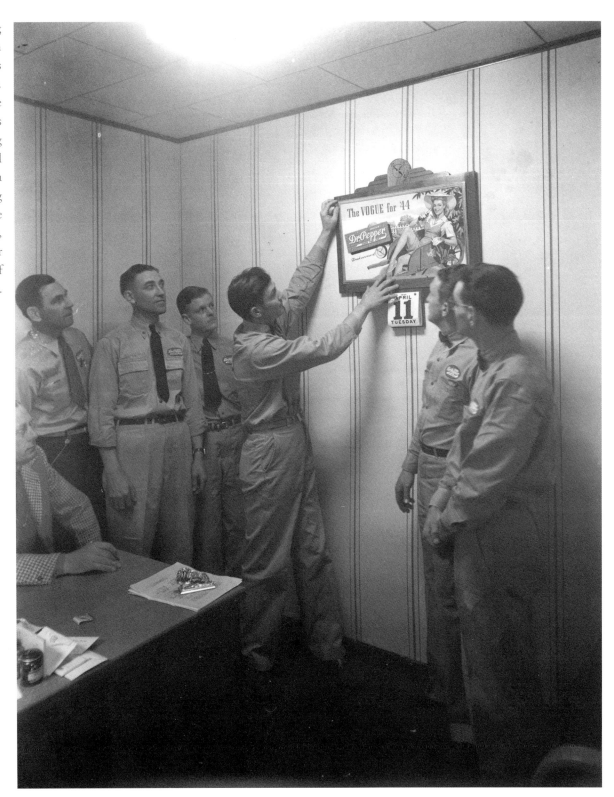

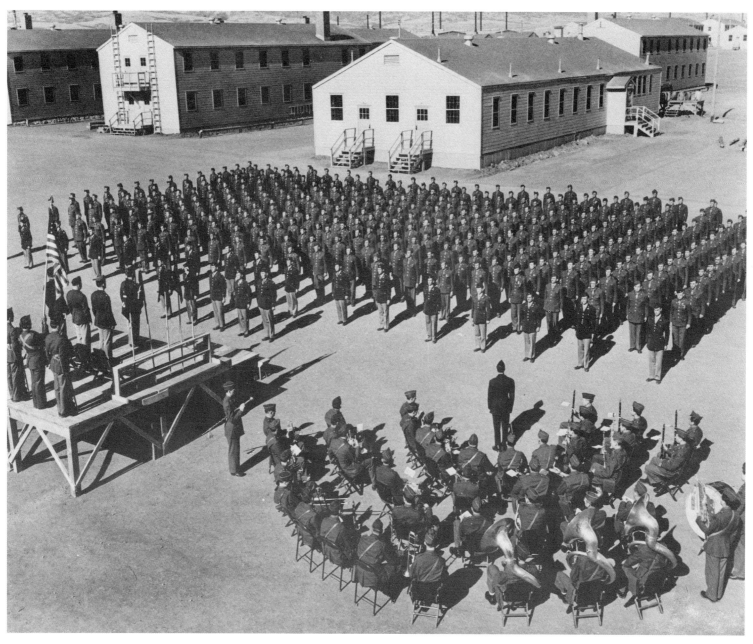

This War Department photo from the early 1940s shows the 122nd Infantry Greek Battalion receiving their company guidon at the conclusion of a ceremony at Camp Carson. The 353rd Infantry Regimental Band has assembled to play. The 122nd was an elite commando unit made up of American soldiers of Grecian ancestry who volunteered to fight on Greek soil during World War II. The casualty rate was extremely high.

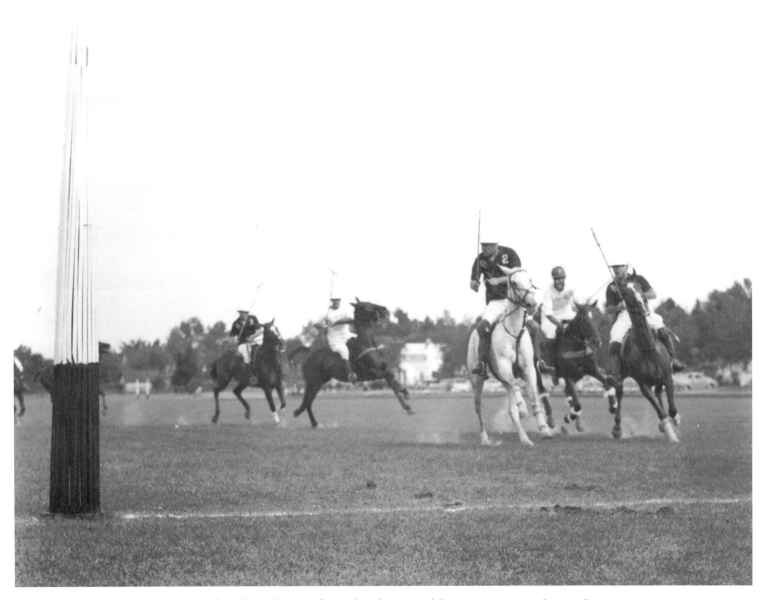

The Broadmoor was a great polo center from the early 1900s forward, with various club teams competing. Spencer Penrose established the Broadmoor Polo Association after World War I, building tournament and practice fields, a grandstand, and horse stables. Here riders play in the Broadmoor Gold Cup Finals in 1947. Concar Polo Club won the cup.

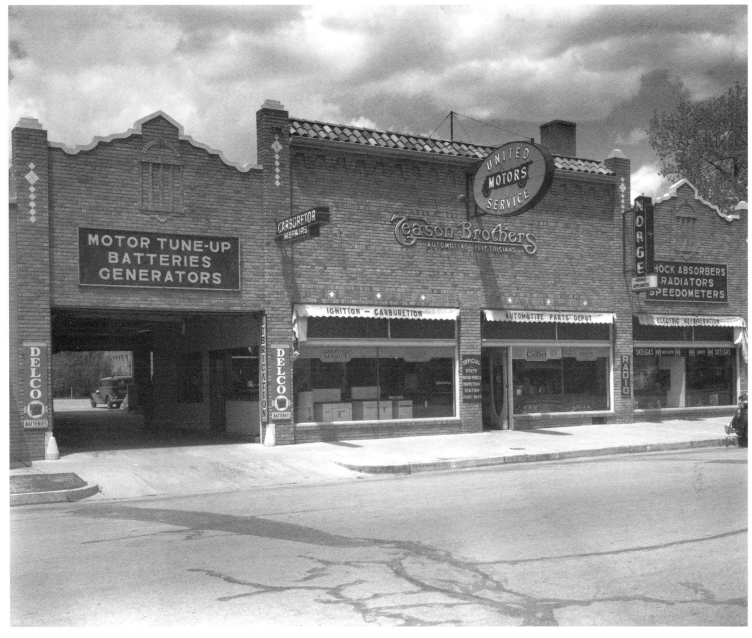

The Teason Brothers served the motorist's needs at 120-124 North Weber Street, including full-service automotive repair and a filling station, as well as a home appliance store. The brick storefront featured stone trim, pedimented flat roof, and a terra-cotta stepped cornice. Neon and hand-lettered signs advertised their services.

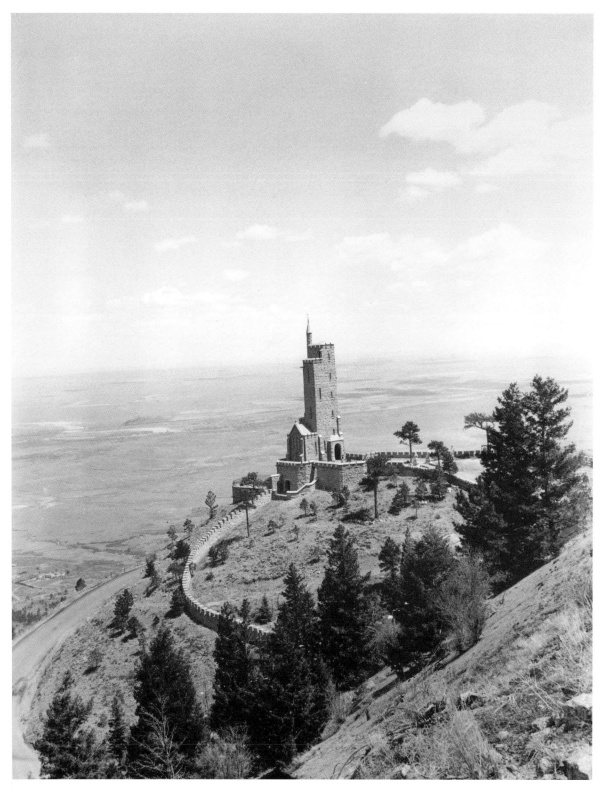

Commissioned by Spencer Penrose and dedicated to his friend Will Rogers, the "cowboy philosopher" who died in a plane crash in Alaska in 1935, the Will Rogers Shrine is located above the Cheyenne Mountain Zoo near the Broadmoor Hotel. Featuring Westminster chimes, a vibraharp, crenellated walls, and a turret, its 80-foot tower is constructed from a single boulder of local pink granite. Spencer and Julie Penrose are interred beneath the chapel floor.

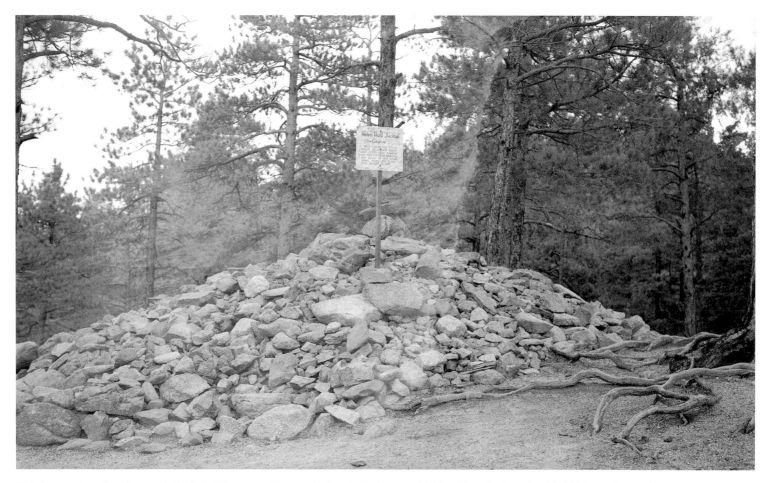

This large cairn of rocks on a hillside in Cheyenne Canyon is the original grave of Helen Hunt Jackson (1831-1885), author and Indian activist. The grave was moved to Evergreen Cemetery because pilgrimages made by increasing numbers of visitors were despoiling the wilderness area.

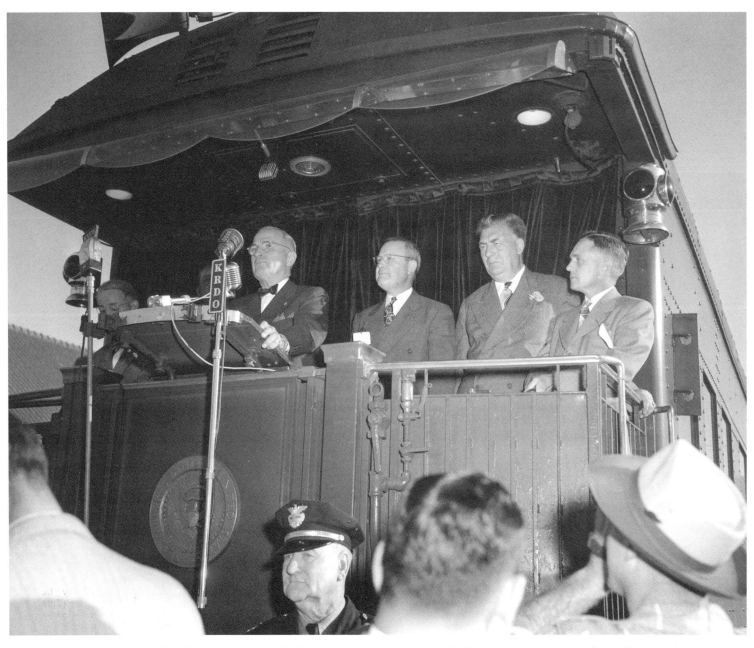

President Truman delivers a whistle-stop campaign speech in 1948 from the observation platform of his presidential railroad car. The two microphones at front are for "KVOR" and "KRDO," two local radio stations. On the platform with Truman are Governor Knous, Louis Poe, Senator E. C. Johnson, and John Marsalis of Pueblo.

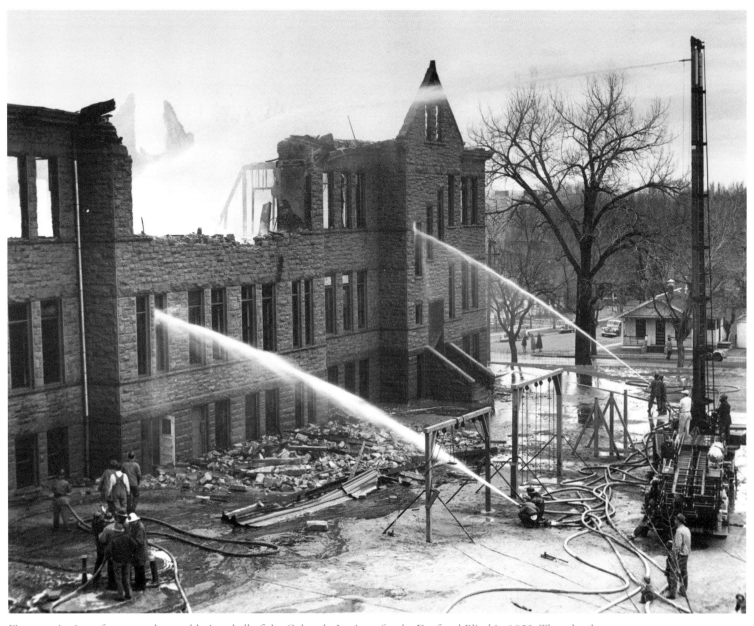

Firemen aim jets of water at the smoldering shell of the Colorado Institute for the Deaf and Blind in 1950. The school was rebuilt and today continues as a school for the deaf and the blind.

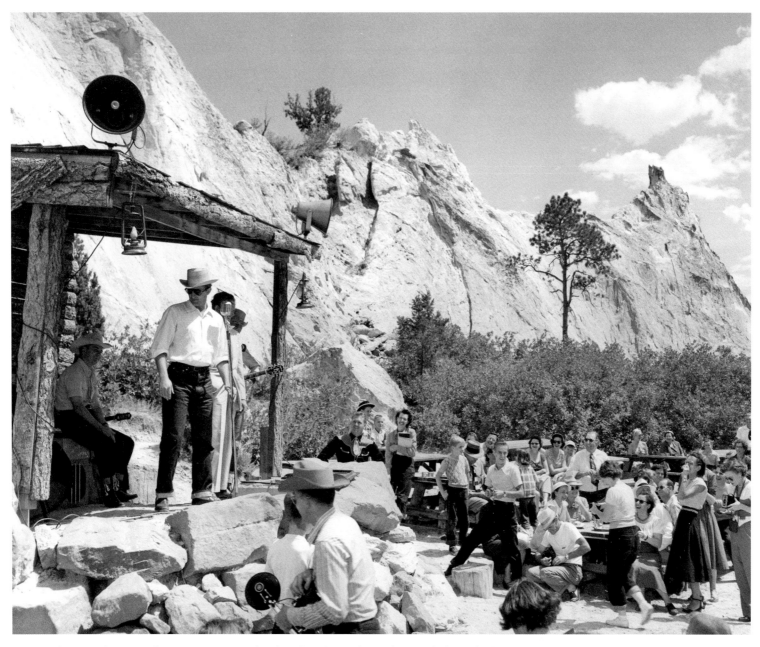

Actor Robert Mitchum stands on a rustic stage of rock and timber in front of a crowd of people sharing a meal at the Jaycee Chuck Wagon Dinner in the Garden of the Gods in 1952. Three men, including two with guitars, share the spotlight with him. Mitchum was in Colorado Springs for the premiere of his movie *One Minute to Zero*.

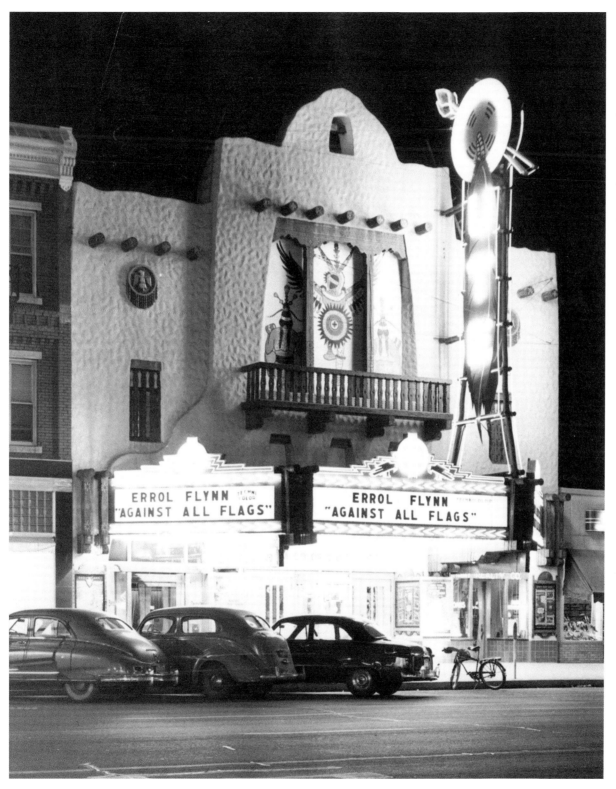

Located at 126 E. Pikes Peak Avenue across the street from the Peak Theatre, the Ute Theatre was built in 1935. *Against All Flags* starring Errol Flynn was playing here when this photo was taken in 1952. This night view focuses on the Ute's distinctive neon lighting. The Ute fell victim to urban renewal following a decline in ticket sales.

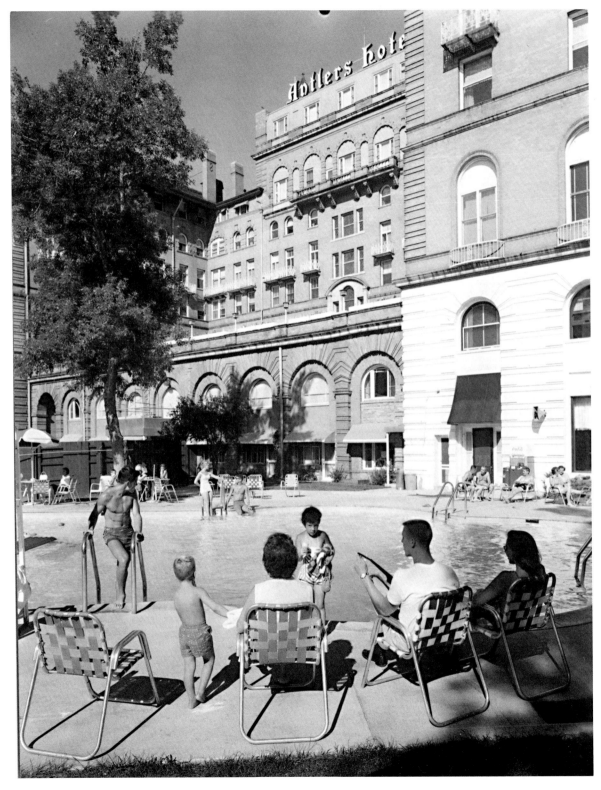

People lounge in outdoor chairs around the swimming pool at the second Antlers Hotel in the 1950s. This view shows the west side of the building.

Ski Broadmoor operated from the 1940s to the 1980s. Situated below Cheyenne Mountain, it offered only two to three slopes served by one chair lift and appealed mostly to beginners. The glass front building held a restaurant and ski shop. The recreational area closed when natural snowfall declined and financial difficulties rose. The lifts were removed but the bare runs are still visible from the city.

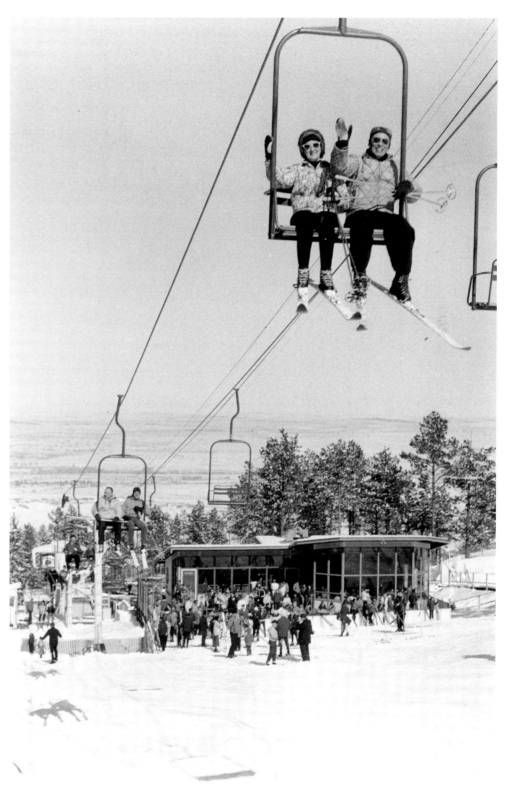

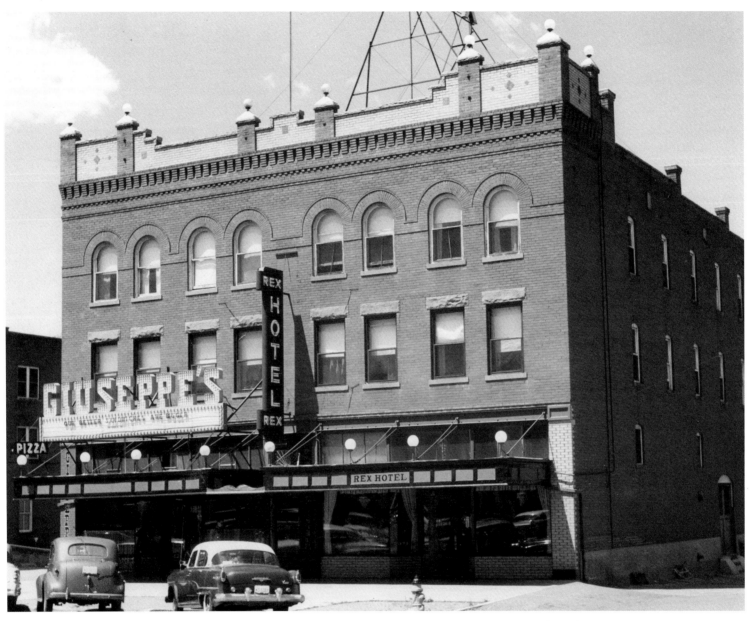

This large, brick building with a marquee over the entrance stands at 120 S. Cascade Avenue in the 1950s. It housed the Rex Hotel and Giuseppe's Restaurant, where "our better sandwiches are bigger." The Rex Hotel fell to urban renewal in the 1960s. Giuseppe's now occupies the old Denver and Rio Grande station west of the Antlers Hotel.

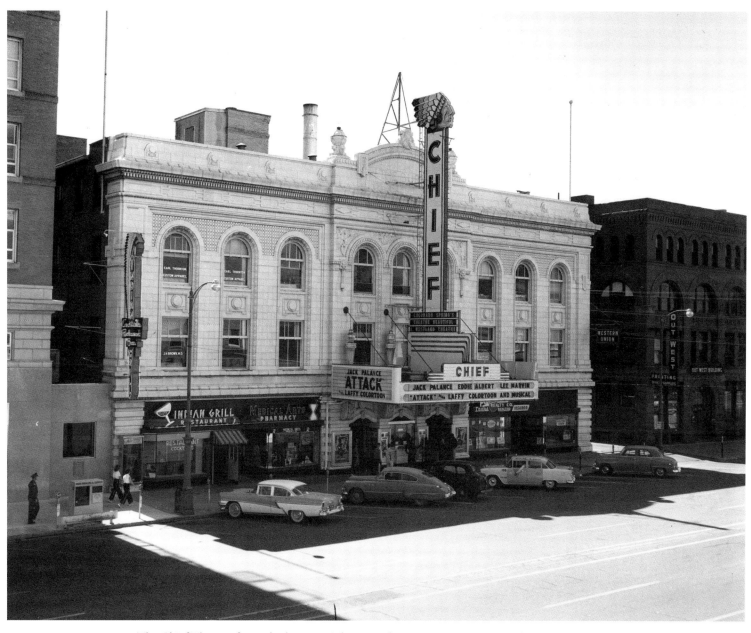

The Chief Theater, formerly the Burns Theatre and Burns Opera House, was located on E. Pikes Peak Avenue. *Attack,* with Jack Palance, Eddie Albert, and Lee Marvin, is playing at the theater here in the 1950s. Also in the Burns Building were the Indian Grill and the Medical Arts Pharmacy. The Burns would be razed in the 1970s.

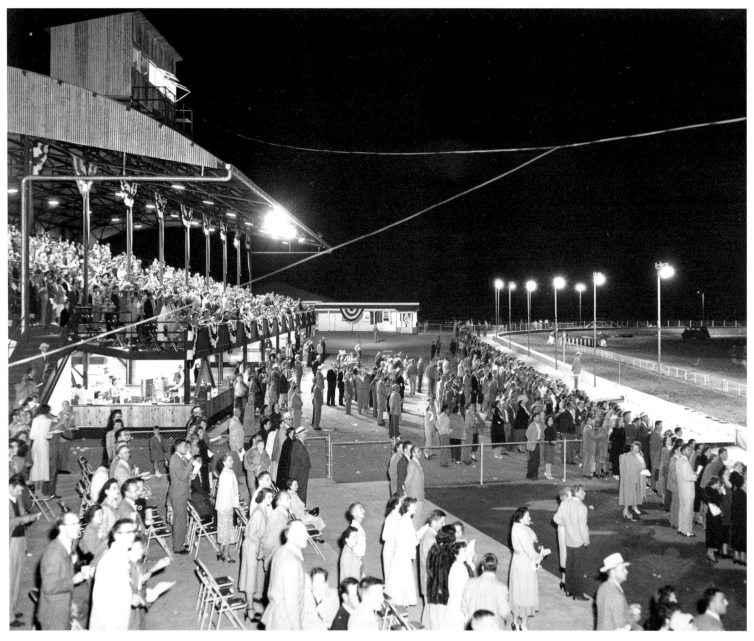

Rocky Mountain Greyhound Park was a busy evening attraction on North Nevada Avenue, offering live greyhound dog races. Crowds are watching a race from the railings and grandstand here in the 1950s.

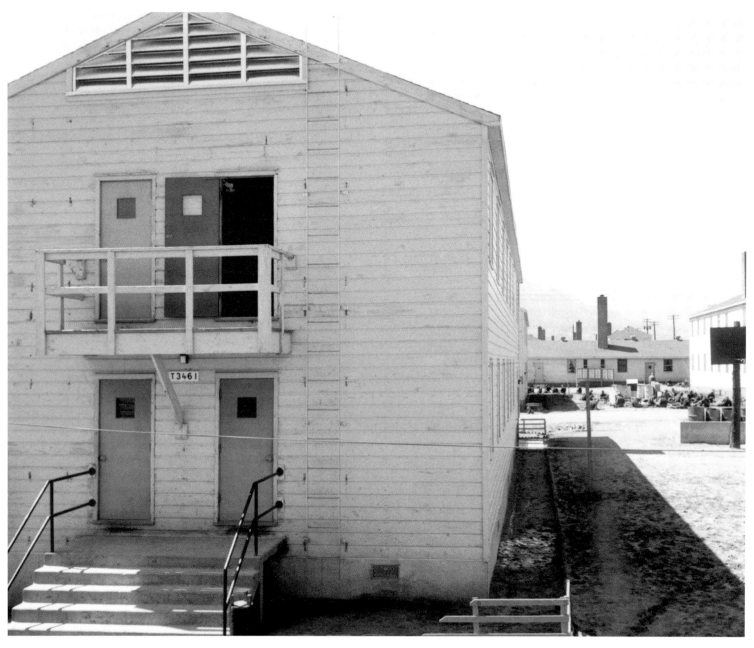

This two-story clapboard building at Camp Carson, named for pioneer Kit Carson, once housed Army troops. The post was upgraded in 1954 to "fort" status. The wooden barracks were later replaced with sleek, modern, brick buildings. The population at Fort Carson today numbers between 15,000 and 20,000 service personnel.

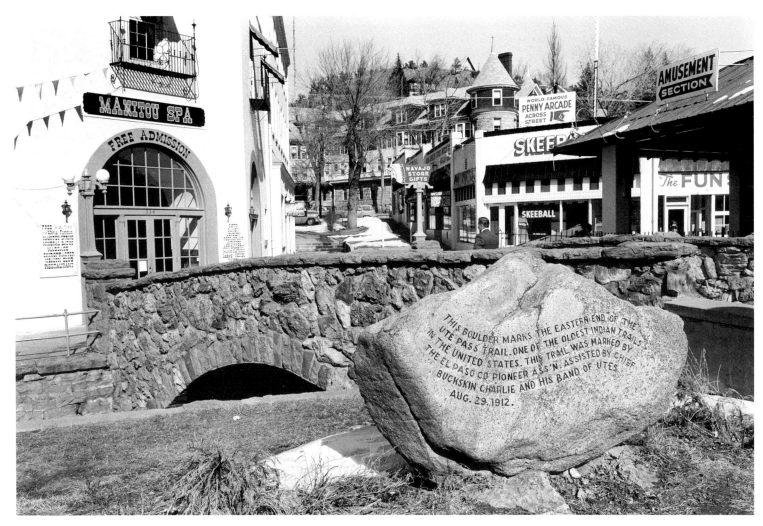

A large boulder beside the stone bridge in front of the Manitou Spa bears the inscription, "This boulder marks the eastern end of the Ute Pass Trail." The Pioneer Association placed the marker with the help of Chief Buckskin Charlie and fellow Utes during the Shan Kive celebration at the Garden of the Gods in 1912. Today, the "world famous" Penny Arcade, at top-right, still occupies the talents of pinball wizards, and at least one of its attractions is still only a penny a play.

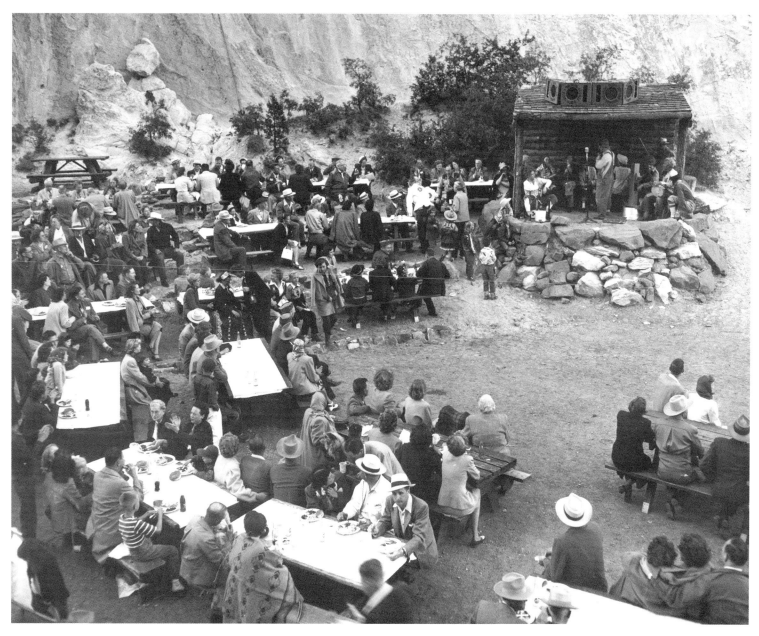

Guests enjoy dinner and entertainment at a picnic grounds in the Garden of the Gods during the 1950s. The Jaycees sponsored these tourist dinners. Today a large new parking lot occupies the same location.

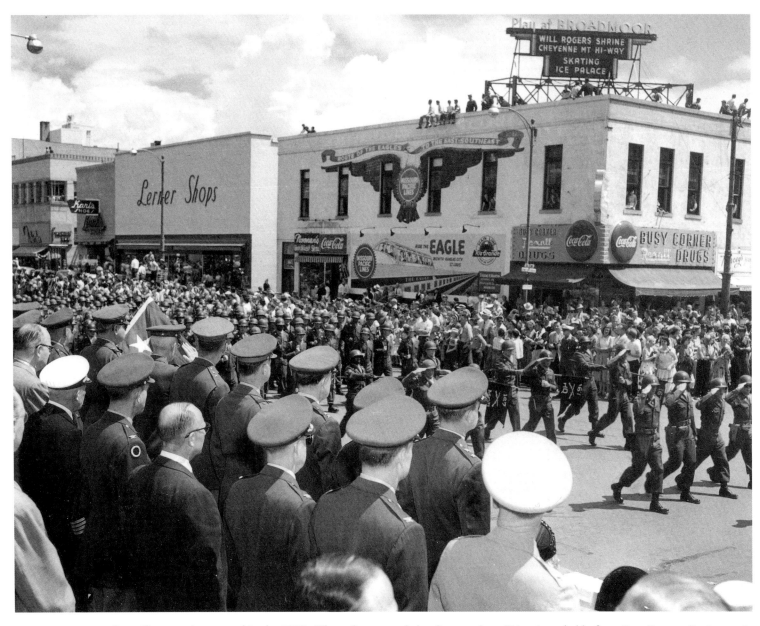

Busy Corner as it appeared in the 1950s. The military parade heading south on Tejon is probably from Fort Carson. Businesses in view include Lerner's Clothing Store, at 7 North Tejon, and Busy Corner Drugs, at 102 E. Pikes Peak.

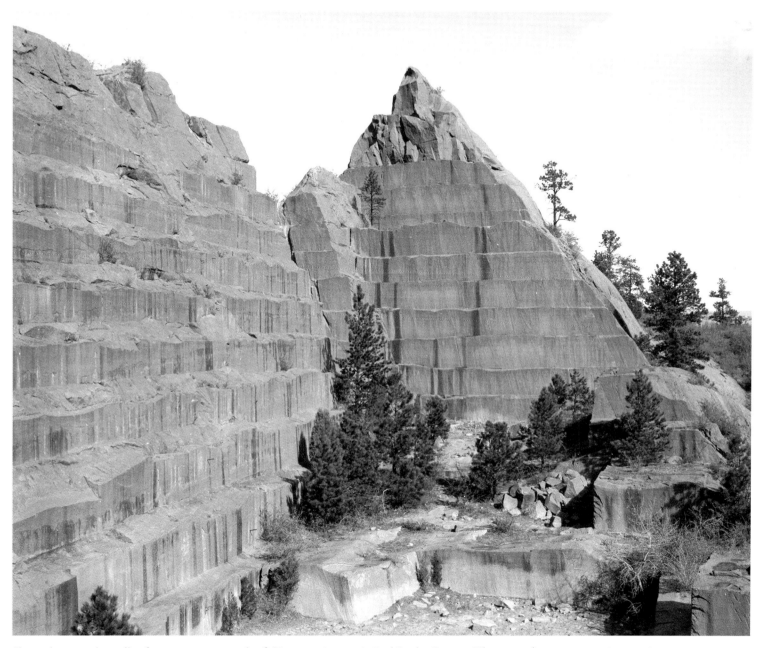

Shown here are the walls of a stone quarry south of Cimarron Avenue in Red Rocks Canyon. The stepped cuts are conspicuous. A spur of the Colorado Midland Railroad that ran to the canyon removed the sandstone blocks, many of which were used in the construction of buildings in Colorado Springs. Today hikers and sightseers use the Red Rocks Canyon open space for recreation.

During the 1960s and 1970s, newer storefronts and buildings were located at the intersection historically known as Busy Corner. Businesses included Baker's Shoes, the Pikes Peak Building, Patsy's Candy, Busy Corner Luncheonette, and the Wigwam Lounge.

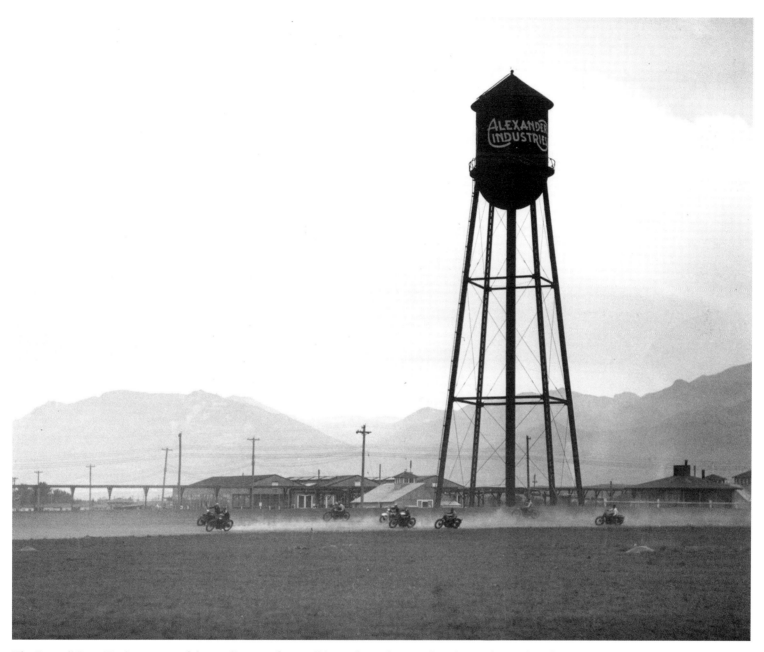

The Roswell Race Track was part of the small town of Roswell located on what was then the northern edge of Colorado Springs, off North Nevada Avenue. The town was a by-product of the arrival of the Chicago, Rock Island, and Pacific Railroad in the 1880s. The Alexander Industries water tower in the foreground served Alexander Film Co. and Alexander Aircraft nearby. Roswell was annexed by the city in the 1950s.

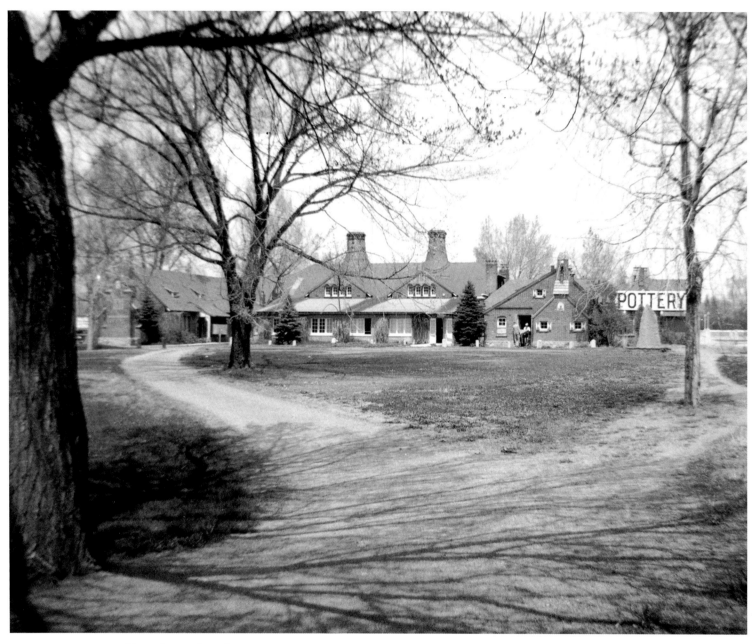

Suffering from tuberculosis, Ohioan Artus Van Briggle sought the drier climate of Colorado Springs in 1899, where he and wife-to-be Anne Gregory established the Van Briggle Pottery in 1901. His prize-winning art nouveau designs enjoyed world acclaim, but his career was cut short in 1904 when the gifted artisan succumbed to TB at the youthful age of 35. Van Briggle's widow went on to open the Van Briggle Memorial Pottery on Glen and Uintah, at the edge of Monument Valley Park, designed by Nicholas Van den Arend and built on land donated by General Palmer. The ornate structure opened in 1908.

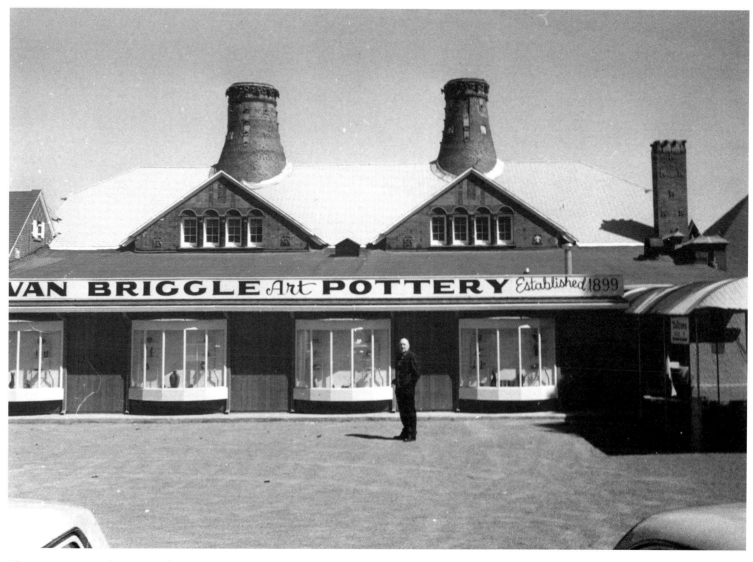

The 1908 Van Briggle Memorial Pottery and showroom featured paired gables, round and square chimneys, and window bays displaying ceramics. It is shown here as it appeared around midcentury.

A sundial was built into the west-side chimney of the Van Briggle Memorial Pottery during construction in 1907. The art nouveau structure is located at Glen and Uintah streets and is currently owned by Colorado College. The pottery itself moved to a renovated railroad roundhouse in the 1950s and is today the nation's oldest, continuously operating pottery, rededicated to the art nouveau styles that made Artus Van Briggle famous.

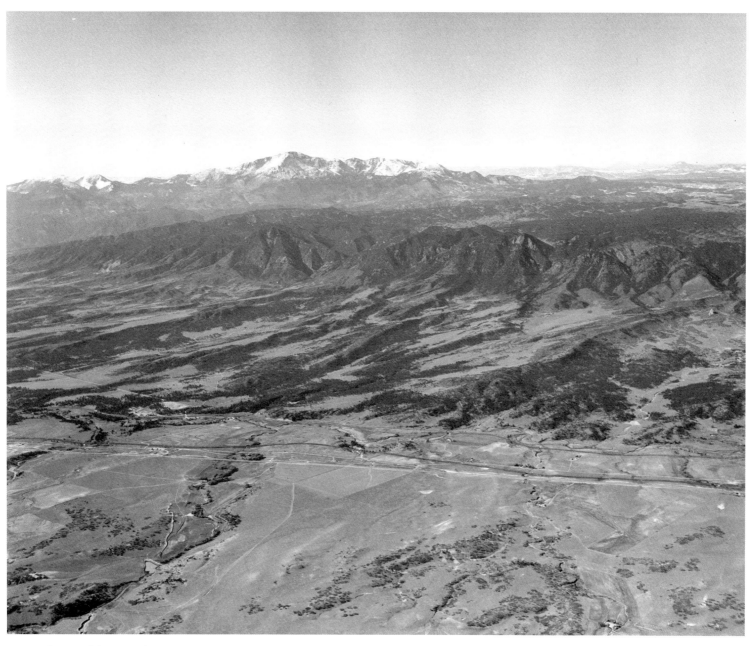

An aerial view of the United States Air Force Academy site around 1954 before construction. The Denver and Rio Grande and Santa Fe Railroad lines are both visible. Some 17,500 acres of land that lay nestled against the Rampart Range of the Rockies were acquired and construction began shortly afterward.

In 1954, Frank Lloyd Wright, at age 83, visited the site of the newly established Air Force Academy. Wright is shown with his foot on a stump talking to three businessmen. Originally, Wright was miffed at not having been selected as chief architect for the cadet chapel but later volunteered his advice.

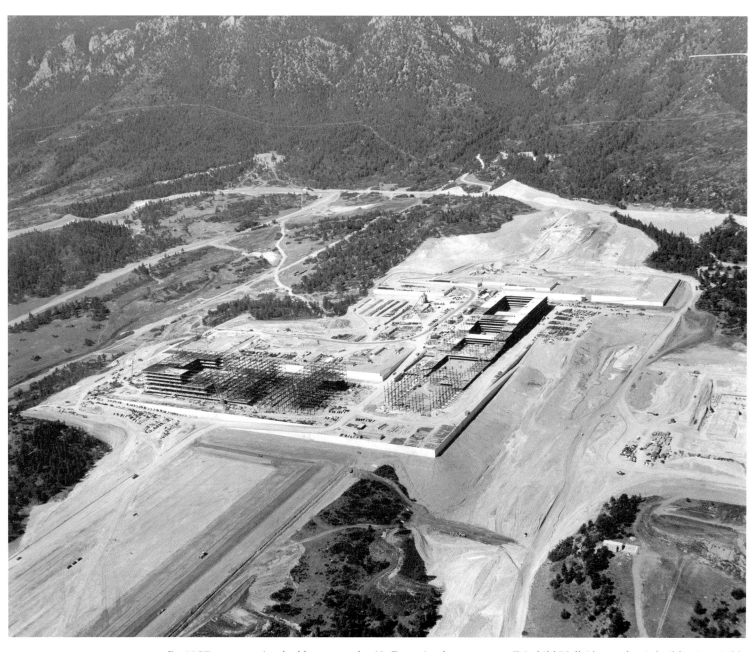

By 1957, construction had begun on the Air Force Academy campus. Fairchild Hall (the academic building) is visible at front with steel framework in place. Vandenberg Hall (the cadet dorm) is at right in various stages of construction. A weather station stands on a hill at lower-right.

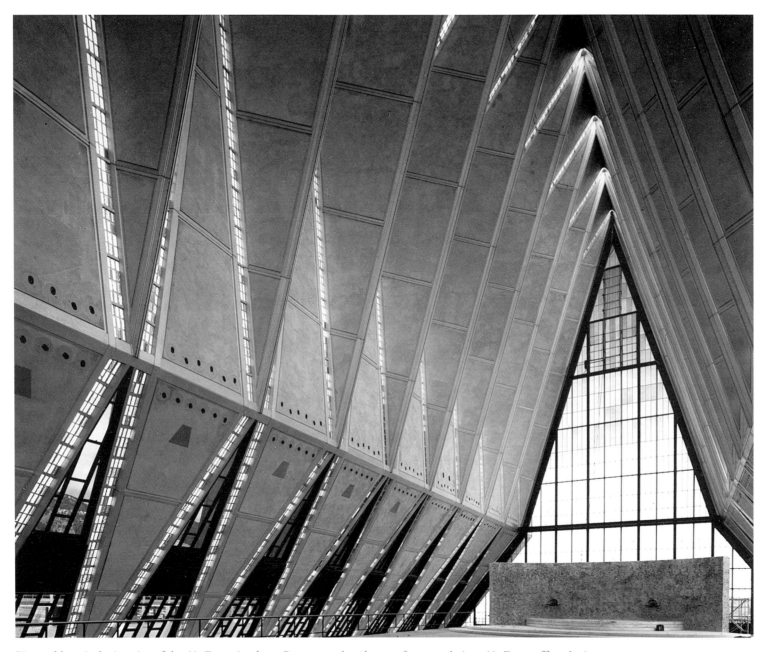

Pictured here is the interior of the Air Force Academy Protestant chapel soon after completion. Air Force officers' wives clubs and military units worldwide contributed furnishings. The Catholic Chapel and Jewish Synagogue are located below. Skidmore, Ownings, and Merrill built the 17-spire structure at a cost of $3.5 million.

An Air Training Officer is inspecting a member of the Air Force Academy Class of 1959 in the cadet barracks at Lowry Air Force Base, before the move to the new facilities in Colorado Springs. The Class of 1959 was the first class to graduate from the academy. This cadet is standing outside his two-man room. A number of presidents, including Kennedy, Nixon, and Reagan, have spoken at Academy graduations.

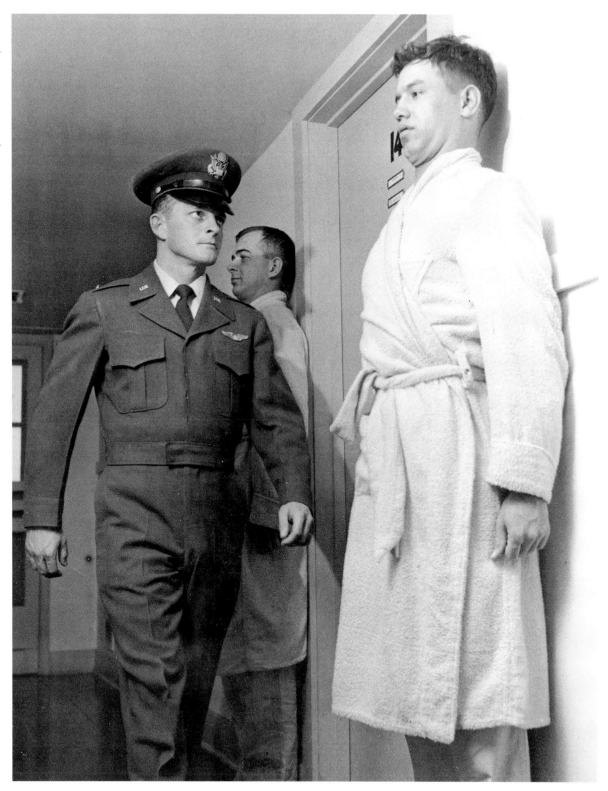

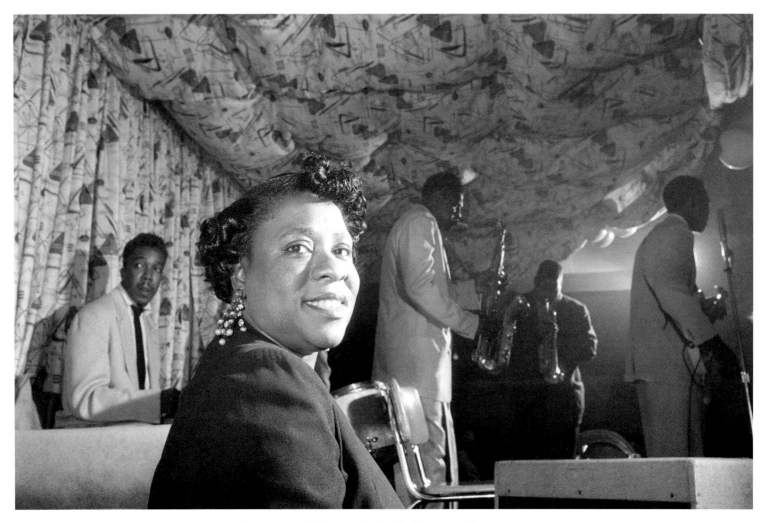

Fannie Mae Duncan is shown here in 1957 at her Cotton Club, named after the famous Harlem entertainment venue.

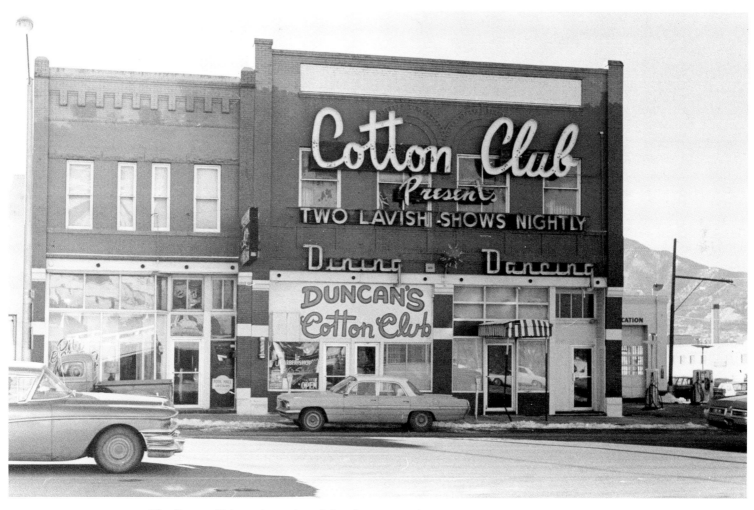

The Cotton Club was located on Colorado Avenue at Tejon Street. Owner Fannie Mae Duncan had expanded her family businesses from a barbershop and restaurant to include the live entertainment venue. Well-known black musicians entertained here, including Duke Ellington and Count Basie. Flip Wilson served as an emcee during the time he was stationed at Fort Carson with the Army. The Cotton Club was eventually torn down and replaced with the Sun Building.

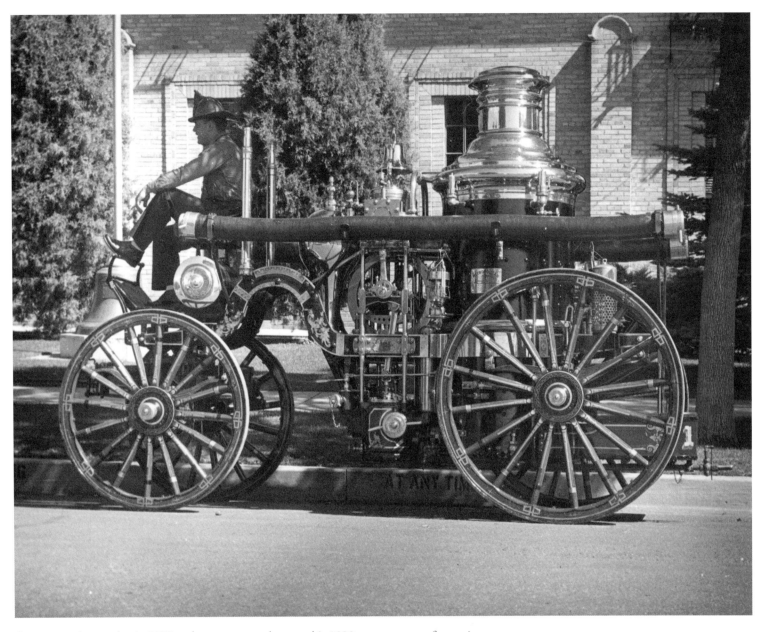

On a sunny August day in 1952 and at an unnamed event, this 1898 steam-pumper fire engine once again sees the streets of Colorado Springs. During its heyday, it would have charged to the scene of a fire behind a team of horses.

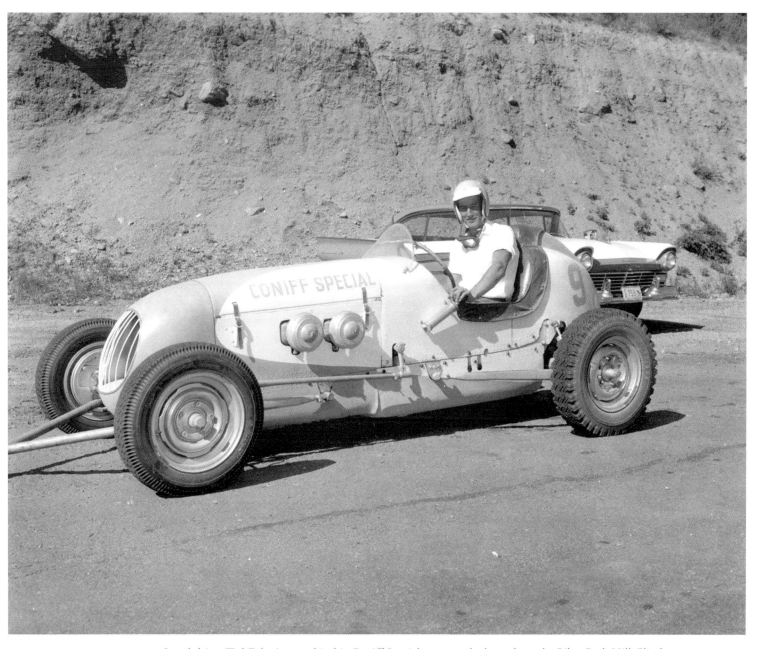

Local driver Ted Foltz is towed in his Coniff Special past a parked car along the Pikes Peak Hill Climb course in 1958. More than 50 cars were entered in the Open Wheel, Stock Car, and Sports Car classes that year. Total prize money was $21,655. Foltz finished 15th, completing the course in 15:50.5 minutes.

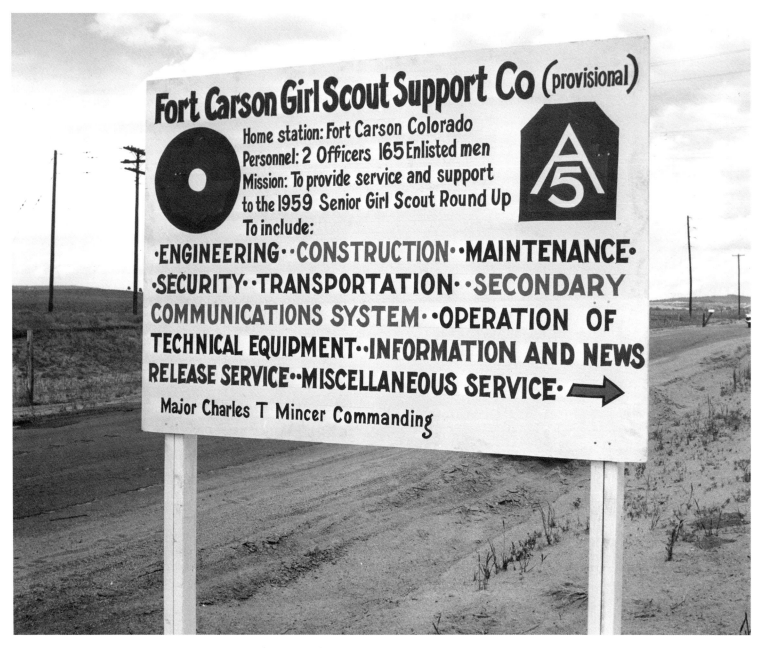

In 1959, the Senior Girl Scout Round Up was held in Colorado Springs. This large, hand-lettered sign posted on the dirt road offers information about Fort Carson and its mission to assist in the round-up.

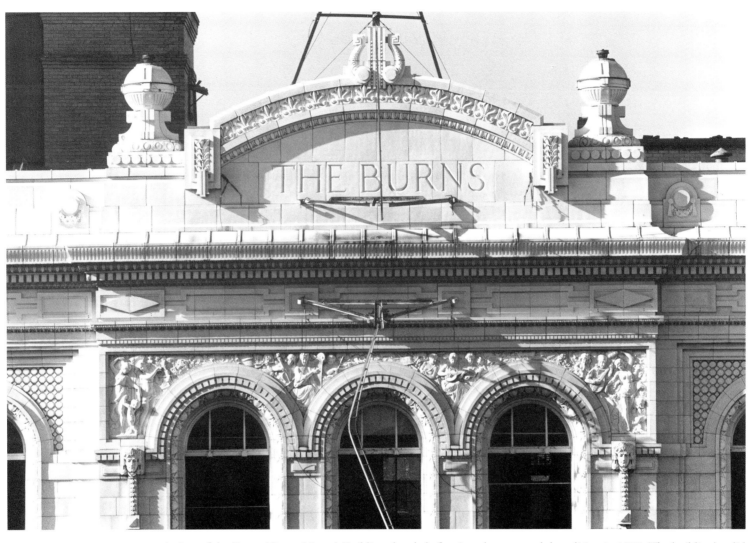

A view of the Burns (Opera House) Building shortly before its urban renewal demolition in 1973. The building's solid construction did battle with wrecking crews, who chipped away at the structure for weeks before making the kill. A drive-through banking facility and parking lot sit today at the location on E. Pikes Peak Avenue.

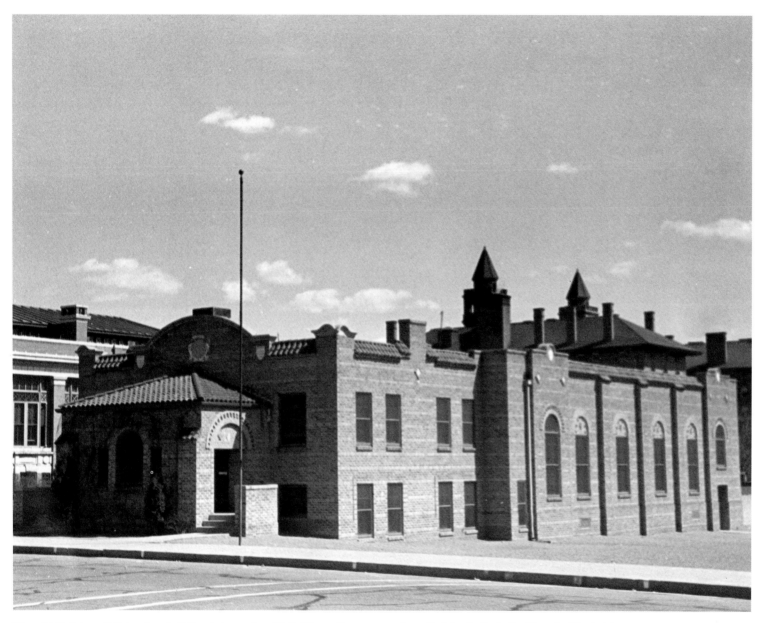

The old Knights of Columbus building is located at 25 E. Kiowa Street across from St. Mary's Catholic Church. The brick building has terra-cotta stepped cornices, arched windows, cartouches, and stone trim. With the help of the Colorado Springs Pioneer's Association and Maude McFerran Price, the Pioneer Museum took over the building for many years, followed by an architectural firm. The Pikes Peak Library District now uses the building for collection management.

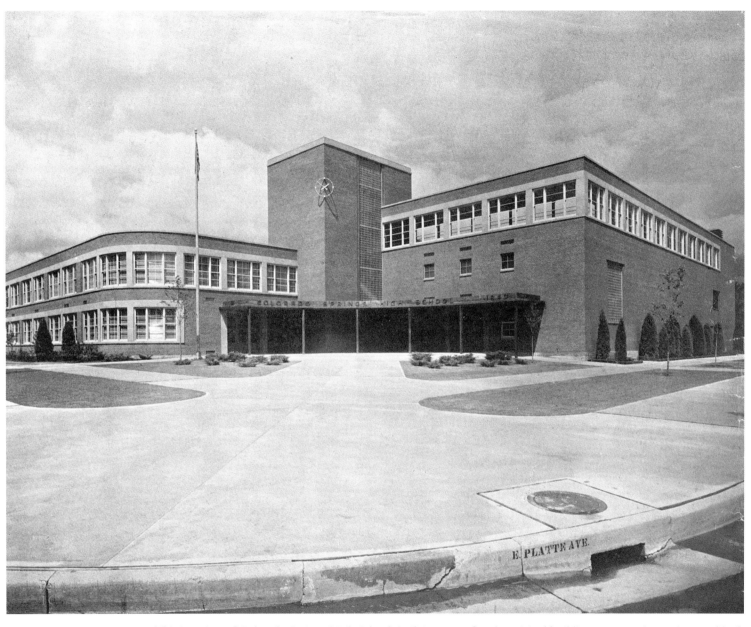

This is a view of Colorado Springs High School, built in 1939 after the original building was torn down. A second high school (Wasson) was constructed as the population grew. Colorado Springs High School changed its name to Palmer.

Students at the Junior League–sponsored Nutrition Camp School, established in 1924, sit writing at their desks. The original goal was to help malnourished children become healthier, to fight off the effects of tuberculosis. The League sponsored five beds the first year and by 1939 helped 450 children.

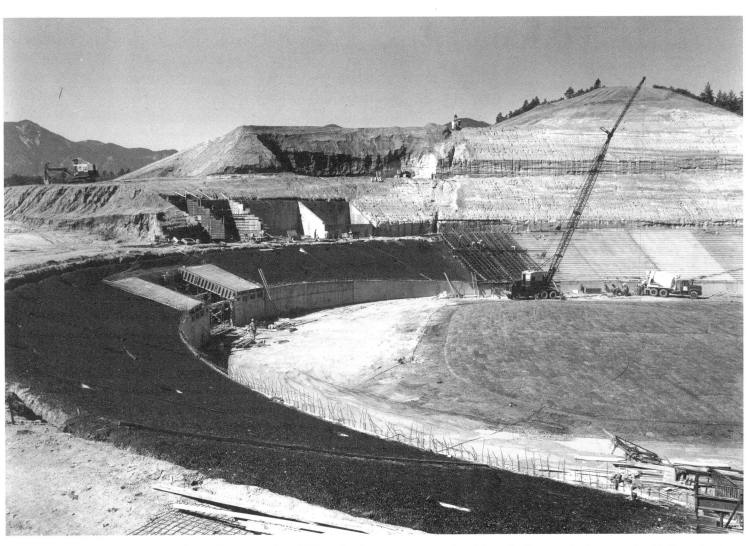

By September 1961, the Air Force Academy was constructing Falcon Stadium, today home to the Air Force Academy Fighting Falcon football team. The stadium's oval shape and tiered sides are clearly visible. In more recent times, another level has been added as well as skyboxes and night lighting.

A group of Fort Carson soldiers conduct field training with machine gun exercises.

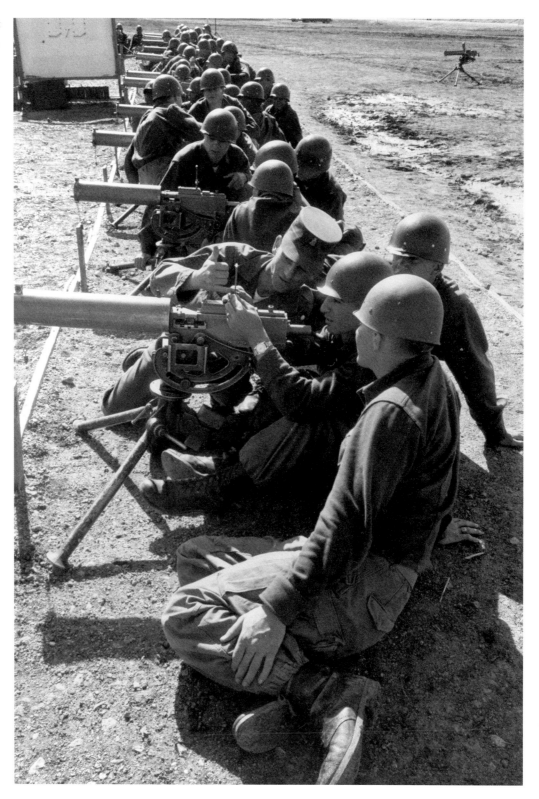

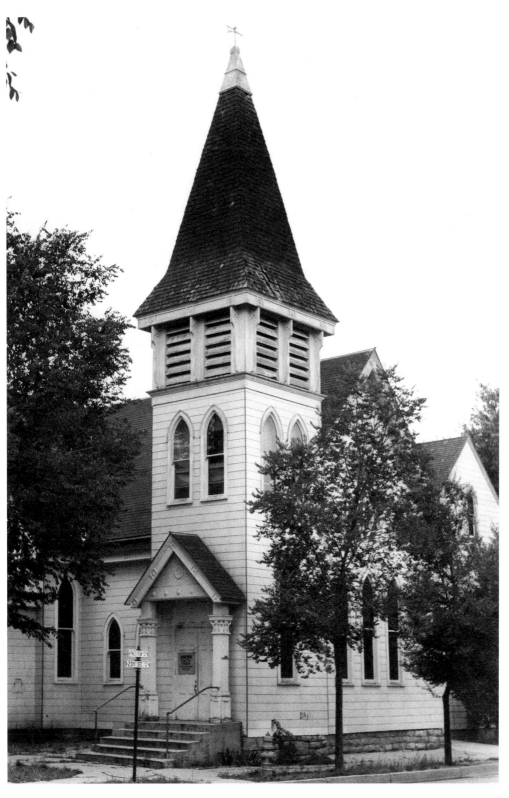

The First Methodist Episcopal Church stood at 2232 W. Pikes Peak Avenue, erected in 1901 at a cost of $11,000. The name was changed to Trinity Methodist Episcopal Church when Colorado City was annexed to Colorado Springs. The building was vacated in the early 1960s.

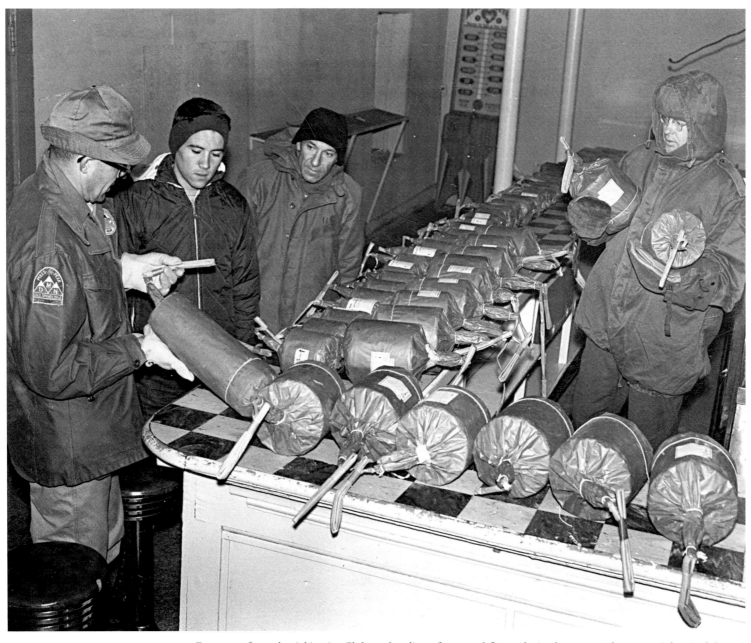

Four men from the AdAmAn Club study a line of wrapped fireworks in the summit house on Pikes Peak late in 1965, in preparation for the annual New Year's Eve display they provide for Colorado Springs residents.

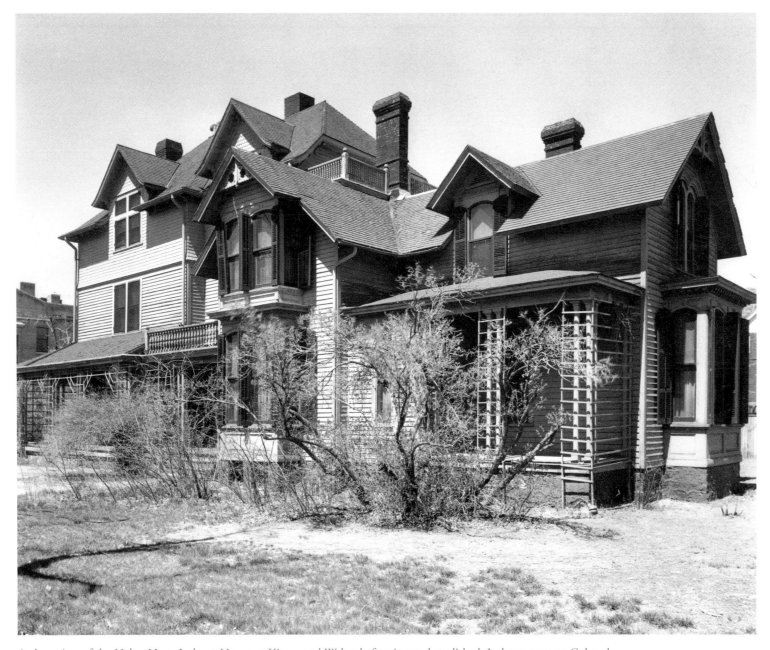

A close view of the Helen Hunt Jackson House at Kiowa and Weber before it was demolished. Jackson came to Colorado Springs for her health, meeting and marrying William Sharpless Jackson, a business partner of General Palmer's. The home was replaced with the new Colorado Springs Police Operations Center.

Van Briggle tiles were used to create the detail on the clock over the facade of the Marksheffel Garage. After the building was demolished, the tiles were placed in the Demonstration Heritage Garden behind the old Memorial Pottery on Glen and Uintah.

194

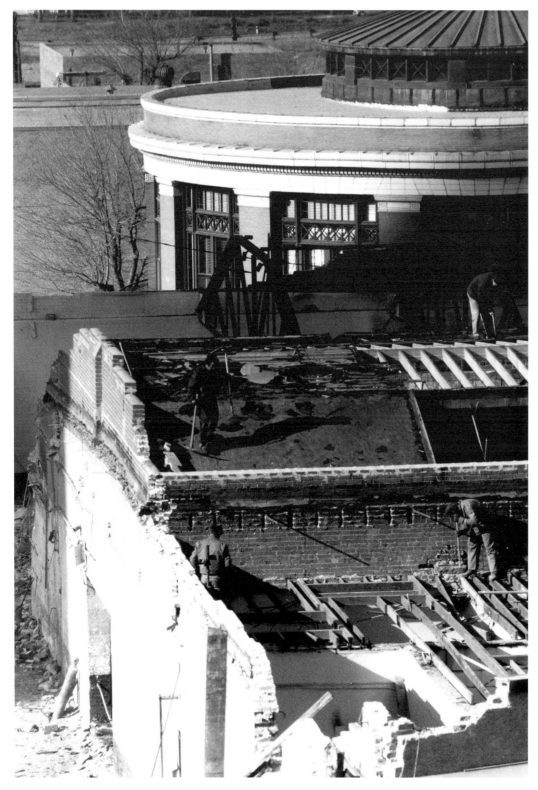

The roof of the Marksheffel Garage is shown during demolition with the rotunda of the Colorado Springs Carnegie Library building in the background. A new, larger library and parking lot are now located next to the old Carnegie Library, which houses local and regional history and genealogical records.

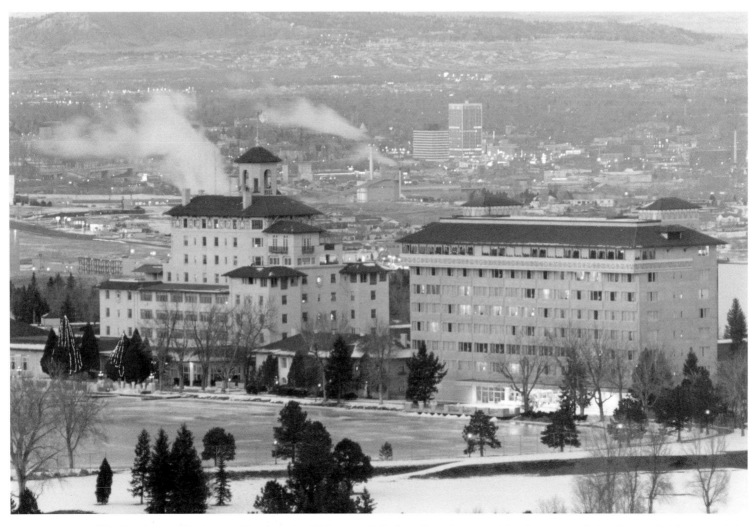

The Broadmoor Hotel opened its doors in 1918 to much fanfare. Over the years, it has been upgraded and expanded far beyond the facility envisioned even by its first owner Spencer Penrose. It has played host to numerous celebrities including presidents. This 1967 view shows the Broadmoor from the west with downtown visible behind.

President Richard Nixon shakes hands with Colorado senator Gordon Allott during the 1972 Colorado Centennial Celebration in Colorado Springs. Allott presents Nixon with a first edition copy of local writer Marshall Sprague's book *One Hundred Plus*.

In the 1890s, Catholics in Colorado City had to travel to Manitou to attend mass until Anthony Bott, a Colorado City pioneer, donated lots for a Colorado City Catholic church. The original brick church and rectory were torn down and a new brick church was built in 1922. Popular architect Thomas MacLaren designed this Spanish mission–style facade with stucco veneer over the brick. Sacred Heart Church is still serving the community and is a Westside landmark.

More than two million visitors to Colorado Springs helped celebrate the nation's Bicentennial by touring the American Freedom Train when it stopped in the city October 3-5, 1975. People waited in line for hours for admittance. Exhibits inside the train covered all phases of America's 200-year history.

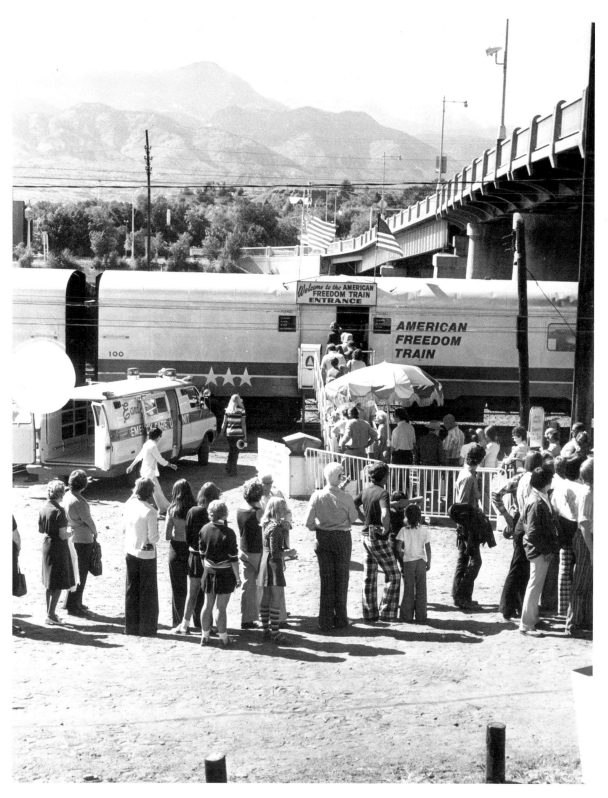

NOTES ON THE PHOTOGRAPHS

These notes, listed by page number, attempt to include all aspects known of the photographs. Each of the photographs is identified by the page number, photograph's title or description, photographer and collection, archive, and call or box number when applicable. Although every attempt was made to collect all data, in some cases complete data may have been unavailable due to the age and condition of some of the photographs and records.

20 EARLY SETTLER TENT
Library of Congress
LC-USZ62-113856

21 COLORADO MIDLAND RAILROAD CONSTRUCTION
Courtesy of Pikes Peak Library District, Special Collections
103-2491

22 PIKES PEAK WEATHER STATION
Library of Congress
LC-USZ62-137696

23 WILLIAM JACKSON PALMER
Courtesy of Pikes Peak Library District, Special Collections
001-376

24 EARLY STREETCAR
Courtesy of Pikes Peak Library District, Special Collections
001-2518

25 CABIN FROM 1858
Courtesy of Pikes Peak Library District, Special Collections
001-62

26 MANITOU SODA SPRINGS TOURISTS
Courtesy of Pikes Peak Library District, Special Collections
001-3343

27 RAILROAD DEPOT, 1889
Courtesy of Pikes Peak Library District, Special Collections
001-2502

28 FIRST GROCERY
Courtesy of Pikes Peak Library District, Special Collections
103-4088

29 COLORADO CITY GLASS WORKS
Courtesy of Pikes Peak Library District, Special Collections
001-2016

30 VOLUNTEER FIRE BRIGADE
Courtesy of Pikes Peak Library District, Special Collections
001-5654

31 GENERAL PALMER AT GLEN EYRIE
Courtesy of Pikes Peak Library District, Special Collections
001-374

32 DOWNTOWN MANITOU
Courtesy of Pikes Peak Library District, Special Collections
001-2523

33 PRESBYTERIAN CHURCH OF THE STRANGERS
Denver Public Library, Western History Collection, H. S. Poley
001-71747

34 FIRE DEPARTMENT PARADE
Denver Public Library, Western History Collection, X-14490

35 PIKES PEAK BURRO
Courtesy of Pikes Peak Library District, Special Collections
001-663

36 TUCKER'S RESTAURANT
Denver Public Library, Western History Collection, H. S. Poley
001-71882

37 BOARD OF TRADE AND MINING EXCHANGE
Denver Public Library, Western History Collection, X-14298

38 JOHN HUNDLEY LIVERY AND TOURS
Denver Public Library, Western History Collection, H. S. Poley
001-72203

39 COLORADO SPRINGS AND CRIPPLE CREEK RAILWAY
Courtesy of Pikes Peak Library District, Special Collections
001-2517

40 FAIRLEY BROTHERS BURROS
Courtesy of Pikes Peak Library District, Special Collections
001-657

41 DENVER AND RIO GRANDE DEPOT
Courtesy of Pikes Peak Library District, Special Collections
001-2497

42 COLORADO COLLEGE DORMITORY ROOM
Courtesy of Pikes Peak Library District, Special Collections
001-115

43 MOVING DAY
Courtesy of Pikes Peak Library District, Special Collections
001-654

44 FLOWER PARADE FLOAT
Denver Public Library, Western History Collection, H. S. Poley
P-2186

45 SUNFLOWER PARADE PARTICIPANTS
Courtesy of Pikes Peak Library District, Special Collections
010-7102

46 ORIGINAL BROADMOOR CASINO
Courtesy of Pikes Peak Library District, Special Collections
010-7098

47 RESIDENTIAL STREET FACING CHEYENNE MOUNTAIN
Courtesy of Pikes Peak Library District, Special Collections
001-2068

48 HUGHES GROCERY
Special Collections, Tutt Library, Colorado College, Colorado Springs, Colorado

111 BEARD'S SERVICE
STATION
Courtesy of Pikes Peak
Library District, Special
Collections
001-2038

112 CRAGMOR PATIENT
SUNBATH
Courtesy of Pikes Peak
Library District, Special
Collections
001-183

114 FIRST ADAMAN
ASCENT OF PIKES
PEAK, 1922
Courtesy of Pikes Peak
Library District, Special
Collections
001-223

115 CLIMBERS AT THE PEAK
Courtesy of Pikes Peak
Library District, Special
Collections
001-2334

116 PATIENT WITH
CIGARETTE
Courtesy of Pikes Peak
Library District, Special
Collections
001-178

118 BURNS OPERA HOUSE,
1921
Denver Public Library,
Western History Collection,
X-14865

119 BUSY CORNER AFTER
SNOWSTORM OF 1921
Courtesy of Pikes Peak
Library District, Special
Collections
001-79

120 TEMPLAR SPECIAL AT
DEVIL'S PLAYGROUND
Courtesy of Pikes Peak
Library District, Special
Collections
015-958

121 HIGHWAY 85-87, 1920
Courtesy of Pikes Peak
Library District, Special
Collections
001-426

122 EL POMAR INTERIOR
Denver Public Library,
Western History Collection,
X-14704

123 TODDLER AT CAPITOL
CRISPETTE SHOP
Courtesy of Pikes Peak
Library District, Special
Collections
001-5284

124 AUSTIN BLUFFS ROAD
Special Collections, Tutt
Library, Colorado College,
Colorado Springs, Colorado

125 ANTLERS HOTEL
GARAGE
Courtesy of Pikes Peak
Library District, Special
Collections
001-5518

126 COLORADO SPRINGS
CITY HALL
Courtesy of Pikes Peak
Library District, Special
Collections
001-4773

127 MANITOU MINERAL
WATER COMPANY
Courtesy of Pikes Peak
Library District, Special
Collections
015-1073

128 HIGH SCHOOL GYM
EXERCISE, 1927
Courtesy of Pikes Peak
Library District, Special
Collections
001-442

129 GOLDEN CYCLE MILL
Courtesy of Pikes Peak
Library District, Special
Collections
001-254

130 GOLDEN CYCLE MILL
#2
Courtesy of Pikes Peak
Library District, Special
Collections
015-896

132 FLOOD OF 1921
Courtesy of Pikes Peak
Library District, Special
Collections
001-143

133 LOUIS UNSER AT PIKES
PEAK HILL CLIMB
1930
Courtesy of Pikes Peak
Library District, Special
Collections
015-1077

134 CHICAGO, ROCK
ISLAND, AND PACIFIC
STEAM ENGINE
Denver Public Library,
Western History Collection,
Otto Perry
OP-5358

136 PRINCESS POWER WITH
PENROSE TROPHY
Courtesy of Pikes Peak
Library District, Special
Collections
015-965

137 HIGH SCHOOL AERIAL
Courtesy of Pikes Peak
Library District, Special
Collections
001-4093

138 THE COLORADO
EXPRESS, 1931
Denver Public Library,
Western History Collection,
Otto Perry
OP-5672

139 CIVILIAN CONSERVATION
CORPS AT REST
Courtesy of Pikes Peak
Library District, Special
Collections
001-3545

140 DOSTAL-HOWARD TIRE
COMPANY
Denver Public Library,
Western History Collection,
X-14284

141 FLOOD OF 1935
Courtesy of Pikes Peak
Library District, Special
Collections
001-4596

142 ROCK ISLAND
INSPECTION CAR
Denver Public Library,
Western History Collection,
Otto Perry
OP-5953